Photoshop Elements®

drop dead
lighting
techniques

Photoshop Elements® drop dead lighting techniques

BARRY HUGGINS

LARK BOOKS
A Division of Sterling Publishing Co., Inc.
New York

Photoshop Elements Drop Dead Lighting Techniques

Library of Congress Cataloging-in-Publication Data

Huggins, Barry.
 Photoshop elements drop dead lighting techniques / Barry
Huggins. -- 1st ed.
 p. cm.
 Includes index.
 ISBN 1-57990-974-4 (pbk.)
 1. Photography--Lighting. 2. Adobe Photoshop elements. 3.
Photography--Digital techniques. I. Title.
TR590.H836 2006
775--dc22

 2006018809

10 9 8 7 6 5 4 3 2 1
First Edition

Published by Lark Books, A Division of
Sterling Publishing Co., Inc.
387 Park Avenue South, New York, N.Y. 10016

© The Ilex Press Limited 2007

This book was conceived, designed, and produced by:
ILEX, Cambridge, England

Distributed in Canada by Sterling Publishing,
c/o Canadian Manda Group, 165 Dufferin Street,
Toronto, Ontario, Canada M6K 3H6

If you have questions or comments about this book,
please contact:
Lark Books
67 Broadway
Asheville, NC 28801
(828) 253-0467

Printed in China

ISBN 13: 978-1-57990-974-1
ISBN 10: 1-57990-974-4

For more information on Photoshop Elements
Drop Dead Lighting Techniques, see:
www.web-linked.com/elltus

For information about custom editions, special sales,
premium and corporate purchases, please contact
Sterling Special Sales Department at 800-805-5489
or specialsales@sterlingpub.com.

CONTENTS

INTRODUCTION

Photography is undergoing a revolution. This is not the first time change has occurred in the field of photography. There was the transition from using glass plates to rolls of film, the gradual phasing out of large, heavy, metal-box-type cameras in favor of small plastic ones that slip into your pocket and automatically set the exposure and focus. There was the mass conversion from black-and-white to color photography, and flash photography that first dispensed with large bulbs to utilize tiny cubes, before even tinier flash units were developed to actually be built into the camera. Then, there was the thrilling arrival of instant Polaroid photography that gave immediate gratification as you could watch images develop before your eyes. These examples of change continue on to read like the evolution of a species. However, all these epic moments, heralded as great technological landmarks by the contemporary enthusiasts of the art, fade in comparison to the momentous times that photography is witnessing today.

The advent and subsequent domination of digital photography has meant that photography will never be the same again. Never has instant photography been so instant, and never has photography been so accessible. We carry cameras built into our cell phones. The power of the image has always been recognized as carrying a greater impact than that of the written or spoken word, and the ability to use images that traverse the world in the blink of an eye is now within the grasp of much of the Western world.

Not that this instantly makes us all first-class photographers holding exhibitions with a gallery of our work captured on our cell phones—or even work taken with serious digital cameras worth thousands of dollars. As prodigious and accessible as the technology is, it is still just a tool, just like those early giant glass plates that recorded images. As with any art, the tools alone do not create masterful work. The skill of the art is still held in the mind, the eyes, and the hands of the artist.

Photoshop Elements, like the digital camera, is also just a tool, albeit an extremely clever one. Over the following pages you will learn how to use this extraordinary tool to create work of merit, work that will stand out from the crowd, and that will raise your own expectations of the results you can achieve.

This book focuses on the lighting effects that can be created using Photoshop Elements. As you will see, these include everything from simple tonal alterations, to turning deserts into underwater landscapes, to creating new suns.

Hopefully, you will be inspired as you work through the various projects, and encouraged to see the processes as skill sets to adapt, dissect, and transform as the basis for your own ideas. Remember, every finished piece of work started as a vision in someone's mind. Using this book will help you understand how the technology at your fingertips can be utilized to make your vision manifest.

The Basics

THE WORKSPACE

The Photoshop Elements workspace is designed to simulate the working environment of a designer or artist in the real world. The center of the screen is taken up by the canvas, and is surrounded by menus and palettes that contain all of the required tools and equipment.

The Menu Bar

As with most applications, the top of the screen houses the Menu Bar. This bar features commands that allow simple functionality, such as opening, closing, and saving files, as well as other more advanced commands and functions.

Shortcut Bar

Immediately below the Menu Bar is the Shortcut Bar. This provides shortcuts to some of the more common tasks, such as opening, saving, and printing files, by way of a one-click icon. Using these icons saves you the trouble of accessing the written command form the Menu Bar.

At the extreme right of the Shortcut Bar there are two modes; Quick Fix and Standard Edit. The Quick Fix mode provides simple functionality for easily remedied problems. In this book we will be using the Standard Edit mode for the increased functionality it offers.

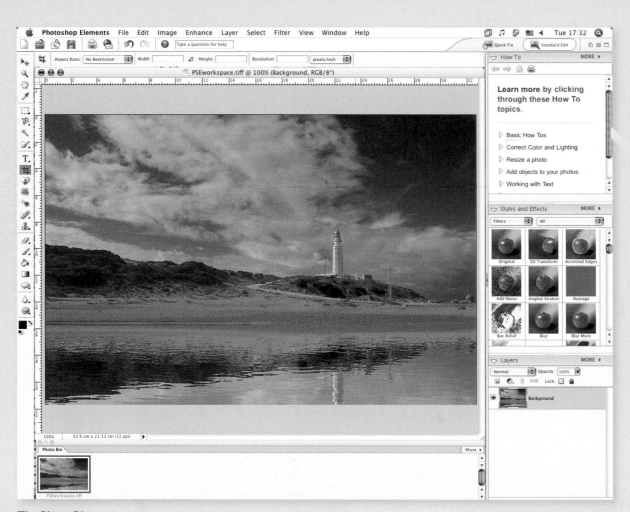

The Photo Bin

The Photo Bin is a separate window that stores thumbnails of any files that are currently open. This is useful for keeping track of images when you have a number of them open.

The Tool Bar

The Tool Bar appears on the left of the screen and houses all the tools you need to interact with your images. Tools appear as icons and are clicked on to select them. Some of the tools have a small black triangle visible in the bottom-right corner. This means further tools are hidden under this icon that have a related function. To access the hidden tools keep the mouse button pressed over the tool icon and a flyout menu will appear enabling the hidden tools to be selected.

The tools are grouped by their basic function into four categories. The top category contains simple tools for functions such as moving elements, zooming, and choosing colors by way of an eyedropper. Next comes the selection tools, a vital group of tools used for isolating areas of an image. Below this category you will find the creation and editing tools. This group includes tools that you will use to create art from scratch, such as the text tool, paintbrushes, and pencils, as well as tools that are used to edit or enhance images including cloning tools, erasers, and sharpening tools. Finally, at the bottom of the Tool Bar, are the foreground and background color squares. Clicking either of these squares opens the Color Picker, enabling you to choose a new color or alter the hue of the current one.

The Palette Bin

1 The Palette Bin appears on the right of the screen. By default, the palettes are locked into place in one column.

The Tool Options Bar

The Tool Options Bar sits at the top of the screen and changes depending on the current tool selected in the Tool Bar. Use this bar to customize the tool to perform in a specific way for the task at hand.

2 Palettes hold specific elements in one easy-to-contain window. For example, the Swatches palette stores color swatches for quick use, similar to a palette of colors in the real world.

3 Palettes can be opened and closed to provide more working space by clicking the white triangle at the top-left of each palette.

4 Palettes can also be separated from the Palette Bin by dragging their title bar away from the bin. They can be reattached by dragging them back.

5 Any palettes that are closed can be opened from the Window menu on the Menu Bar found at the top of the screen.

MAKING SELECTIONS

Accurate selections and masks are hugely important when manipulating photographs, so it is no surprise that Photohop Elements contains a number of different tools for making them.

The Magic Wand

1 Choosing the Magic Wand tool reveals the Tool Options Bar, where custom settings can be made. The Tolerance refers to the range of colors that will be selected when any pixel in the image is clicked. The higher the tolerance, the more colors will be selected.

Anti-alias is enabled by default. This allows for a smoother edge when the selection is created.

The Contiguous option, when enabled, will only select colors that are actually touching.

Tolerance: 32 ☑ Anti-alias ☑ Contiguous ☑ Sample All Layers

2 When using the default settings as shown, clicking any single area of the yellow sun umbrella in the following example only selects part of it. The range of yellows is too great for them all to be selected with a Tolerance of 32.

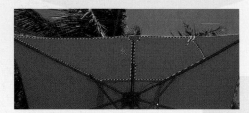

3 To complete the selection the mode can be changed to "Add to selection." Now clicking another unselected part of the umbrella will add that area to the selection. The third and fourth mode icons Subtract from the selection and Intersect with the selection respectively.

Select	Filter	View	Window
All		Ctrl+A	
Deselect		Ctrl+D	
Reselect		Shift+Ctrl+D	
Inverse		Shift+Ctrl+I	
All Layers			
Deselect Layers			
Similar Layers			
Feather...		Alt+Ctrl+D	
Modify		▶	
Grow			
Similar			

4 An alternative way to increase the selection is to go to Select > Similar.

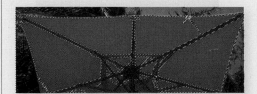

5 The Similar command has selected virtually the whole umbrella.

The Lasso Tools

1 The Magic Wand is of little use when colors are not similar enough, or the object is too similar to its background. In these situations the Lasso tools offer a manual or semimanual method of selecting an area.

The Lasso tool is a simple tool for outlining the edge of the target object. Just click and drag to draw around the desired object. The mouse button must remain pressed for the duration. You need a steady hand, lots of patience and sufficient time to use this tool successfully.

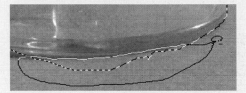

2 The selection of the glass is ruined by the area at the base where the mouse went off course, but this is easily remedied by changing the Lasso Tool mode to Subtract from selection.

Now you can simply draw another small selection that will subtract the area that you do not want.

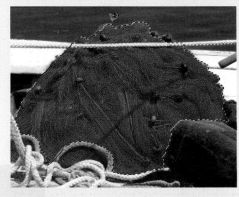

3 For areas that have confusing elements within them, the Magnetic Lasso tool is worth a try as long as the area has a well-defined edge. These yellow fishing nets have been successfully selected using this tool. The tool works in the same way as the Lasso tool but anchor points are automatically placed as you draw. If at any time the edge becomes less well-defined, you can also click to make an anchor point yourself. Unlike the Lasso tool, you can release the mouse button and continue drawing without losing the selection.

The Polygonal Lasso tool is best used for areas with straight lines only.

The Marquee Tools

For basic squares, rectangles, circles, and ellipses use either the Rectangular or Elliptical Marquee tools; both share the same location in the Tool Bar. To constrain the Elliptical tool to a circle or the Rectangular tool to a square, keep the Shift key pressed once you begin to create the selection.

The Magic Selection Brush

1 This tool can be used in the same way as the Magic Wand tool or the Lasso tool. Either click on the area you want to select, or draw around it. The tool can also be scribbled over an area to make the selection.

2 The Tool Options Bar allows you to use this tool in Add-to or Subtract-from modes, as with other selection tools. The color and size of the brush can also be changed to aid clarity as you draw.

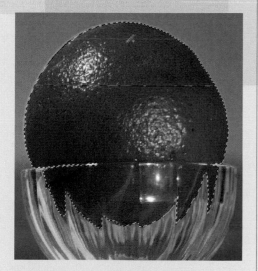

3 The image of the orange has a wide range of shades. In this instance I used the Magic Selection Brush to click a mid-range shade toward the top and a complete selection was made with one click.

Feathering a Selection

1 This creates a selection with a soft edge. When the Rectangular Marquee, Elliptical Marquee, or Lasso tools are selected, the Tool Options Bar displays the Feather box. By default it is set to zero. The higher the value entered into the feather box the softer the edge becomes.

2 Here a circular selection with no Feather has been filled with yellow, creating a sharp, well-defined edge.

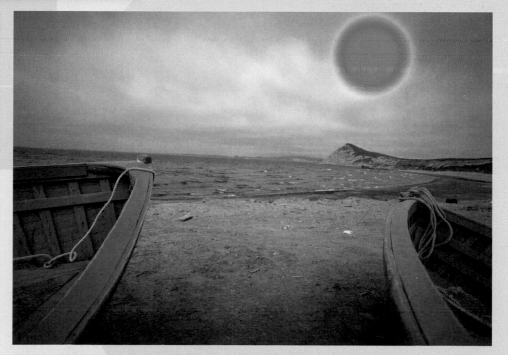

3 Here the selection has been made with a 10 pixel Feather, again filled with yellow. If you want to apply a feather to an existing selection, go to Select > **Feather** and enter the value into the Feather Radius box. The Feather then works in exactly the same way.

LIGHTING EFFECTS FILTER

The Lighting Effects filter is where you'll spend much of your time when you're experimenting with lighting in Photoshop, so it's worth getting to know it well before you begin. The main use of the filter is to emulate the effect of a light being shone onto your image by brightening certain areas and darkening others, but it can do much more than that...

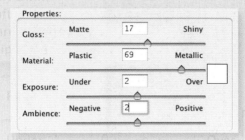

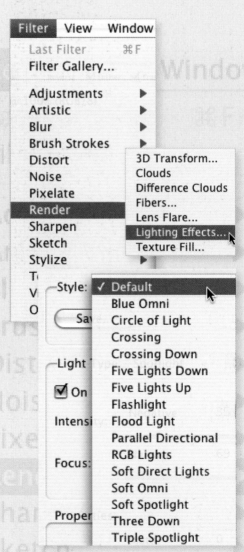

1 The Lighting Effects Filter dialog box has wide array of effects and settings. If you want to use one of the predefined lights, click the Style drop-down box at the top of the dialog box and choose any of the presets. To create your own light, use the Default setting.

2 The Light Type drop-down box offers a choice of three lights: Directional is a broad ambient light from a chosen direction; Omni is a round light where light emanates from the center; and the Spotlight is a bold beam of a light just like its real-life counterpart.

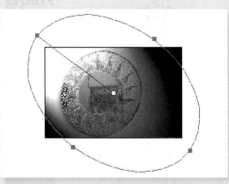

3 The Preview window allows you to change the shape, size, and direction of the light by clicking and dragging the anchor points situated on the light's oval bounding box. This example shows the bounding box of a Spotlight.

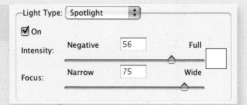

4 The effect of the light is defined in two sections. The Light Type section refers to the light being cast itself. Use the Intensity slider to increase or decrease the amount of light and the Focus slider to increase or decrease the area of coverage.

5 The Properties section refers to the area on to which the light is being cast.

For Gloss effects, drag the slider toward Matte for reduced reflections and toward Shiny for greater reflections.

For Material effects, settings closer to Plastic emphasize the light's color, whereas settings toward Metallic emphasize the object's color.

When adjusting the Exposure, increase the light in the image by dragging the slider toward Over or drag the slider toward Under to decrease the light.

The Ambience allows for other light sources in the image such as natural daylight or an interior room light. Drag toward Negative to reduce light and toward Positive to increase light.

6 The color of the light can be changed by clicking the white square in the Light Type section. This opens the color picker enabling you to choose a color.

7 New lights can be created by clicking and dragging the Lightbulb icon into the Preview window. Drag a light from its white center point onto the trash can icon to delete unwanted lights. Note that you can't delete the last light from a scene; there always has to be one left.

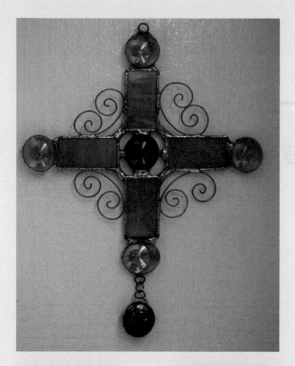

The Lighting Effects Filter

The Lighting Effects filter has a series of preset lights built in as standard. Although not all immediately useful, they can be used as bases from which to create your own lighting set ups. Listed below are all of the standard presets using the image of a cross shown to the left.

Directional

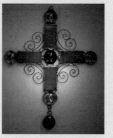

Omni

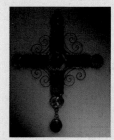

Spotlight

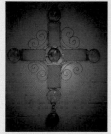

Blue Omni

Circle of light

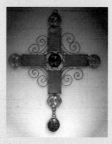

Crossing

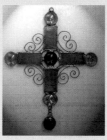

Crossing Down

Five Lights Down

Five Lights Up

Flashlight

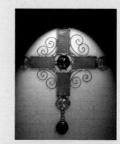

Floodlight

Parallel Directional

RGB Lights

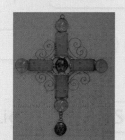

Soft Direct Lights

Soft Omni

Soft Spotlight

Three Down

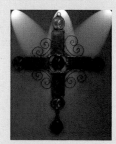

Triple Spotlight

THE BRUSH TOOL

The Brush is perhaps one of the most basic tools, and it is the one that most Photoshop Elements beginners start with, but it can do more than most people give it credit for. The key to getting the most out of this tool lies in understanding its various settings in the Tool Options Bar.

1 The icons in the Tool Options Bar display four types of brush. The first icon is the standard Brush.

2 Preset brushes can be accessed from the Show Selected Brush Presets drop-down box. Scroll down the menu and click a brush to use it.

3 Farther brush sets are accessed by clicking the Brushes drop-down box when the Show Selected Brush Presets menu is open.

4 Set the brush size by adjusting the Size slider or by typing a number directly in the Size numeric box.

5 The Mode drop-down box affects the way paint is applied to the underlying pixels. In Normal mode paint is applied without any special effects, that is, it works in exactly the same way as a conventional paintbrush does when you paint on paper.

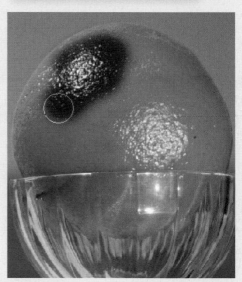

6 By accessing Color mode from the drop-down box and painting over an image, only the color is applied, enabling the texture, light, and shadow of the original image to show through. This is a useful technique to use for coloring grayscale images.

7 Use the Opacity slider to reduce the strength of the paint, allowing more subtle brush strokes to be made.

8 Clicking the Airbrush icon converts the brush to an airbrush, this works like a traditional airbrush. Keep the mouse button pressed and paint continues to spray onto the image. This brush is a subtle one that can produce high-quality results when applying highlights or shadows.

9 Click the More Options button to reveal further settings to enhance the brush stroke.

10 The Spacing defines the amount of space between each icon that was used to create the original brush. The first brush stroke uses 25 percent spacing. The second stroke uses 150 percent spacing.

11 Fade allows the brush stroke to fade out, in the same way as a conventional brush runs out of loaded paint.

The red stroke was set to fade out after 30 steps. Use this option to create strokes that gently taper.

12 Hue Jitter controls how the colors set as the foreground and background colors are applied to the brush stroke. When set to 0 percent only the foreground color is used. Higher percentages result in a greater exchange of the two colors. In the example the foreground color was set to red and the background color was set to blue. The Hue Jitter was set to 80 percent.

13 The Hardness controls how soft the edge of the brush appears. The first stroke was set to 100 percent for maximum Hardness. The second stroke was applied at 0 percent.

14 Scatter controls how far the individual brush icons deviate from the applied brush stroke. At 0 percent all brush icons follow the exact path of the applied stroke. The example shows a single straight line applied to the page but with a Scatter setting of 100 percent, resulting in an extremely random pattern.

Angle: 45°
Roundness: 35%

15 The Angle and Roundness of the brush can be changed by typing numbers into the relevant numeric boxes or by dragging the arrowhead and the two black dots in the Brush Preview window.

16 With Angle set to 45 degrees and Roundness set to 35 percent, a calligraphic style of brush stroke is created.

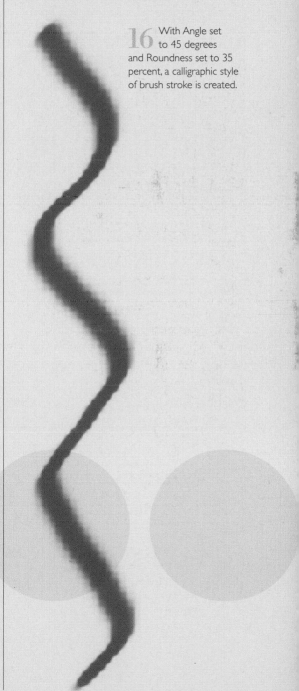

FILTER GALLERY

The Filter Gallery provides a neatly packaged and efficient method for trying out different filters when experimenting. Here, an image of a lemon tree is used to show the effects of the filters.

1 The Filter Gallery can be accessed from the main menu by going to *Filter* > **Filter Gallery**.

3 Click the Artistic folder to open it, revealing thumbnail examples of all the Artistic filters.

2 The Filter Gallery is split into three columns in the default setting. The left column shows a preview of the filtered image, the middle column displays folders covering all the category of filters that can be applied through the Filter Gallery, and the third column provides settings for the current chosen filter.

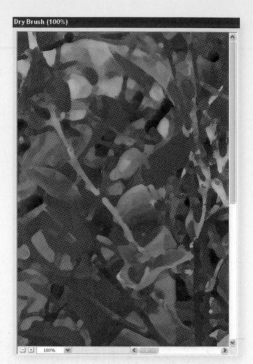

4 Clicking a thumbnail applies that filter to the image and updates the Preview window on the left.

5 Individual settings can be applied to farther customize the image.

6 Click the OK button to apply the filter.

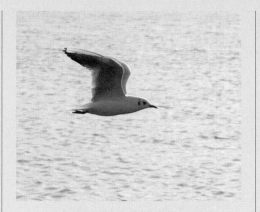

Using The Filter Menu

1 All the filters in the Filter Gallery can also be applied individually from the Filter menu. Some filters, such as Blur and Sharpen, do not appear in the Filter Gallery, and must be applied directly from the menu.

3 Although the Sharpen and Blur filters are seen as predominantly functional, they can also be used creatively, particularly the Blur filters. This image of a bird in flight has been caught with a fast shutter speed so the bird and the background are captured in equally focused detail.

4 The impression of speed can be greatly enhanced by blurring the background to give an impression of motion. Make a selection of the background and go to *Filter > Blur > **Motion Blur*** to apply the effect.

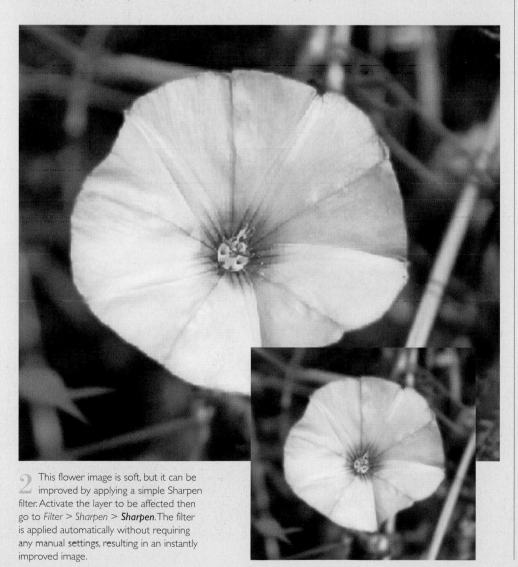

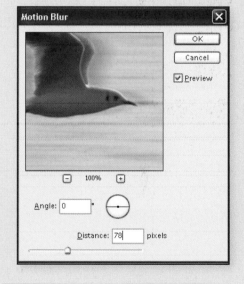

2 This flower image is soft, but it can be improved by applying a simple Sharpen filter. Activate the layer to be affected then go to *Filter > Sharpen > **Sharpen***. The filter is applied automatically without requiring any manual settings, resulting in an instantly improved image.

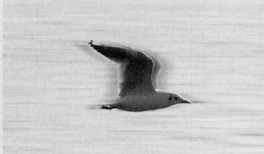

5 The 0 degree angle of blur has been set to align with the direction of the bird. The Amount here was set to just enough to make the water ripples blend into a smooth, uniform pattern, giving the impression of the camera being panned.

WORKING WITH LAYERS

Layers are a hugely important feature of photomanipulation software, and it is essential to familiarize yourself with their use. If the Layers palette is not visible on your screen, it can be accessed by going to *Window > Layers*.

1 When a photograph is opened or a new file created, the image contains just one layer called "Background." The Background layer is locked by default. This means the layer cannot be erased to transparency nor can other layers be dragged below it.

2 If either function needs to be performed double-click the word "Background," and rename the layer in the dialog box that opens. The layer can now be used as an ordinary editable layer.

3 When new artwork is to be added to an image, creating a new layer prevents errors being made on the work completed so far. To make a new layer, click the More button in the top-right corner of the Layers palette and choose New Layer.

4 Alternatively, click the Create a new layer icon at the top of the palette.

5 Layers can be deleted by again clicking the More button and choosing Delete Layer or by clicking the trash can icon at the top of the Layers palette.

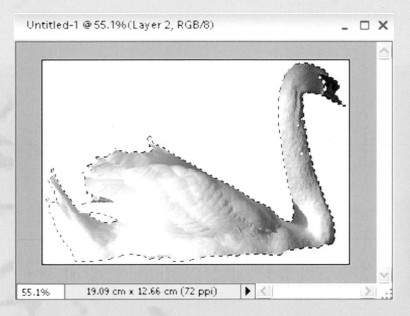

Untitled-1 @ 55.1%(Layer 2, RGB/8)

55.1% 19.09 cm x 12.66 cm (72 ppi)

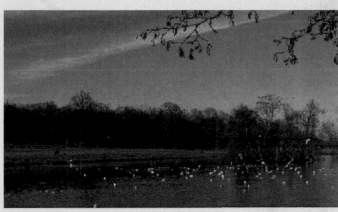

6 Layers can be dragged from one file to another for the purpose of montaging images. The swan has been selected in its own image and can now be dragged into the lake image using the Move tool.

Layers can be hidden and revealed by clicking the Eye icon next to the layer thumbnail.

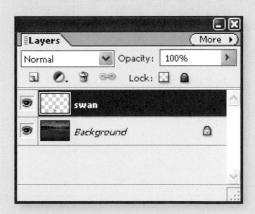

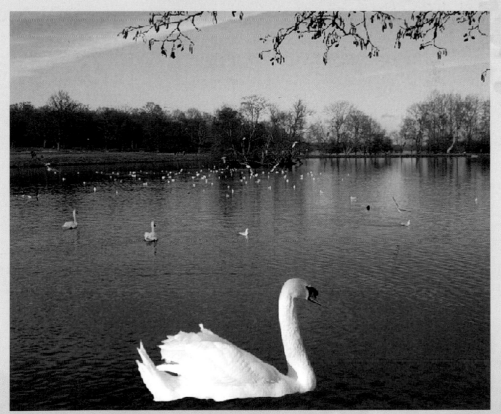

7 When layers are dragged in this way a new layer is created automatically in the destination file. The gray-and-white check pattern visible in the swan layer thumbnail denotes transparent areas of the layer. Think of a transparent area as a clear sheet of acetate onto which paint can be applied. In this case the paint is the swan. The swan can now be moved and edited independently without the background being affected.

WORKING WITH LAYERS

9 The first of the pair of lock icons locks only the transparent areas of the image. This has been enabled on the main swan layer of the image below. Now paint can be applied to the entire layer but only the swan will be affected.

Lock:

8 To protect layers from accidental editing, they can be locked in two ways. The black padlock icon prevents a layer from being edited in its entirety. Click this icon with any layer active (other than the Background layer which is always locked) to prevent any action from being performed on the layer. Click the padlock again to unlock it.

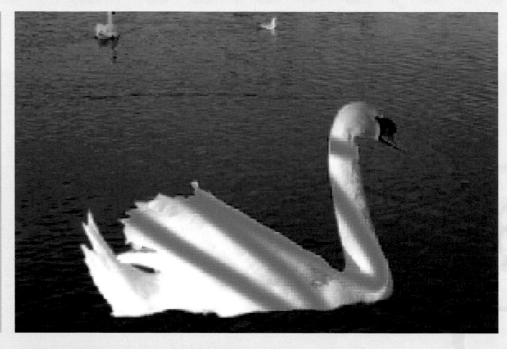

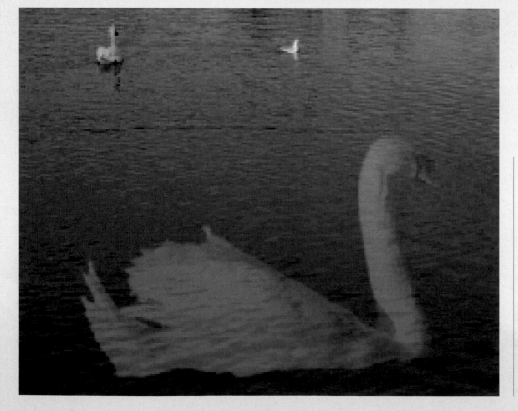

10 Use the Opacity slider to reduce opacity of the pixels on a layer.

11 When two or more layers need to be moved in unison they can be linked together so they move as one. Keep the Shift key pressed and click any layers that are to be linked then click the link icon. Clicking the same icon again will unlink the layers.

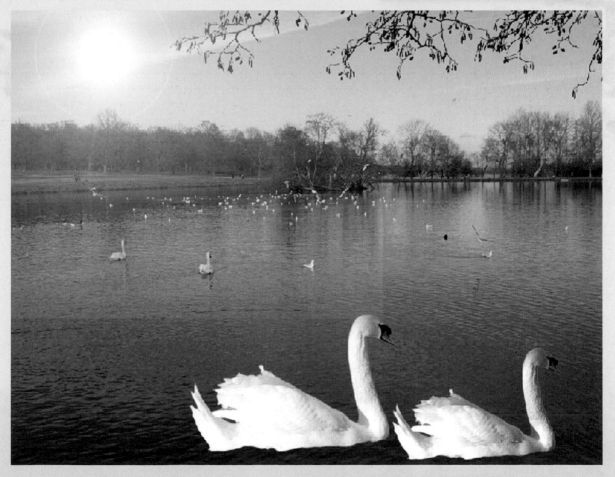

12 Layer blend modes allow the pixels on layers to interact with each other to create special effects. Normal is the default mode, this has no effect on other layers. Click the drop-down box to reveal the range of blend modes.

13 In this example a black-filled layer has had a Lens Flare filter applied to simulate the sun. The layer blend mode has been changed to Screen, this hides the dark areas of the layer allowing the underlying layers to show through. The false sun can now be positioned independently, which would not be possible if the filter had been applied directly to the Background layer.

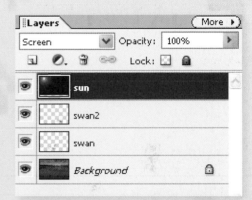

ADJUSTMENT LAYERS

Adjustment layers are an extremely useful way of applying effects such as Brightness/Contrast changes to your images. By using them, you can keep the alterations separate from the image data, so they can easily be modified or turned off if required.

2 The new Adjustment Layer will appear above the previously active layer. To edit the settings at any time double-click the left thumbnail on the adjustment layer in the Layers palette to access the dialog box once again.

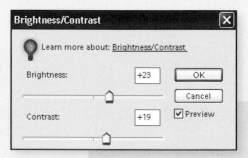

3 The chosen dialog box will then open where the desired edits can be made.

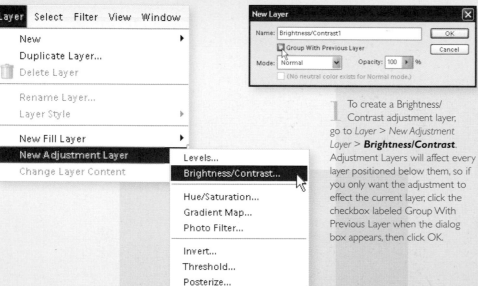

1 To create a Brightness/ Contrast adjustment layer, go to *Layer > New Adjustment Layer > **Brightness/Contrast***. Adjustment Layers will affect every layer positioned below them, so if you only want the adjustment to effect the current layer, click the checkbox labeled Group With Previous Layer when the dialog box appears, then click OK.

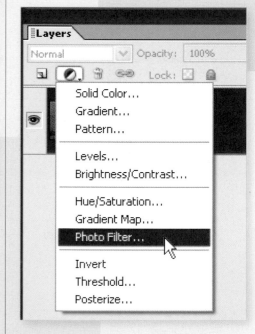

4 Multiple Adjustment Layers can be applied on top of each other. This time, use a different method of applying an adjustment layer. Click the adjustment layer icon at the top of the palette and choose Photo Filter. The Photo Filter simulates the traditional photographers' filters used for effects such as warming the tones of a photograph.

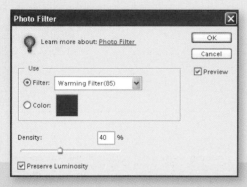

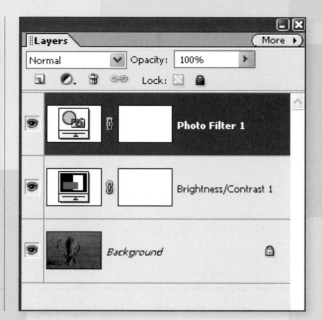

5 Once again the requested dialog box opens where the various options can be selected. Click the OK button when you're done.

6 The second Adjustment Layer now appears in the Layers palette and can be edited in the same way by double-clicking the left thumbnail.
 Adjustment layers can be deleted in the same way as ordinary layers by activating them and then clicking the trash can icon in the Layers palette.

FILLS AND GRADIENTS

The entire image, or a selection within it, can be filled with any color that you create using a variety of methods. The conventional method is to go to *Edit > Fill selection*. Gradients are fills consisting of two or more colors or transparent areas that blend into one another.

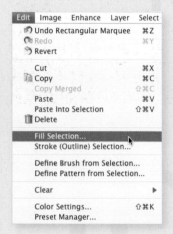
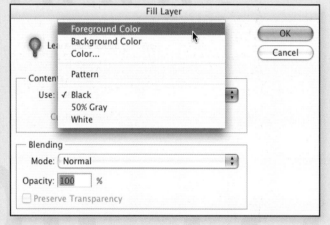

The Paint Bucket Tool

1 Another method is to use the Paint Bucket tool. Select the options from the Tool Options Bar. The Tolerance is important if the selection contains areas of different shades of color. A higher Tolerance setting will fill areas with greater variance of color and shade.

Filling Selections

1 After going to *Edit > Fill Selection*, choose the type of color you wish to use from the Use drop-down box.

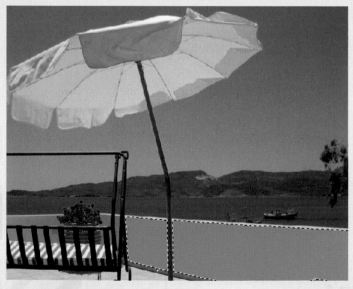
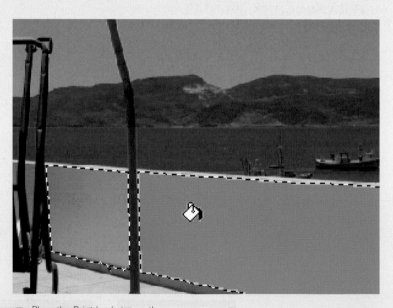

2 If a selection has been made it will be filled with the chosen color.

2 Place the Paint bucket over the selection and click to fill.

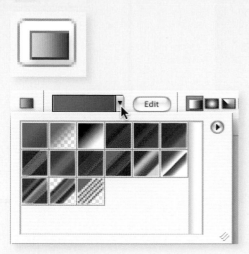

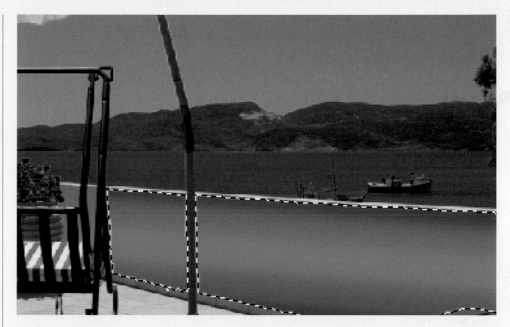

The Gradient Tool

1 Choose the Gradient tool. The gradient drop-down box in the Tool Options Bar reveals the basic default set of gradients. Click any thumbnail to use it.

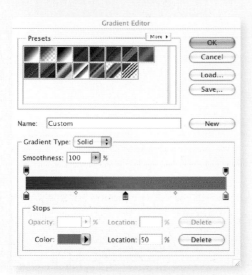

2 Clicking the Edit button next to the drop-down box opens the Gradient Editor from where gradients can be customized or created. In this example the red/green gradient has been chosen. By clicking the red marker below the gradient the color drop-down box becomes enabled, from where a new color can be applied.

To create an additional color, click anywhere between the lower markers. Then choose the desired color as in the previous step.

Dragging a color marker downward will remove the color from the gradient, but a minimum of two colors must remain.

3 To apply the gradient, drag the Gradient tool across a selection or any area of the image. The longer the drag, the more subtle the blending of the colors.

4 There are five different gradient types to choose from, all of which are displayed on the Tool Options Bar.

The Linear choice gives straight gradients where colors are parallel to each other. The Radial option gives circles of color like those of a bull's-eye; this is often used to depict spherical shapes. The Angled selection gives the appearance of a cone when viewed form above, and the Reflected selection simulates the appearance of a tubular object, depending on the colors used. The Diamond choice is similar to Radial, but uses a diamond shape.

5 The Mode drop-down box controls how the gradient is applied to the page. In Normal mode the gradient is applied conventionally. The other modes replicate the way layer blend modes work by applying the gradient using special effects.

Opacity reduces the strength of the gradient when used below 100 percent, Reverse switches the order of colors, Dither creates a subtle random mixing of pixels that helps reduce the flatness sometimes associated with gradients, and Transparency allows a transparency to be blended in with a color.

CLONING AND HEALING

The Clone Stamp tool is useful for removing distracting elements from your images. The Healing Brush works in a similar way to the Clone Stamp tool except the Healing Brush doesn't just clone pixels from one place to another. It also matches the texture, lighting, and shading, making for a more seamless result in most cases.

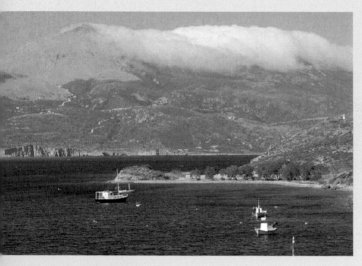

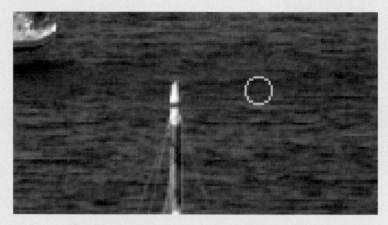

4 To begin cloning, a registration point must first be made. This is the point from where pixels will be copied. The cursor is positioned at a suitable point then, with the Alt key (Option key on a Mac) pressed, the mouse is clicked. The point clicked will now be the source for any cloned pixels.

The Clone Stamp

1 The tip of a boat's mast has sneaked into the bottom corner of this harbor image. It can be removed through careful use of Photoshop Elements' cloning and healing tools.

2 Choose the Clone Stamp tool from the Tool Bar.

3 The Tool Options Bar allows you to select the brush type, the brush size, its Mode, and its Opacity. To remove the boat mast, a soft-edged brush has been selected from the brush drop-down box with a size of 60 pixels. Normal mode clones pixels in their exact form as they appear in the original. For more subtle cloning the Opacity percentage can be reduced.

The Aligned checkbox, when enabled, automatically keeps the registration point relative to the tool as it is used. Unchecking the Aligned box maintains the registration point at its original position regardless of where the cloning tool is used within the image.

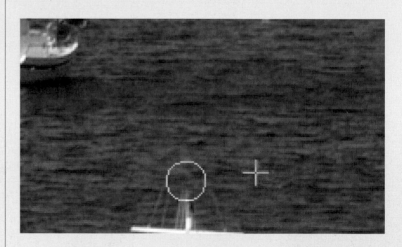

5 Now the Clone Stamp tool can be dragged over the problem area and pixels will be cloned from the source area. A small cross appears to show where pixels are being cloned from throughout the cloning process. If necessary, new registration points can be made to avoid repeat patterns appearing.

 Size: 60 px ▶ Mode: Normal ▼ Opacity: 100% ▶ ☑ Aligned

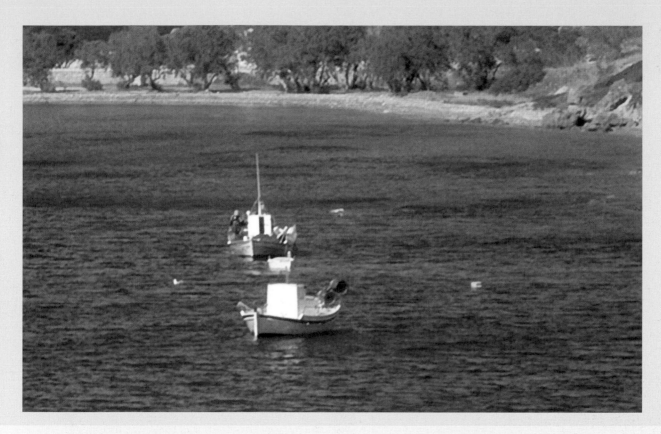

6 This final image shows that, when cloned with care, the removal is impossible to detect with the eye.

The Healing Brush

1 The Healing Brush tool options are similar to those of the Clone Stamp tool. Brush type and size can be selected from the drop-down box and the Mode can be adjusted. Normal mode copies conventionally, just like the Clone Stamp tool. The main difference here is the Source option. Use the Sampled radio button to copy the image pixels or the Pattern radio button to copy from a predefined pattern. When this option is chosen, the pattern drop-down box is enabled, giving a variety of patterns to choose from.

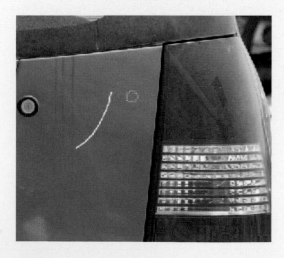

2 The scratch on this vehicle covers a variety of subtle shades as well as light and dark areas.

3 Using the Healing Brush removes the mark invisibly.

Shadows and projections

CAST SHADOWS

Photographers spend a disproportionate part of their lives engaged in the process of removing or avoiding shadows in their images. Shadows have earned an undeserved bad press over the years, particularly in the area of product photography, where the very thought of photographing the latest gleaming chrome gizmo with even the hint of a shadow would be heresy. It's time to redress the balance in favor of the shadow. Here you'll see how to apply a cast shadow as an intentional creative feature to add some interest to an otherwise ordinary image.

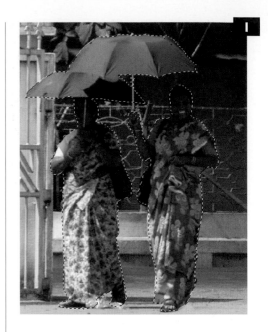

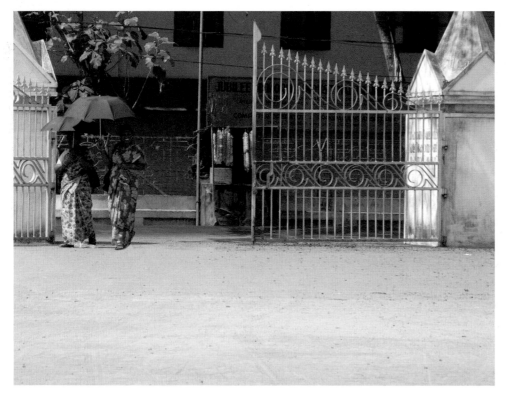

Original image

1 Make a selection of the two women including their sun umbrellas. The selection does not have to be highly accurate because it will be used as the basis for a shadow that will have a soft edge.

2 Go to *Select* > **Feather** and apply a Feather Radius of 10 pixels.

3 Create a new layer, naming it "Shadow women."

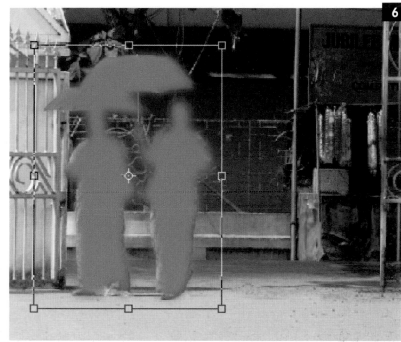

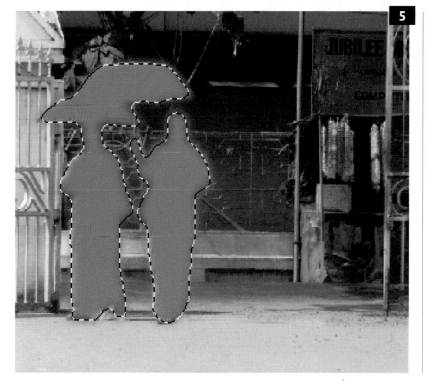

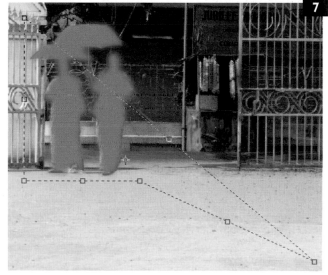

4 Using the Eyedropper tool, sample a naturally dark area from the ground.

5 Use the sampled color to fill the selection by pressing Alt+Backspace (Opt+Backspace on a Mac).

6 Deselect the selection (Ctrl+D, Cmd+D on a Mac). Then go to *Image* > *Transform* > **Distort** to reveal the Distort bounding box.

7 Click and drag the top-right handle of the bounding box at a 45 degree angle toward the bottom right.

CAST SHADOWS

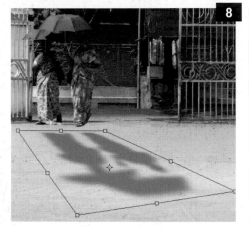

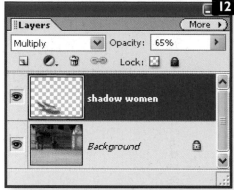

8 Do the same with the top-left corner handle.

9 Drag the bottom-right handle until the shadow lines up correctly with the woman's feet.

10 Repeat the process with the bottom-left corner handle.

11 Now that the four handles have been positioned, carry out any final adjustments to each handle to perfect the shape of the cast shadow, then press the Enter/Return key to confirm the distortion.

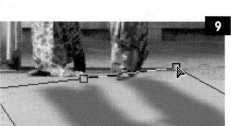

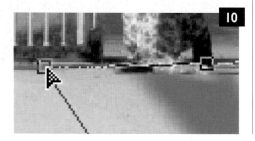

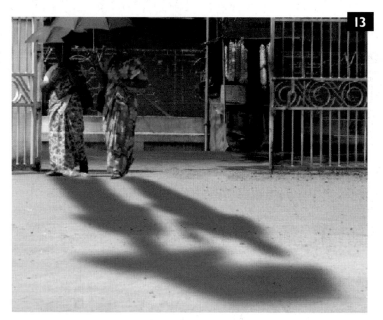

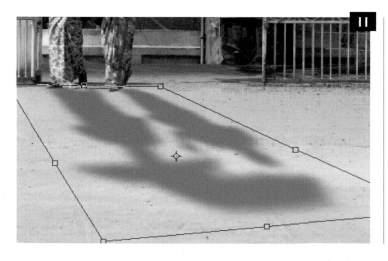

12 Change the Shadow women layer's blend mode to Multiply to blend the shadow into the earth.

13 In Multiply mode the texture of the earth is allowed to show through, while at the same time the earth is darkened by the shadow.

14 The density of the shadow can be controlled by the layer's Opacity. Reduce this to about 80 percent. Repeat the same procedure to create a cast shadow from the gate to finish the image.

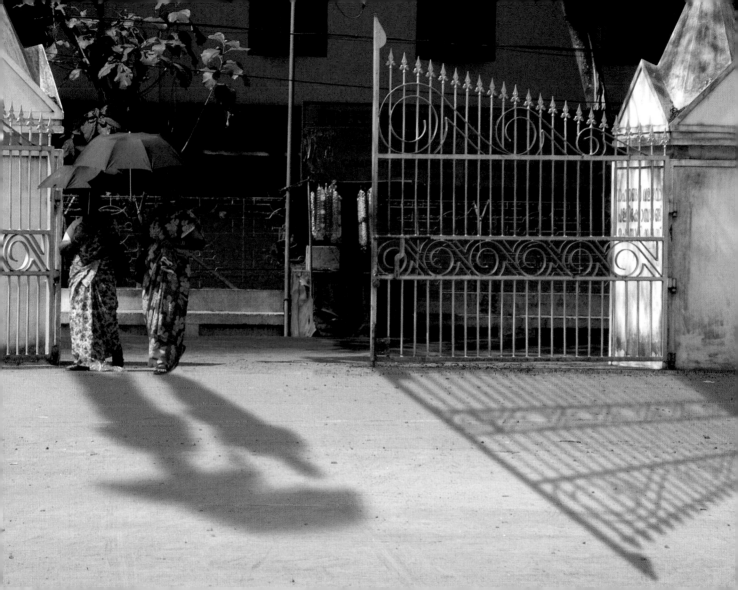

DROP SHADOW

The ubiquitous drop shadow seems to assault our sense of esthetics with increasing regularity. From Web pages to business cards and letterheads, logos on shops, and on the sides of airplanes, the insatiable appetite for drop shadows shows no signs of abating. The drop shadow has earned itself a bad press in recent years, largely through indiscriminate use, but it is actually a very important device in the toolkit of designers, photographers, and artists. Photoshop Elements makes the creation of a drop shadow incredibly easy. The ornamental cross in the following example is embellished with gemstones meaning that for a photorealistic effect, you need to illustrate the cast light filtering through the gemstones and integrate it into the drop shadow.

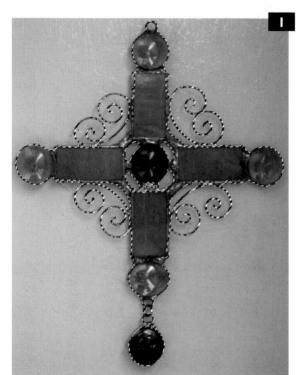

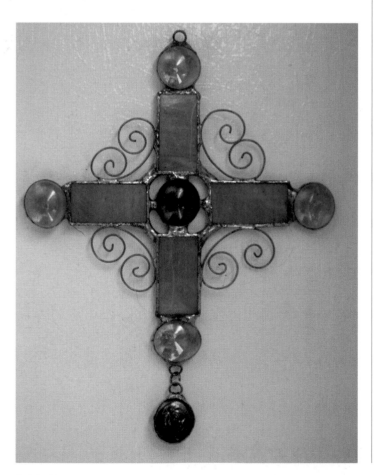

Original image

1 Make a selection of the white background using the Magic Wand tool, then go to *Select* > **Inverse** to reverse the selection.

2 Go to *Layer* > *New* > **Layer via copy** to copy and paste the selection to a new layer. Name the layer "Shadow effect."

3 If the Styles and Effects palette is not visible, go to *Window > Styles and Effects* to reveal it. From the drop-down boxes in the palette, choose Layer Styles and Drop Shadows.

4 Click the High thumbnail to apply it to the layer.

5 We are going to create the impression that the cross is farther from the background. Double click the "f" icon in the layer to reveal the drop-shadow Style Settings box.

6 Increase the Shadow Distance to 90 pixels.

7 Reduce the layer's Opacity to 60 percent.

8 To imply filtered light falling through the gemstones, create a circular selection with a Feather of 12 pixels positioned near the lower, aqua-colored gemstone.

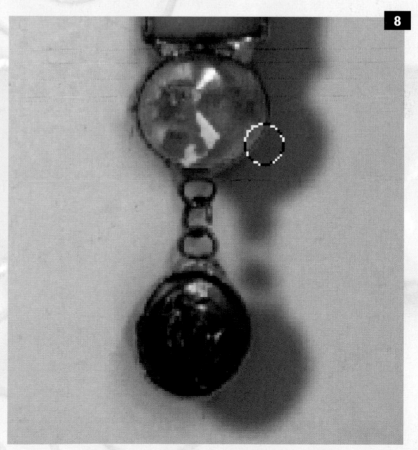

DROP SHADOW

9 Use the Eyedropper tool to sample a dark color from the gemstone.

10 Create a new layer called "Light shadow."

11 Fill the selection with the sampled color, then change the layer's blend mode to Linear Dodge.

12 Deselect the selection. The light is overlapping the object that is apparently casting its shadow so this needs to be fixed. Holding the Ctrl/Cmd key, click the thumbnail of the Shadow Effect layer in the Layers palette. This loads the selection of the cross.

13 Activate the Light shadow layer, then press Delete on the keyboard to delete the part of the light shadow that overlaps. Repeat the process for the three other aqua-colored gemstones.

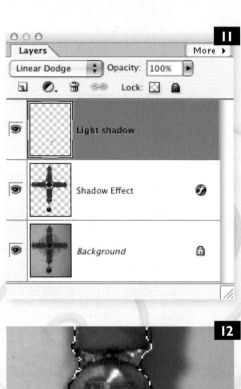

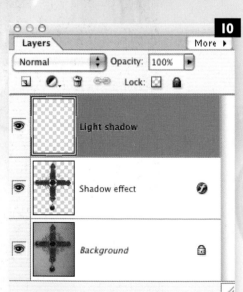

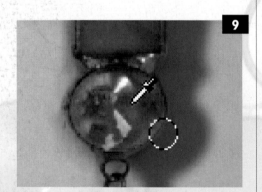

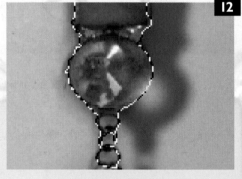

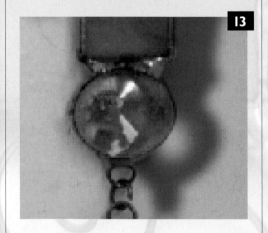

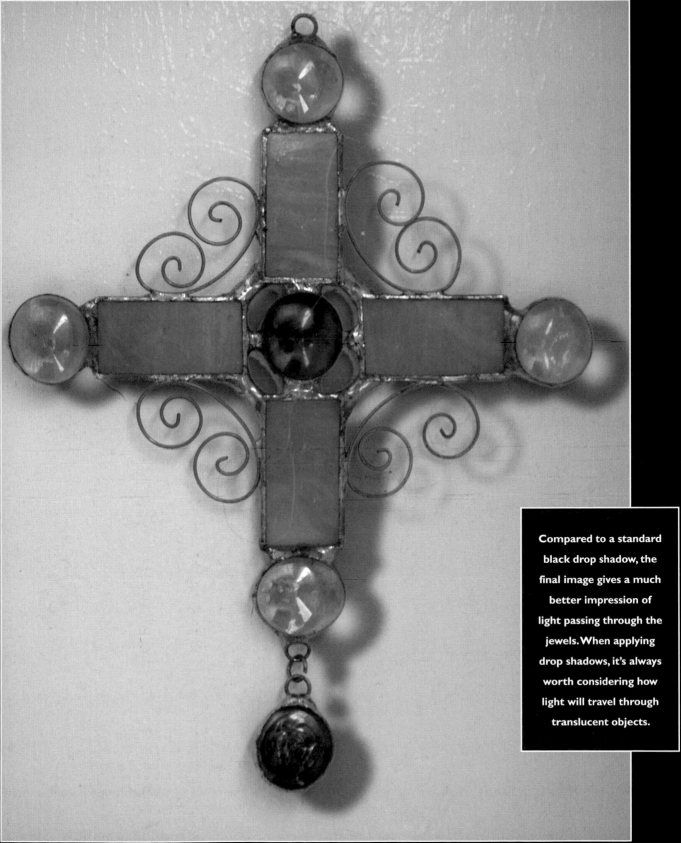

Compared to a standard black drop shadow, the final image gives a much better impression of light passing through the jewels. When applying drop shadows, it's always worth considering how light will travel through translucent objects.

CAST AND PROJECTED LIGHT

Projected light can create some amazing scenes. Direct sunlight shining through an ornate window or cut-out signage will create bold shapes on the surface that it falls upon. In the absence of sunlight, movie and slide projectors can be used to cast a bold pictorial light over a scene and this effect is great for adding a touch of interest to an image. Of course carrying a projector around with you in order to flood a scene with light is far from practical—but it's easy to add something later in Elements. This scene of an alley is the perfect stage for projecting a digital light source into.

1 Create a new layer named "cast light."

2 Select the Polygon Marquee tool and set the Feather to 9 pixels.

3 Create a selection that will define the light being cast into the alley and up the wall.

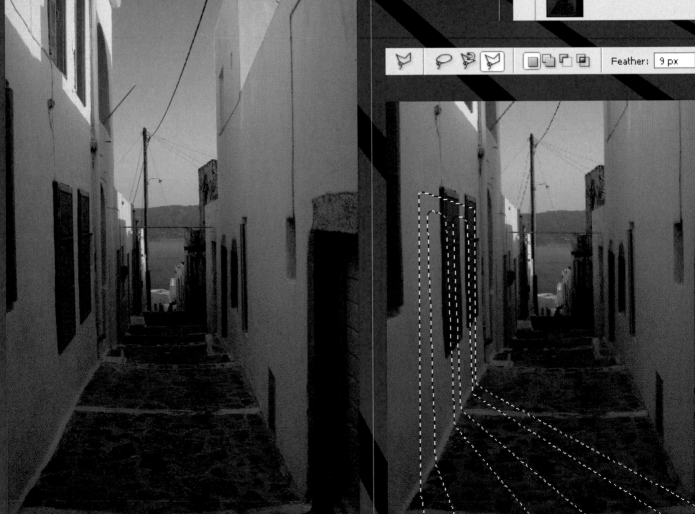

Original image

4 Use the Eyedropper tool to sample a pale color from the foreground.

5 Fill the selection using the sampled color, then press Ctrl/Cmd+D to deselect the selection.

6 Change the layer's blend mode to Color Dodge.

7 To increase the level of light you need to duplicate the layer. Click the More button in the top-right corner of the Layers palette and choose Duplicate Layer.

8 The amount of light can now be controlled using the layer's Opacity. Reduce the duplicate layer's Opacity to 65 percent.

9 Next, we'll cast some light from an imaginar sign. Choose the Horizontal Type Mask tool

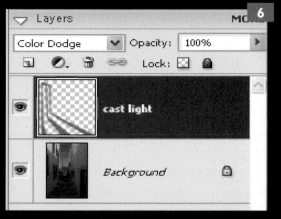

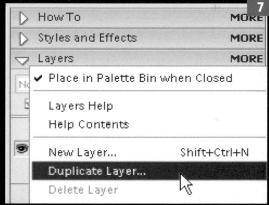

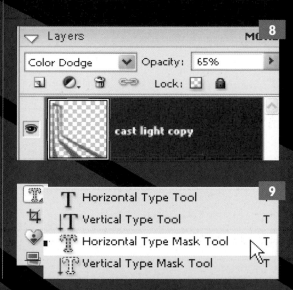

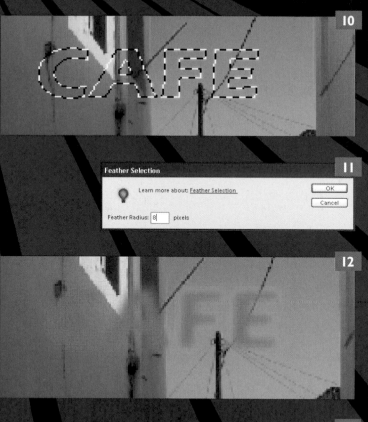

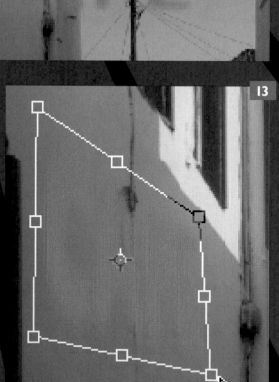

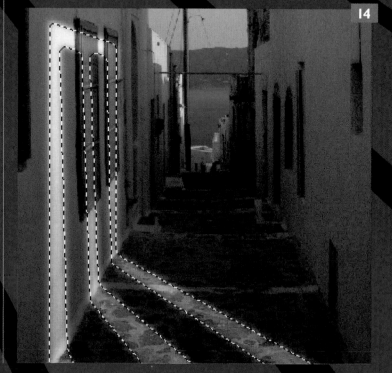

10 Using any simple bold font, type "Cafe" in upper case letters using a point size of 170.

11 Go to *Select > Feather*. Enter 8 as the value.

12 On a new layer, fill the type selection with the same color as was used in step 5. Deselect the selection.

13 The text can now be shaped to appear as if it is being cast onto the wall. *Go to Image > Transform > Distort.* Use the bounding box corner handles to shape the text as shown. Position it on the wall then press the Enter/Return key to confirm the distortion. Change the text layer's blend mode to Color Dodge. To emphasize the cast light and add more atmosphere to the image, the rest of the scene needs darkening. Duplicate the Background layer using the More button from the Layers palette. Change the Background Copy layer's blend mode to Overlay and reduce the Opacity to 62 percent.

14 This has darkened the cast light, so you need to bring the light back to increase the contrast. Press and hold the Ctrl/Cmd key and click the thumbnail of the cast light layer in the Layers palette. This will load the selection of the cast light layer.
 Make sure the Background Copy layer is active then press the Delete key on the keyboard. This will delete the part of this layer that obscures the cast light.

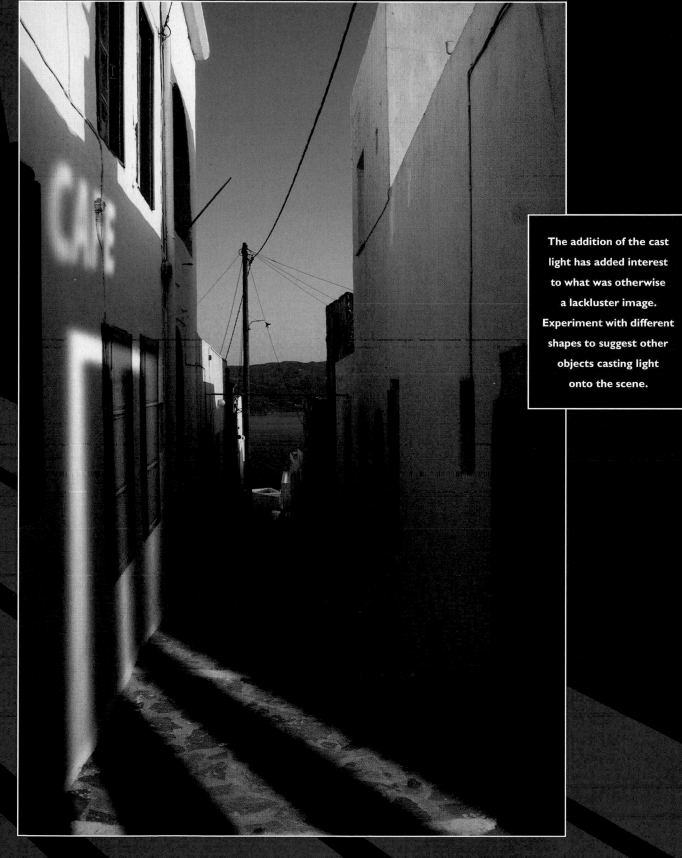

The addition of the cast light has added interest to what was otherwise a lackluster image. Experiment with different shapes to suggest other objects casting light onto the scene.

CASTING LIGHT AND SHADOW THROUGH BLINDS

Light and shadow are the basic ingredients for adding atmosphere to your images. Although the process of simulating these elements is not too demanding in itself, objects that are not obligingly flat do present their own set of problems. In the real world, light and shadow wrap around the object that they fall upon, conforming to the object's contours like a well-fitted garment. Although the challenge of replicating this phenomenon may seem daunting at first glance, Photoshop Elements contains a potent tool called a displacement map that enables you to achieve this effect with remarkable accuracy.

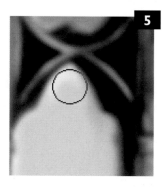

Original image

1 In order to use a displacement map you need an additional grayscale version of the color image. Go to *File > **Duplicate**. Name the file "Displace."

2 To convert to a grayscale image go to *Image > Mode > **Grayscale**. In the dialog box that opens click OK to discard the color information.

3 Press Ctrl/Cmd+L to bring up the Levels dialog box. The contrast first needs to be improved in order to wrap the light and shadow more convincingly. Apply the settings as displayed in this example image.

4 By adding some blur we will achieve a softer effect, avoiding any harsh and unsightly edges in the finished work. Go to *Filter > Blur > **Gaussian Blur**. Apply a Radius of 7.5 pixels.

5 When the shadows are cast across the glass parts of the mirror it is important that they lie flat, as a true shadow would not distort around the reflection. To be sure the shadow remains flat, paint the glass areas a uniform gray, taking a sample from an existing dark area within the glass.

6 Save the file in Elements' PSD format somewhere on your computer, and then close it.

7 Back in the original color file, create a new layer named "Blinds."

8 Create a rectangular selection with a Feather of 4 pixels at the top of the image. This will be the shadow of the first strip of the blind.

9 Go to *Edit* > **Fill selection**. Select 50% Gray from the Use drop-down box, click OK, then use Ctrl/Cmd+D to Deselect the selection.

10 All the other strips of the blind can now be duplicated. Keep the Alt/Opt+Shift keys pressed, then drag the original blind downward to where the second blind should appear. This action also duplicates the artwork onto a new layer.

11 Repeat this process until all the blinds have been created.

12 All the Blinds layers can now be merged into one. Click the Eye icon in the Layers palette to hide the Background layer, then activate the original Blinds layers. Click the More button in the top-right corner of the Layers palette, then choose Merge Visible from the flyout.

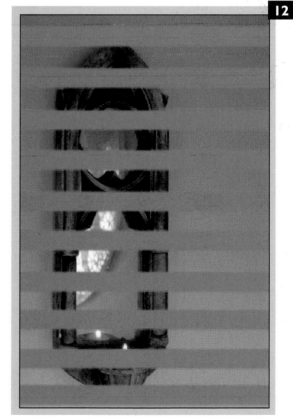

CASTING LIGHT AND SHADOW THROUGH BLINDS

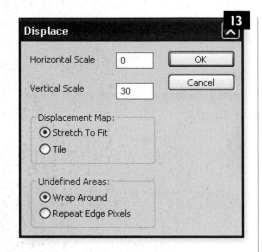

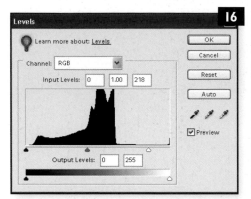

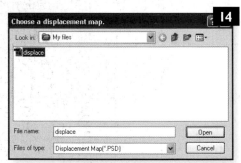

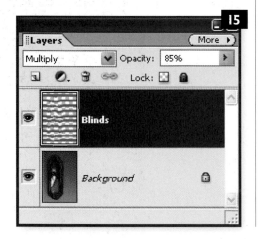

13 Reveal the Background layer again, click the Blinds layer so it is active, then go to *Filter > Distort > **Displace***. Enter the values and settings as pictured, then click OK.

14 Navigate to the displace.psd file that you saved earlier and click Open.

15 Change the Blinds layer's blend mode to Multiply and reduce the Opacity to 85 percent.

16 For this amount of shadow to appear, a large amount of sunlight would also be present. To emulate this, lighten and warm up the image using Levels. Go to *Enhance > Adjust lighting > **Levels***. Adjust the default RGB channel's white Highlights slider to 218.

17 Using the Channel drop-down box select the Red channel. Adjust the white Highlights slider to 222.

18 Now choose the Blue channel and set the black Shadows slider to 45.

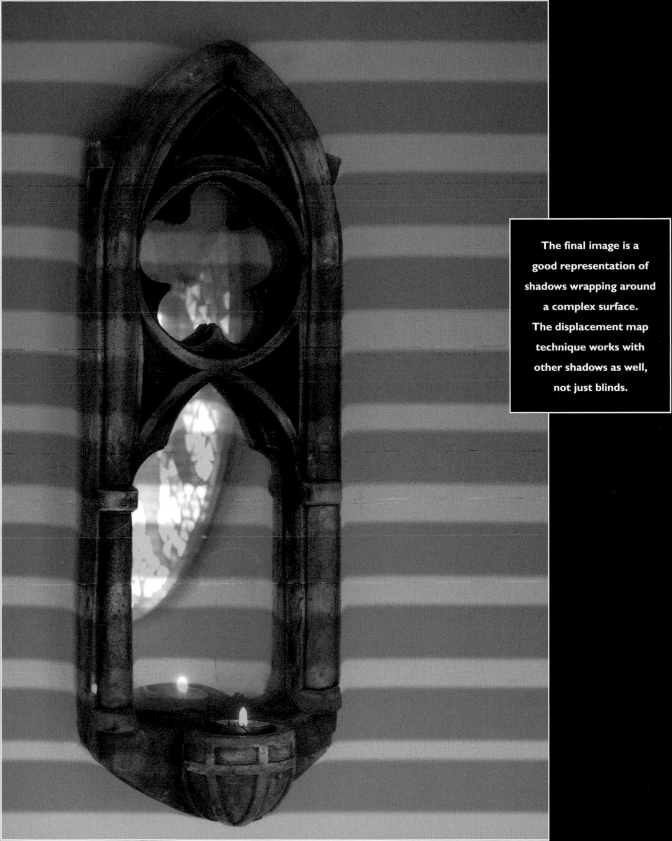

The final image is a good representation of shadows wrapping around a complex surface. The displacement map technique works with other shadows as well, not just blinds.

LIGHT THROUGH STAINED GLASS

What could be more beautiful than the effect of sunlight falling on the multi-faceted, intricate color of a stained-glass window? The light it casts has an ethereal quality all of its own, and the gently glowing rays cascade in jewellike tones, softly tinting dim, quiet interiors. Reproducing such an effect is not difficult with the right knowledge, and it's extremely gratifying to sit back and admire the beauty of the finished result.

1 Make a selection of the colored-glass part of the window.

2 Go to *Layer > New > **Layer via copy*** to copy, and paste the selection to a new layer. Name the layer "Reflection."

3 The copied layer needs to be flipped and distorted so it sits in place. Go to *Image > Rotate > **Flip Vertical***. Position the layer on the stairs.

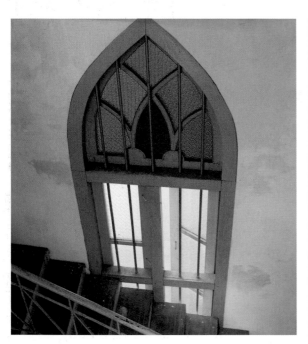

Original image

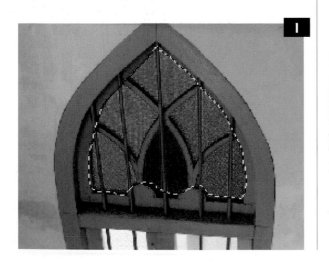

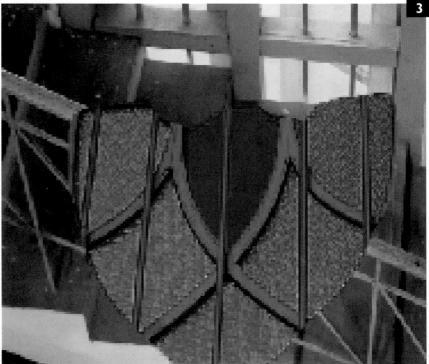

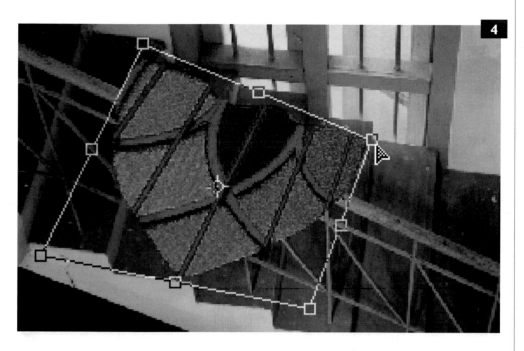

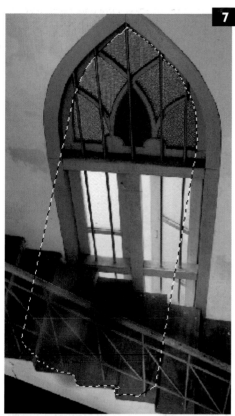

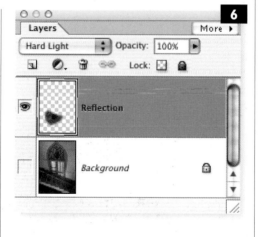

4 To simulate the effect of the window light lying on the stairs go to *Image > Transform > **Distort***. Drag the corners of the bounding box to position the window on the stairs. Press the Enter/Return key to confirm the distortion when finished.

5 A true reflection would be fairly indistinct so you need to break up the window's shape a little more. Go to *Filter > Blur > **Gaussian blur***. Apply a setting of 20.

6 Change the layer's blend mode to Hard Light to give it the illusion of cast light.

7 Make a selection of the area depicting the ray of light from the window.

8 Go to *Select > **Feather*** to bring up the Feather dialog box. Enter a value of 12.

9 Create a new layer named "Light ray."

10 Set up the Gradient tool with a white-to-transparent linear gradient.

LIGHT THROUGH STAINED GLASS

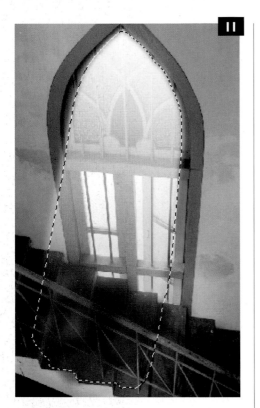

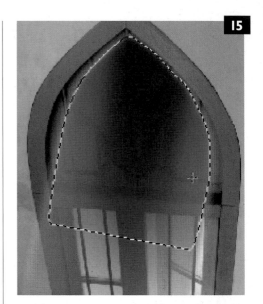

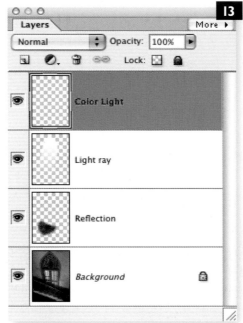

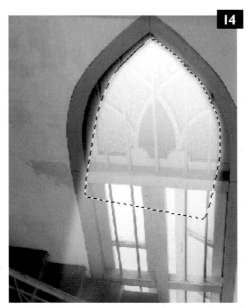

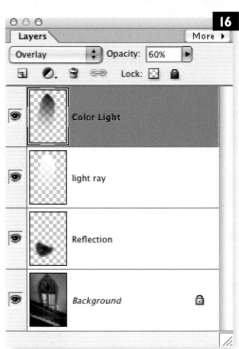

11 Drag the gradient from the top to about two-thirds of the way down the selection.

12 Create a new three-color gradient that replicates the colors of the stained glass.

13 Create a new layer at the top of the Layer palette naming it "Color Light."

14 We are going to use the selection from the light ray layer. Keep the Ctrl/Cmd key pressed and click the thumbnail of the light ray layer. The selection will appear on the image.

15 Make sure the Color Light layer is active then drag the yellow, red, yellow gradient from the left to the right of the selection. Deselect the selection.

16 Change the layer's blend mode to Overlay and reduce the layer Opacity to 60 percent, because we only want a hint of the colors to show through.

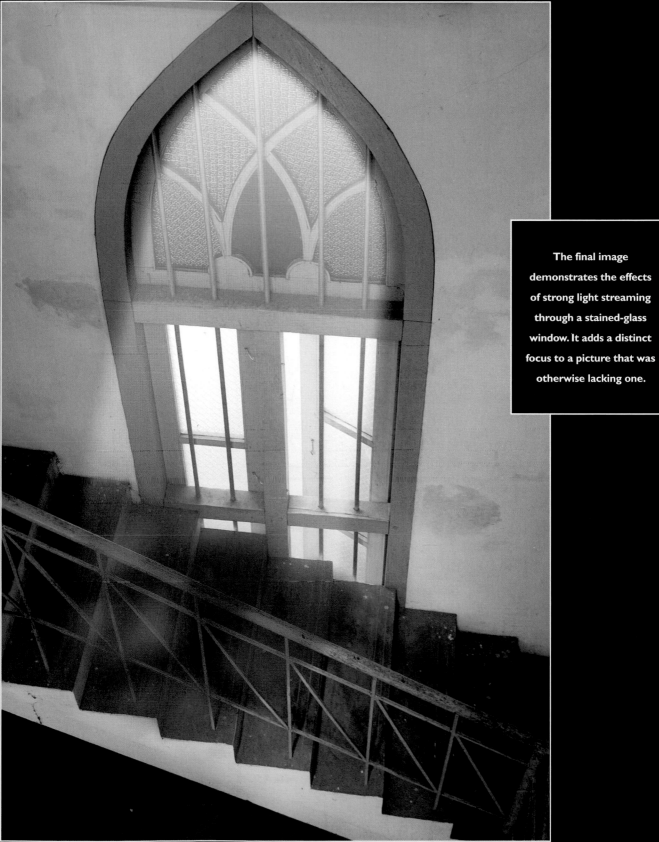

The final image demonstrates the effects of strong light streaming through a stained-glass window. It adds a distinct focus to a picture that was otherwise lacking one.

Reflections

REFLECTIONS ON WATER

Reflections on water are subject to a wide range of variables that dictate how the reflection is perceived. Smooth, mirror-like surfaces can turn into broken, abstract patchworks within seconds depending on the wind, current, ambient light, depth of water, and the color and texture of the sky. It's worth trying to take all of these factors into account when you create our own body of water and customized reflection.

1 The starting image has a naturally broad foreground area that will act as a perfect stage for the fake reflection we are about to create.

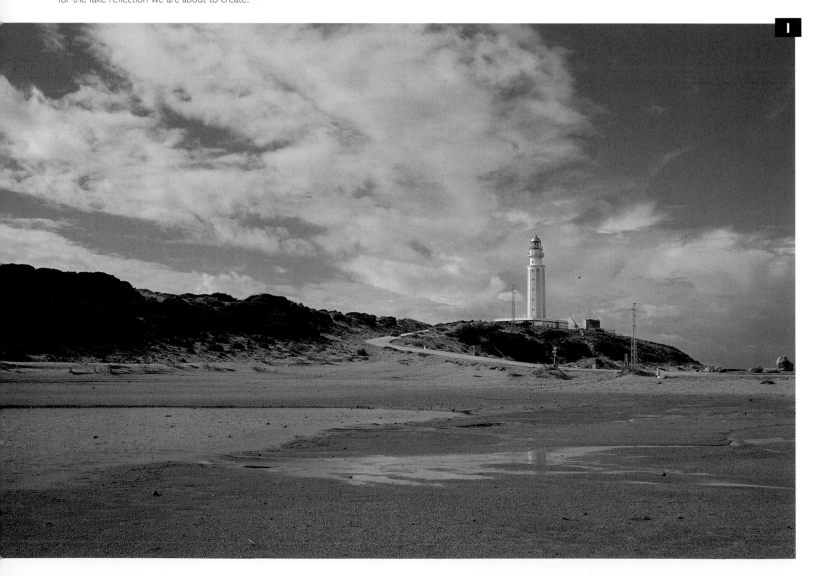

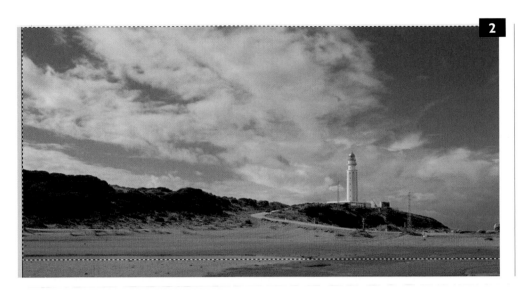

2

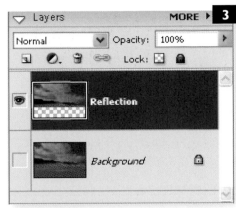

3

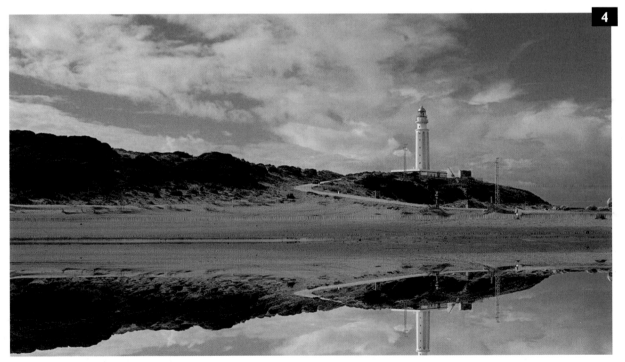

4

5

2 Using the Rectangular Marquee tool, make a selection of the top two-thirds of the image. This area will be used as the basis for the reflection.

3 The selection can now be copied and pasted onto a brand new layer. Go to *Layer > New > Layer via copy*. The Layers palette now shows the original Background layer and the newly copied layer. Rename the new layer "Reflection."

4 The reflected layer can now be turned upside down. Go to *Image > Rotate > Flip Layer Vertical*. The flipped layer should be repositioned at the bottom of the image window.

5 Most water reflections lose a certain degree of color from the original scene. To simulate this effect go to *Enhance > Adjust Color > Adjust Hue/ Saturation*. Drag the Saturation slider to a value of -51 to weaken the color overall.

REFLECTIONS ON WATER

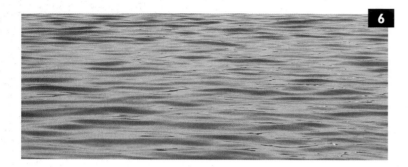

6 The most important step in making this effect convincing is the addition of a photorealistic water texture. Any simple image of a water surface will do. The one featured here is much smaller than the lighthouse image but this doesn't matter because the water surface will be tiled to cover the entire expanse of the reflection.

7 The water surface texture should appear to diminish where it recedes from the angle of view, so you need to select just the foreground area to limit the extent of the texture. Using the Rectangular Marquee tool, make a selection as shown below.

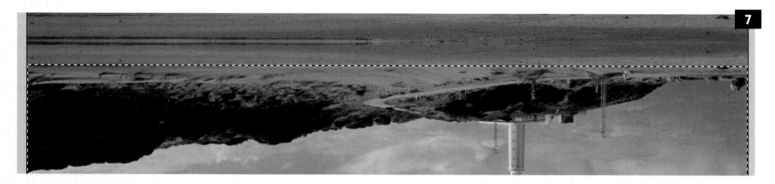

8 Make sure the Reflection layer is active and then go to *Filter > Distort > Glass*. Click the round button next to the Texture drop-down box and then click on the Load Texture pop-up that appears. This will enable you to use your own image as a texture.

9 Choose your water image file and then click the Open button.

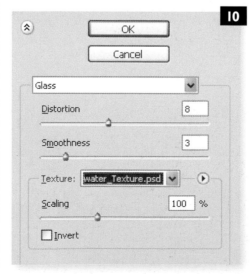

10 The file name can now be seen in the Texture drop-down box. Choose the settings as shown and click OK. Finally, remove the selection by going to *Select > Deselect.*

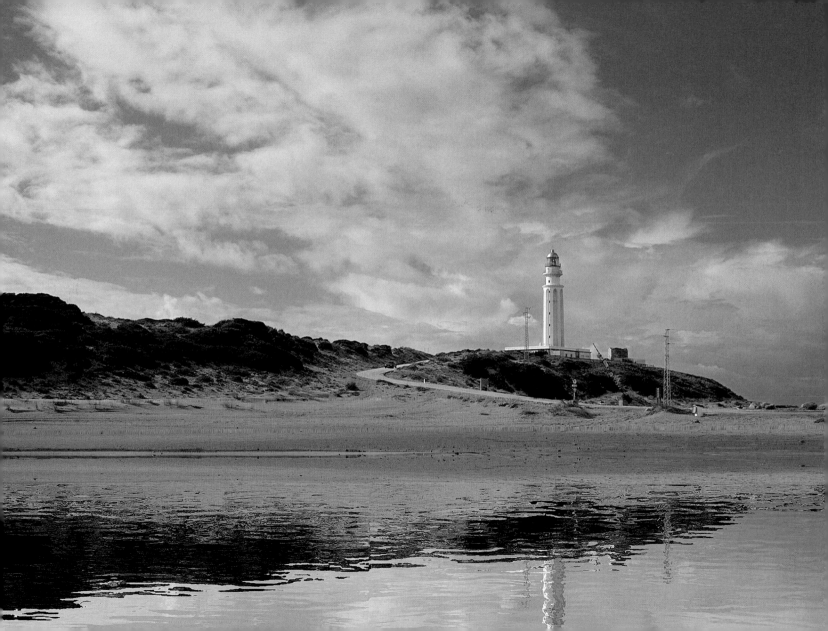

REFLECTIONS ON METAL

Unlike the predictable, flat-image reflection of a mirror, metal reflections bring all sorts of confusing elements into the equation. The full spectrum of reflective types is covered by the broad range of metal surfaces, from the mirror-like response of highly finished chrome to the barely perceptible ghost of an image that is witnessed on stainless steel. Using the example of a saxophone, we will attempt to bring the brass to life by applying some simple but effective techniques for increasing the intensity of the instrument's reflective properties. We'll also add some specular highlights.

1 Make a selection with a wavy edge along the front of the saxophone using the Lasso tool.

2 Create a new layer called "front selection."

3 Use the Eyedropper tool to select a dark and a light color from the saxophone to use as the foreground and background colors.

4 Choose the Gradient tool and set it to Foreground to Background, and Linear in the Tool Options Bar.

5 Drag a gradient through the selection running from right to left.

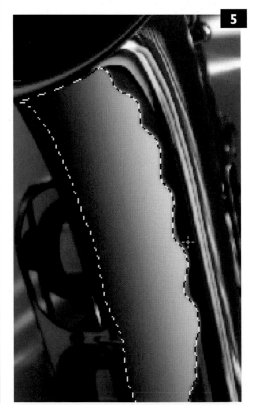

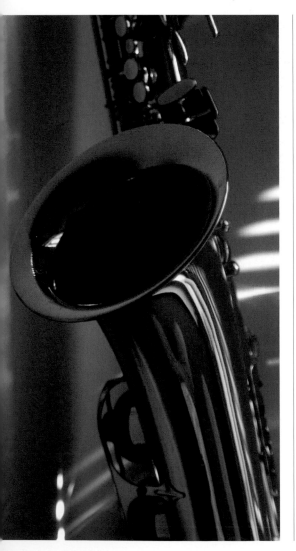

Original image

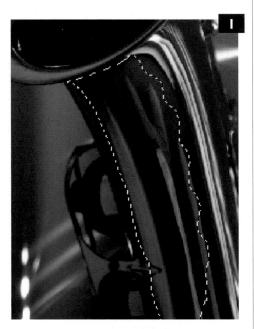

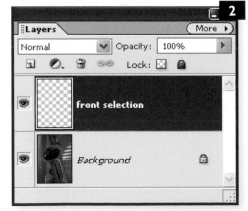

6 Deselect the selection and change the layer's blend mode to Linear Dodge.

7 Create another selection over the bell of the saxophone. If you don't feel comfortable drawing a curve with the Lasso tool try using the Magic Wand tool with a low Tolerance setting. Use a Feather setting of 3 pixels in either case.

8 Create a layer called "Lower bell selection."

9 Using the same two-color gradient, drag the Gradient tool through the selection from left to right.

10 Deselect the selection and change the layer's blend mode to Linear Light.

11 Using the Lasso tool, make two further selections at the top of the saxophone bell.

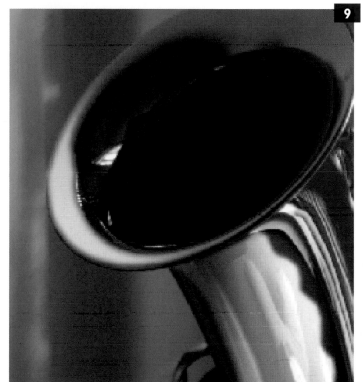

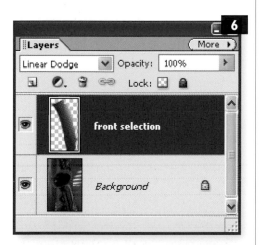

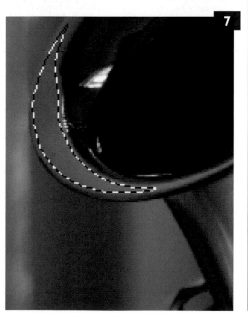

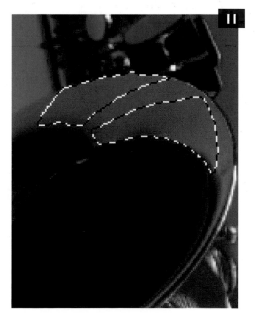

REFLECTIONS ON METAL

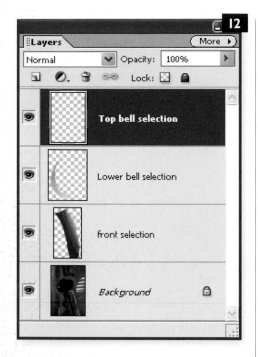

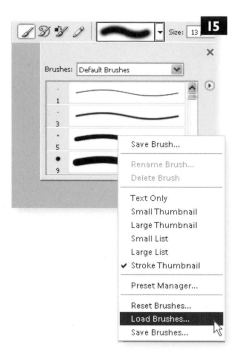

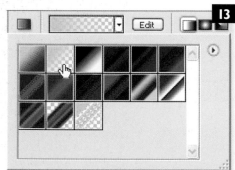

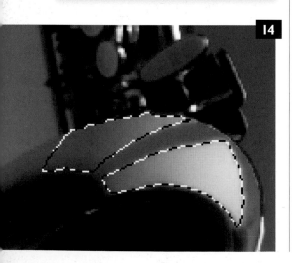

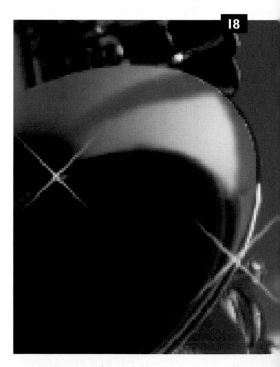

12 Create a new layer named "Top bell selection."

13 Make sure that the lighter color is the foreground color in the Toolbox, and then choose the Gradient tool, setting its options to Foreground to Transparent, and Linear.

14 Drag the Gradient tool through the selection from right to left, then deselect the selection.

15 Choose the Brush tool and click on the Brushes drop-down box in the Tool Options Bar. Click the Brushes pop-up menu button and choose Load Brushes from the flyout menu.

16 Choose Assorted Brushes.

17 This loads the Assorted Brushes palette ready for use. Click the Brushes drop-down box again and choose Crosshatch 48.

18 On a new layer, click with the Crosshatch Brush a couple of times where a natural highlight might occur. Change the brush size of each for a more natural feel.

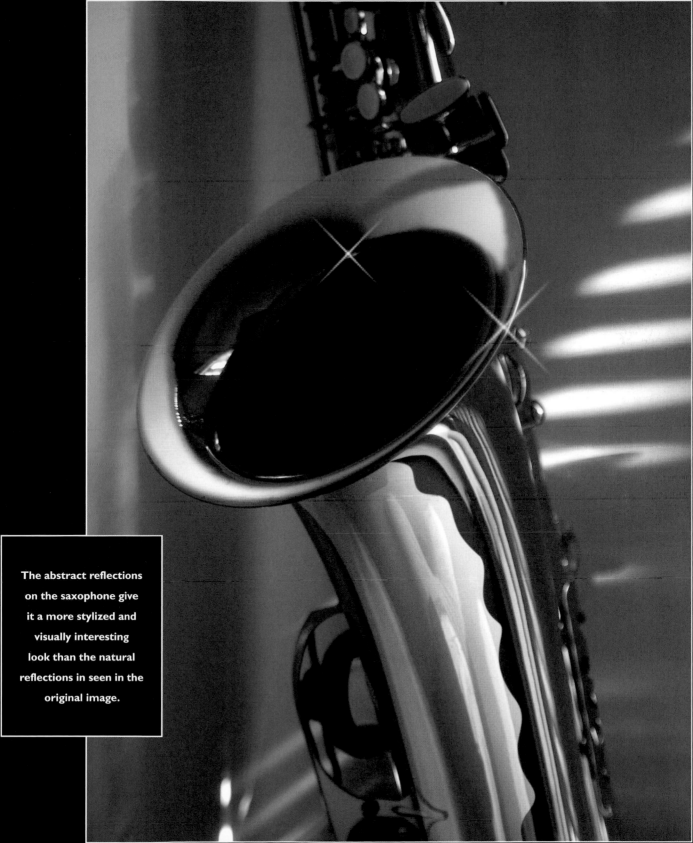

The abstract reflections on the saxophone give it a more stylized and visually interesting look than the natural reflections in seen in the original image.

REMOVING UNWANTED REFLECTIONS

Life is full of challenging decisions. Some are major, like choosing to run a marathon or doing voluntary work in developing countries. Others are less demanding, such as seeing an interesting photo opportunity that is ruined by unwanted reflections, but deciding to take the picture anyway with the intention of sorting out the problem later. Here, we'll look at providing a solution for the latter—removing the distracting traffic signs from this cafe's metallic surfaces, leaving the gleaming steel intact.

Original image

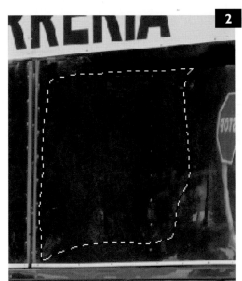

1 Make a selection of the stop sign with the Lasso tool. Don't make it too regular. The natural bends and warps of the metal will blend better with a wavy selection.

2 With the Lasso tool still active, drag the selection to a clear part of the metal, from where a sample copy can be made.

3 Go to *Layer* > *New* > ***Layer via copy*** to copy
and paste the selection to a new layer. Name
the new layer "metal copy."

4 Drag the copied layer and position it over the
stop sign reflection.

5 To remove the hard edges around the copied
layer, select the Eraser tool and set the Tool
Options Bar settings to Size 75, the Mode to Brush,
and the Opacity to 20 percent.

6 Drag the Eraser tool over the edges of the
copied layer several times to smooth and
blend it in with the background.

REMOVING UNWANTED REFLECTIONS

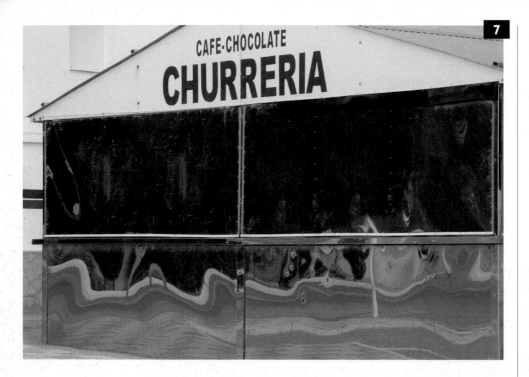

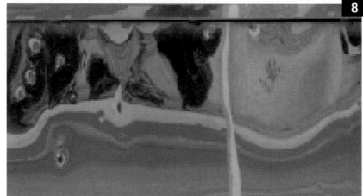

Brush: 30 Mode: Normal Source: ⦿ Sampled ○

7 Repeat the process to remove the direction arrow signs on the left of the image.

8 For smaller areas, such as the lower half of the signpost, an alternative method is to use the Healing Brush tool.

9 Select the Healing Brush and apply the settings shown above in the Tool Options Bar.

10 Make sure the Background layer is active. Position the cursor to the left of the signpost pole, then hold the Alt/Opt key and click with the mouse to create a registration point.

11 Place the cursor over the area to be removed and click and drag along the length of the signpost pole.

12 Continue to reposition the cursor, holding Alt/Opt and clicking to make new registration points over different parts of the pole. Matching similar areas continuously will make for a better result. Remember to change the size of the brush accordingly where necessary.

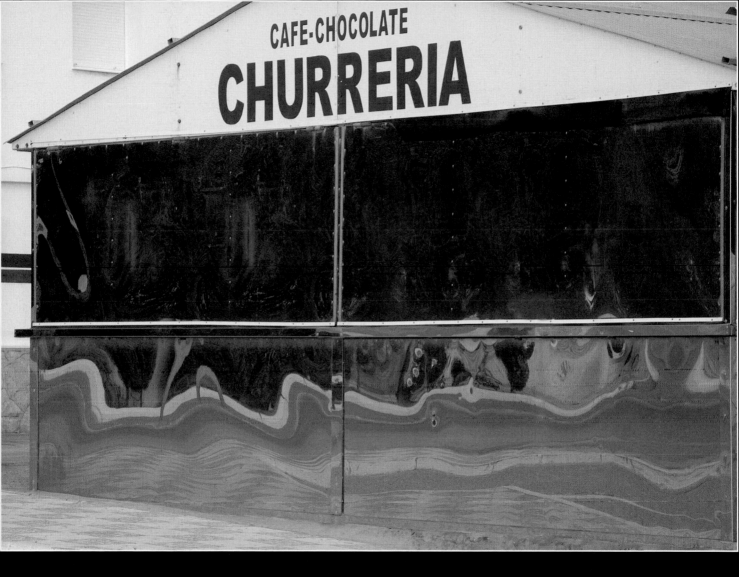

There are now far fewer visual distractions in the image. Perhaps the metal surface is now a blank canvas to which you can add your own interesting reflections.

Quality of light

WARM LIGHT

The term warm light describes colors toward the red end of the visible color spectrum. Reds, oranges, and yellows are all considered "warm" colors and they can greatly affect our perception of an image. A vision of a hot sunny day tinged with yellow or one of a roaring log fire suffusing a room with red and orange gives a comfortable feeling of well-being, and these tones can be used to manipulate an emotional response. Let's put this into practice by turning this cold, uninviting image into a warm, hospitable one.

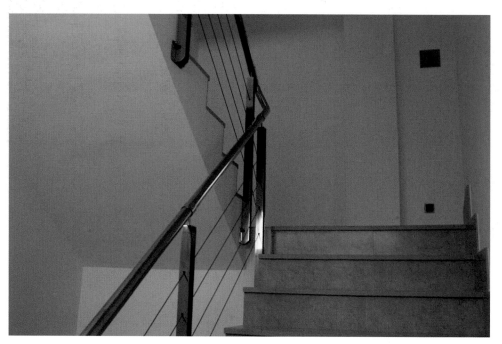

Original image

1 The cold atmosphere of the image is generated by the predominance of blue over the whole scene. Tackling this problem first will enable us to add a warm color in the final stage with far more pleasing results. Go to *Enhance > Adjust Lighting > **Levels***. Drag the white Input slider to a value of 193. This performs a general brightening of the whole image.

2 Click the Channel drop-down box and choose the Blue channel.

3 Drag the black slider to a value of 50. This reduces the blue in the image and compensates by increasing its complementary color, yellow.

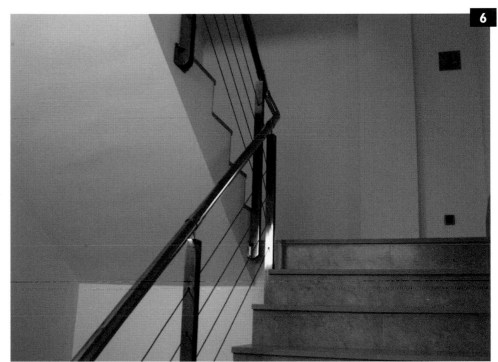

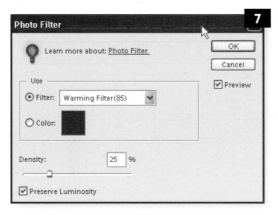

4 Now choose the Red channel from the Channel drop-down box.

5 Drag the white Input slider to a value of 22. This setting increases the amount of red in the image and at the same time reduces the cyan, which is at the cold end of the color spectrum. This red combined with the yellow in the previous step serves to create an overall warm hue.

6 At this stage the photograph has successfully been converted from cold to warm colors, but you may still want to make further creative adjustments. particularly if you are happy to emphasize the warmth at the expense of realism.

7 Photoshop Elements' Photo Filter allows you add color enhancements to your images in the same way as photographers would in more traditional photography. Go to *Filter > Adjustments > **Photo Filter***. The default filter is Warming Filter (85), a traditional filter used to cover the lens to add warmth to a photograph. The density is preset to 25 percent, but this can be increased for more emphasis.

WARM LIGHT

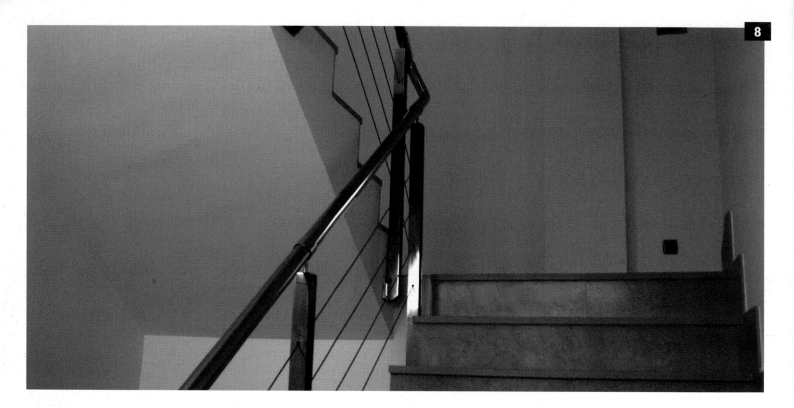

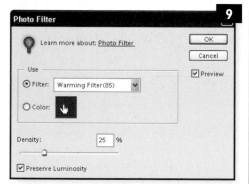

8 The result is subtle compared to the last step, but the warmth is clearly visible.

9 If the warm color you want to achieve is not covered by one of the presets, you can also select your own color for a unique effect. In the Photo Filter dialog box, click the orange color square to open up the Color Picker, from where you can choose your own color.

10 Choose the color you want to use. Here, we've chosen something with more yellow than the Warming Filter (85) preset.

11 Click OK to close the Color Picker and you will be returned to the Photo Filter dialog box. Set the density as required. I've increased the density to 45 percent to achieve a more pronounced effect.

12 The final result is a far cry from the original cold scene, but it is worth experimenting with the Photo Filter colors because the range of warming effects you can achieve is almost infinite.

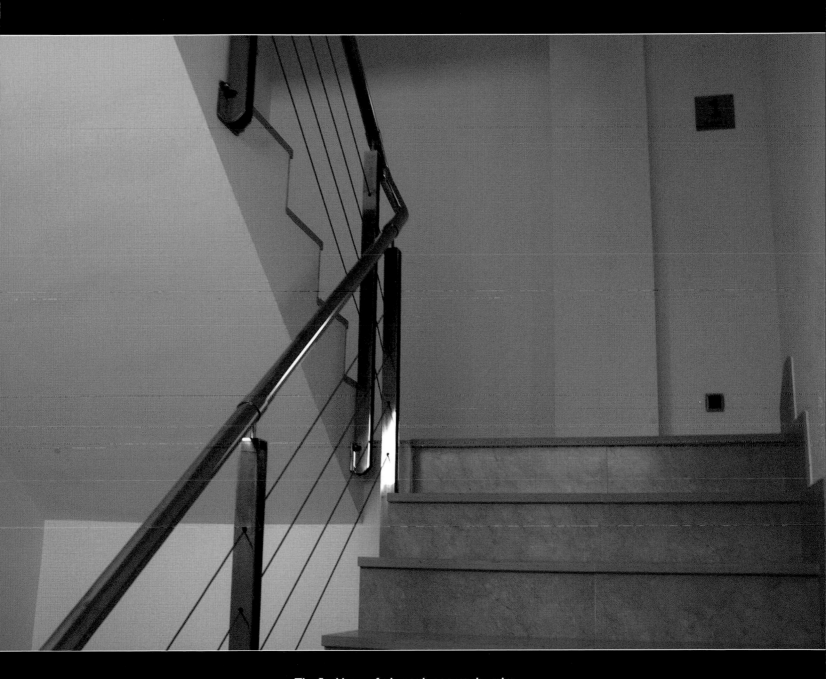

The final image feels much more welcoming
because of the simple color change. This sort
of psychology is often used in advertising to
make a product seem more appealing.

COLD LIGHT

Cold light describes a quality of light where the overriding color gravitates toward the blue end of the visible color spectrum. A scene filtered through such a light can send particular messages to the viewer, so that the perception of the image becomes tinged with a bleak, cheerless quality. This use of tone to engineer conditioned responses is clearly a powerful tool, and is used by many designers to instill a particular feeling in the viewer. Follow the steps in this example to learn how to manipulate your own images to create a particular mood.

Original image

1 For maximum flexibility, use adjustment layers to create this effect. Go to *Layer > New Adjustment Layer > Hue/Saturation*. The New Layer dialog box opens. Click OK to confirm.

2 Now the Hue/Saturation settings box opens. Adjust the Hue setting to -178 and the Saturation to -40.

3 The Layers palette now displays an additional layer that holds the color settings that were applied in the previous step.

4 These applied settings can be accessed at any time and edited by double clicking the left thumbnail in the Hue/Saturation adjustment layer.

5 Add a Levels adjustment layer to the image to make farther adjustments to the quality and color of the light. Click the Adjustment Layer icon at the top of the Layers palette and choose Levels from the flyout that appears.

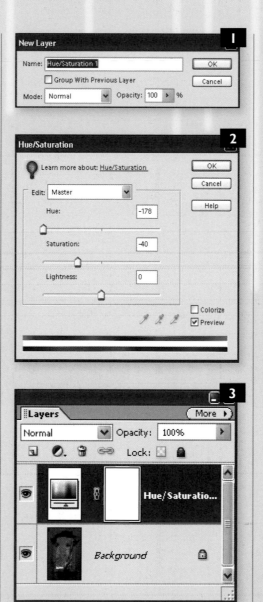

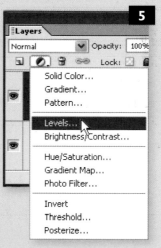

6

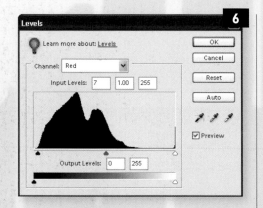

7

8

9

10

6 Select the Red channel from the Channel drop-down box. Increase the black Input slider to 7. This reduces some of the warm red in the image and emphasizes cyan.

7 Select the Blue channel from the Channel drop-down box. Decrease the white Input slider to 230.

8 Two adjustment layers are now shown in the Layers palette. The Levels adjustment layer can be accessed in the same way as the Hue/Saturation layer. Both layers are affecting the Background layer.

9 At this stage, the image appears a little too dark, but this is easy to fix using the Levels adjustment layer. To access this, double click the left thumbnail of the Levels layer in the Layers palette.

10 This time adjust the RGB channel that appears as the default option. Adjust the gray slider to a value of 1.21 and the black slider to 222.

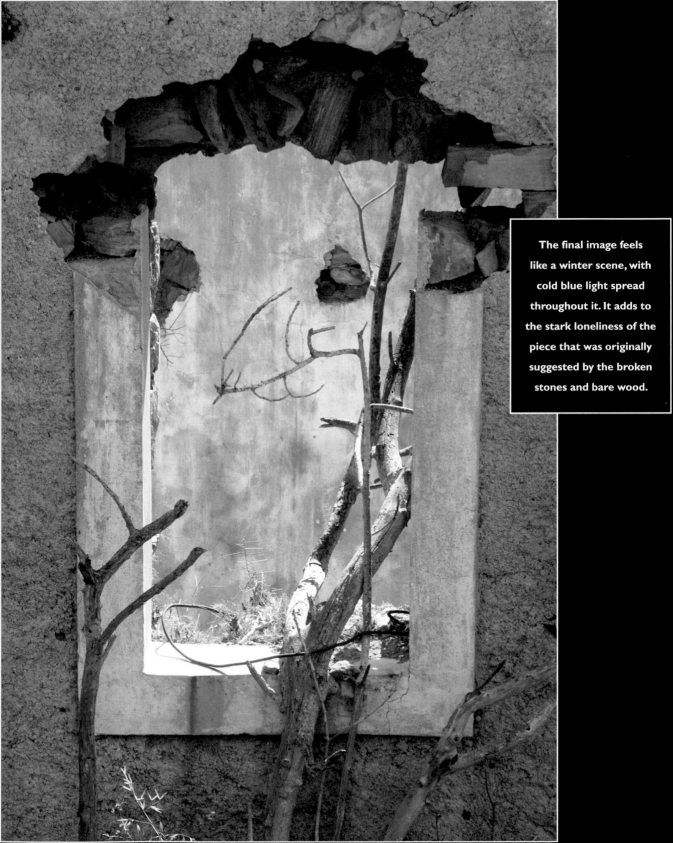

The final image feels like a winter scene, with cold blue light spread throughout it. It adds to the stark loneliness of the piece that was originally suggested by the broken stones and bare wood.

CREATING MOONLIGHT

Recreating the cool, mellow appearance of a moonlit night requires subtlety. The milky quality of moonlight is unique and it's not always easy to capture the ethereal beauty of the original setting on camera. For a highly flattering rendition of moonlight, you can call upon the versatile Lighting Effects filter to simulate the romantic qualities embodied by this most enigmatic type of light.

1 The flat blueness of the sky in this example image is ideal for creating a hazy, undefined moon.

2 Go to *Filter > Render > **Lighting Effects***. The Lighting Effects filter dialog box seems daunting at first with its large number of settings, but its complexity allows you to create many highly realistic effects. Under the Light Type section, choose Omni.

3 The Preview window allows you to position the light anywhere in the scene. Using the white dot in the center of the light's circle, drag the light to an area of the blue sky as shown.

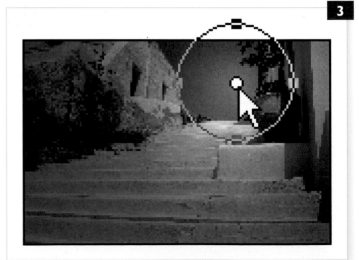

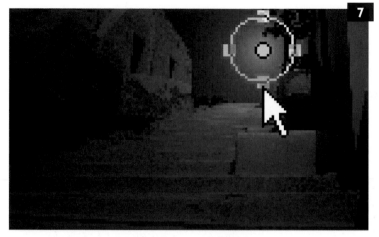

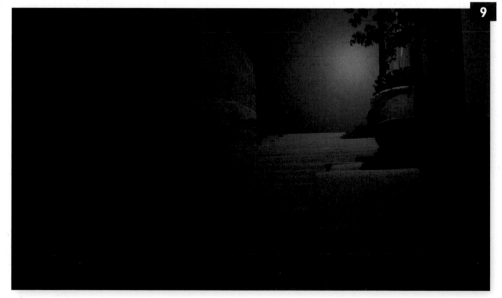

4 The default color of the light is white, but any color can be used. Use a pale blue light here to better capture the quality of moonlight. Click the white square in the Light Type section.

5 Choose a pale blue color from the Color Picker that opens, then click OK to close the Color Picker and return to the Lighting Effects dialog box.

6 Set the Intensity to 53. Higher settings produce a more powerful light.

7 Back in the Preview window you are able to adjust the size of the light as well as its position. Use any of the handles positioned around the edge of the light's circle to do this. Dragging toward the center of the light will reduce its size.

8 Under the Properties section, the Ambience slider controls the general light in the scene. Drag the slider to -4 to darken this.

9 Click OK to close the Lighting Effects dialog box and the first stage of the moonlight is complete.

10 The current position of the moon would cast a shaft of light down the stone steps. In order to create this a second light will be used, but first you need to make a new selection to control where the light appears. Choose the Marquee Selection tool and set the Feather amount to 10.

CREATING MOONLIGHT

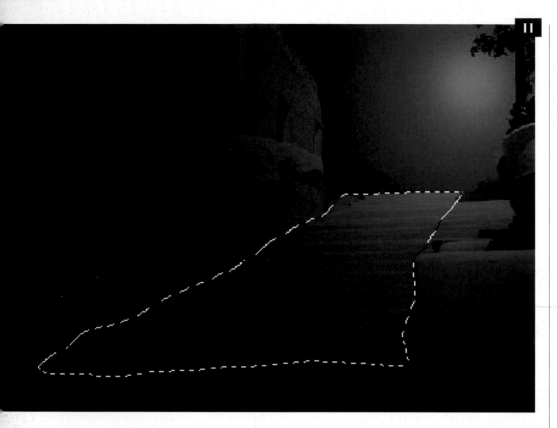

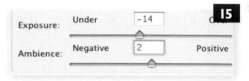

Exposure: Under −14
Ambience: Negative 2 Positive

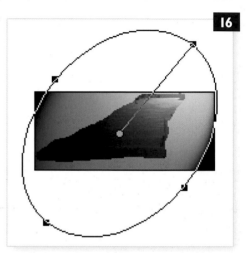

Levels

Learn more about: Levels OK Cancel Reset Auto

Channel: RGB

Input Levels: 0 0.92 255

Preview

Output Levels: 0 255

Layers More ▶

Normal Opacity: 100%

Lock:

light

Background

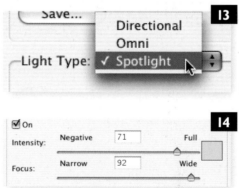

Save... Directional Omni

Light Type: ✓ Spotlight

☑ On

Intensity: Negative 71 Full

Focus: Narrow 92 Wide

11 Draw a selection with the Lasso tool to depict the shaft of light.

12 The selection can now be copied and pasted onto a new layer. *Go to Layer > New > Layer via copy* or use the shortcut Ctrl/Cmd+J. Name the new layer "light."

13 Make sure the light layer is active and go to *Filter > Render > Lighting Effects*. Change the Light Type to Spotlight.

14 Use a similar blue color as was used with the Omni light in step 5, and change the Intensity to 71 and Focus to 92.

15 Set the Exposure to -14 and Ambience to 2.

16 Again, using the handles on the edge of the circle that encompasses the Spotlight, create a size and shape similar to the one displayed, then click OK.

17 Finally you can control the overall level of light by using Levels. Click the Background layer in the Layers palette to activate it, then press Ctrl/Cmd+L to open the Levels dialog box. Adjust the gray slider to 0.92. Of course you can also experiment to achieve any degree of darkness, depending on the kind of effect you are trying to create. Drag the gray slider to the right to darken and to the left to lighten.

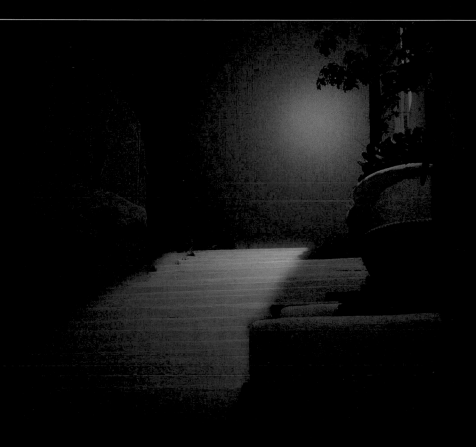

**The final image is a realistic and
atmospheric representation of moonlight,
and is a stark contrast to the original
daylight photograph.**

LOW-KEY IMAGES

An abundance of dark tones is the hallmark of a low-key image. However, using purely dark tones with no middle or light tones makes for a boring image that lacks contrast. Here, we will create a classic low-key image complete with dramatic contrast. This technique can give even simple subjects high photographic merit.

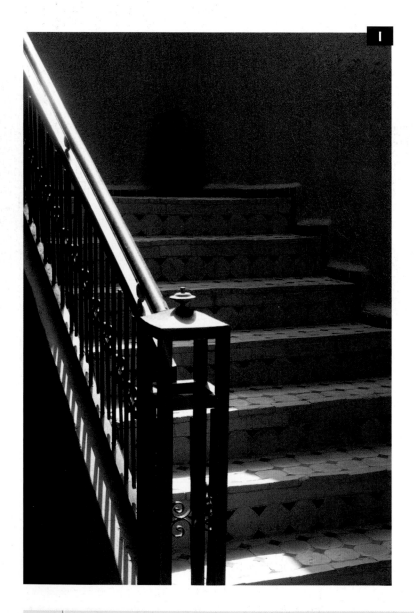

 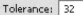 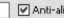

Tolerance: 32 ☑ Anti-alias ☑ Contiguous ☑ Sample All Layers

1 The image of the stairs was exposed for the midtones when it was shot. This has resulted in an appealing highlight on the banister that should be preserved, but additional highlights should also be created to contrast with the darker areas that will be added later.

2 Start by selecting some more suitable areas for highlights. Choose the Magic Wand tool, then apply the settings as shown. Note that the Add to selection mode is activated, allowing you to make multiple selections.

3 A natural place for a highlight to appear would be on the top of each step. Click on the lightest part of the top of the step with the Magic Wand tool as shown. If you select too much, just press Ctrl/Cmd+D to deselect and then click again until you achieve the right selection.

4 Continue to select the top of each step until you have five distinct selections.

5 The selection currently has hard edges that can ruin the final effect, so before doing anything else you need to soften them. Go to *Select > Feather* and enter a value of 2 pixels. This will create a subtle edge without losing too much of the edge detail.

6 The selected areas can now be separated and kept for later use. Go to *Layer > New > Layer via copy*. This option copies the selection and pastes it on to a new layer. The useful shortcut for this operation is Ctrl/Cmd+J.

7 Rename the new layer "highlights" and click its Eye icon in the Layers palette to hide it—you won't need to use it until later.

8 Return to the Background layer ready to darken the majority of the image. To give you the flexibility to adjust that darkness at any time you can use an adjustment layer. Click the Adjustment Layer icon at the top of the Layers palette.

9 Choose Levels from the drop-down box.

10 Adjust the black Input slider to 59 and the gray slider to 0.42. This setting darkens all but the brightest highlights, in keeping with a good low-key image.

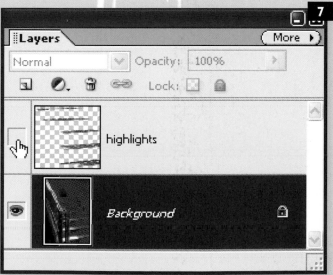

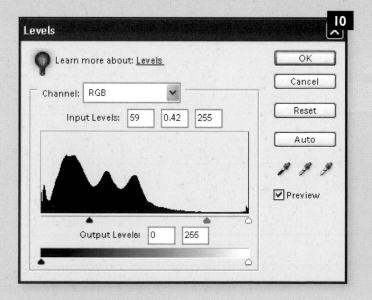

LOW-KEY IMAGES

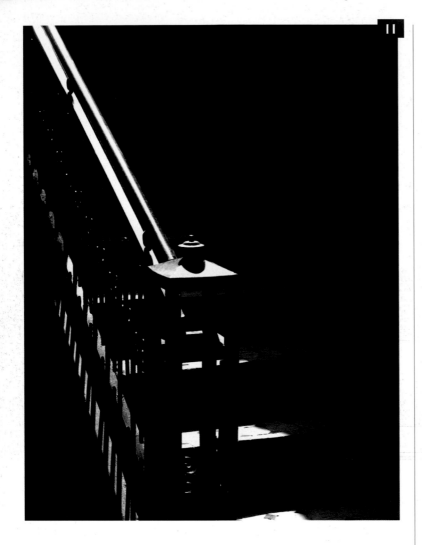

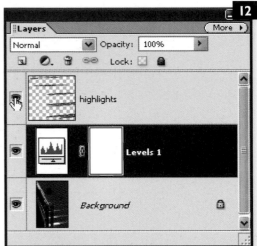

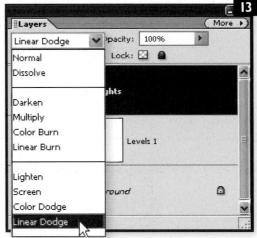

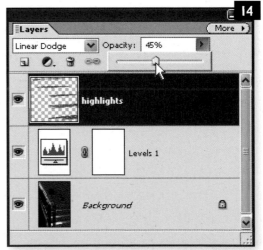

11 The resulting image is a classic low-key photograph. However, the addition of a few more highlights would give some extra tonal contrast.

12 Click the highlights layer's Eye icon in the Layers palette to reveal it again.

13 Change the layer's blend mode to Linear Dodge.

14 Reduce the layer's Opacity to about 45 percent, or more, to give you the required degree of subtlety. The final result is now completely editable by altering the Opacity setting of the highlights layer and by modifying the Levels adjustment layer that was applied to the Background.

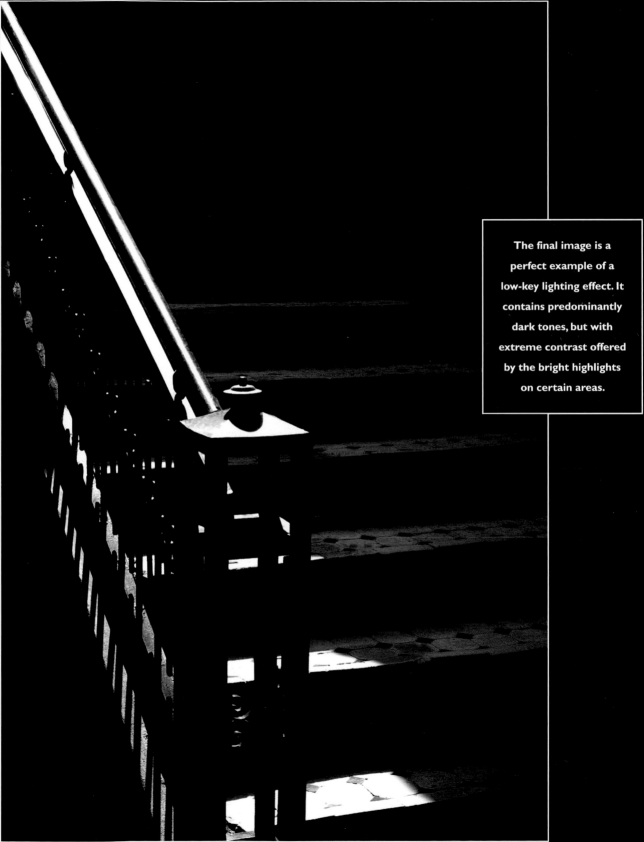

The final image is a perfect example of a low-key lighting effect. It contains predominantly dark tones, but with extreme contrast offered by the bright highlights on certain areas.

HIGH-KEY IMAGES

A high-key image is one in which there are more light tones than dark, but for a high-key image to be successful, further lighting considerations are necessary. Imagine a bright spring sun bathing a snow-covered mountain in light. Although this image could technically qualify as a high-key image, for it to be interesting there needs to be a balance of darker values somewhere in the image. Without some subtle contrast the result can merely look like an accident of over-exposure.

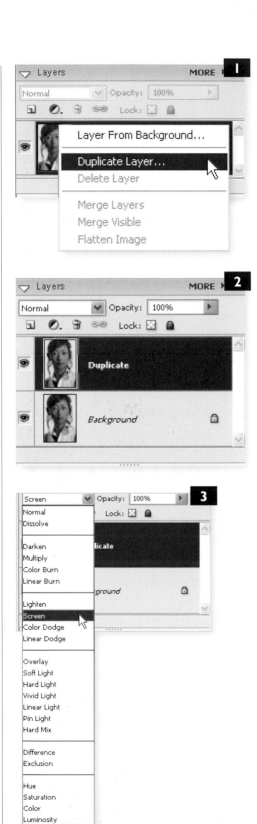

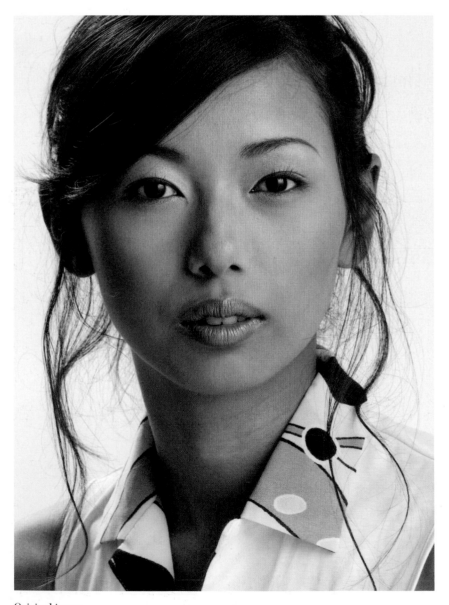

Original image

1 In one simple step you can brighten the full range of tones throughout the image without any complicated settings. Duplicate the Background layer by clicking the More button in the top-right corner of the Layers palette (if you are using a PC, you can also right-click the Background layer). In the subsequent pop-up menu, choose "Duplicate Layer."

2 Name the new layer "Duplicate," and leave it in its default position in the Layers palette.

3 Make sure the duplicate layer is active, then click the layer's blend mode drop-down, and choose Screen.

4 Screen mode results in a brighter overall image .

5 If the aim was to simply correct the brightness, this step would be sufficient in itself, but the high-key image we are creating requires some further adjustment to gain the true feel of abundant light. Go to *Enhance* > *Adjust Lighting* > **Levels**. Levels is a very powerful tool for adjusting brightness, contrast, and color. In this instance, you need to make just two adjustments to increase brightness. First, drag the white Input slider to the left to a value of 211. As an alternative to dragging the white slider, a number can be typed directly into the box.

6 Now drag the gray marker to the left to a value of 3.06. Again, a number can be typed directly into the central numeric box. The gray marker adds further brightness but works by adjusting the middle tones of the image so the overall effect is more subtle.

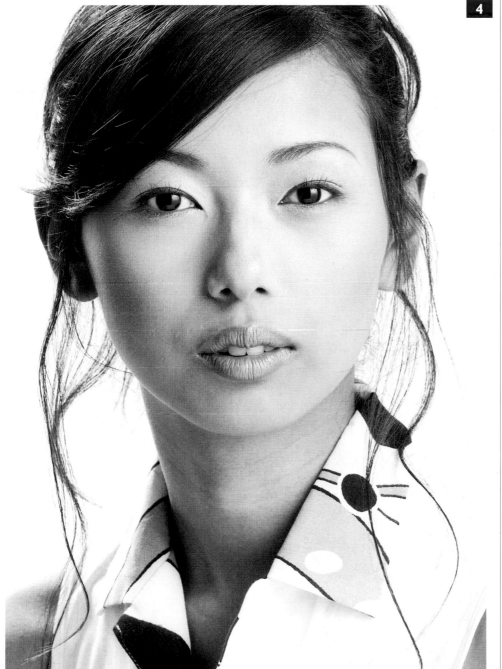

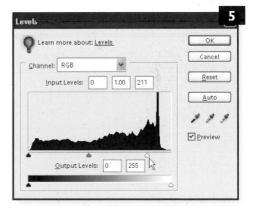

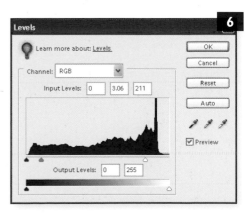

HIGH-KEY IMAGES

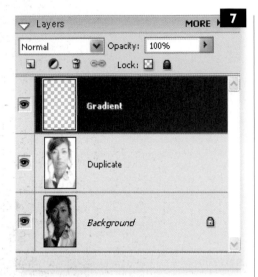

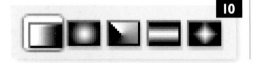

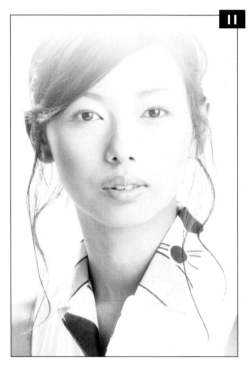

7 By adding one more simple controlling device it is possible to fine-tune the degree of exposure until the desired effect is achieved. To begin, create a new layer named "Gradient."

8 Select the Gradient tool, then choose white as the foreground color.

9 Click the Gradient drop-down box in the top-left corner of the screen and choose the Foreground to Transparent gradient.

10 Select the Linear gradient, which is the first of the five gradient options in the Tool Options Bar.

11 Using the Gradient tool, place the cursor at the top of the image and drag it down about quarter of the way. Keep the Shift key pressed as you drag to hold the gradient in a perfect vertical line.

12 The effect as it stands is probably too strong, but the idea is to control the degree of white by using the layer Opacity slider. Reduce the layer's Opacity to about 45 percent, or experiment with the percentage until you get a pleasing result.

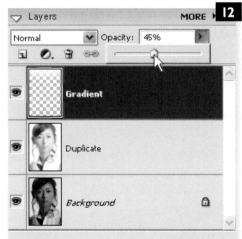

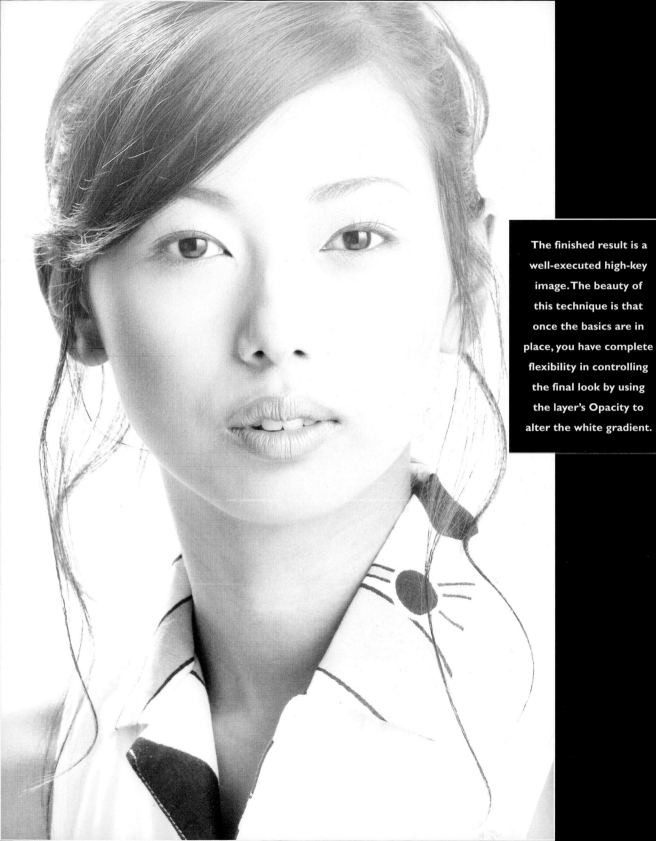

The finished result is a well-executed high-key image. The beauty of this technique is that once the basics are in place, you have complete flexibility in controlling the final look by using the layer's Opacity to alter the white gradient.

MIXING DIFFERENT LIGHT SOURCES

In general, when we think about a white object we think of its color as simply being white. We rarely make allowances for the white being slightly blue or slightly orange or some other variant. This is largely due to the fact that our brains constantly compensate for the color's variances, so we will immediately describe a white car as white whether it is tinged by the blue light of a cold dawn or bathed in the soft yellow glow of a showroom. Because cameras do not benefit from the same mental faculties as we do, many of today's digital cameras incorporate a white-balance function to make the distinction between the different kinds of light to ensure that the resulting picture will look natural for a given lighting situation. Photographically interesting results can appear if two sources of light are mixed in one image. The following example uses natural blue daylight as the main source of light, and we will artificially create a second light source of incandescent light.

1 The only light source illuminating this interior is natural daylight, resulting in a predominantly blue light. By artificially turning on the ceiling spotlights you can add their warm yellow light to create a contrast to the strong blue entering through the skylight.

2 Using the Polygonal Lasso tool, make a selection of the interior, as shown in the example. Only the right side of the image needs to be selected because this is the area that will be lit by the spotlights.

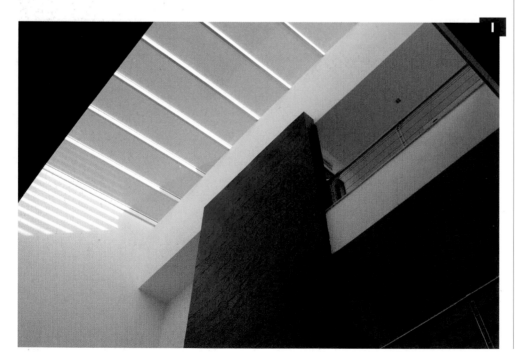

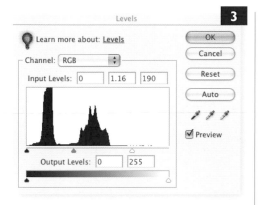

3 Go to *Enhance > Adjust Lighting > Levels*. The first task is to lighten the interior. Apply the numeric settings shown. By adjusting the white and gray Input sliders the overall level of brightness is increased.

4 Now the color needs to change to simulate a warm yellow light. Select Blue from the Channel drop-down box. Change the first Input Levels numeric box to a value of 29 to warm the color.

5 Choose Green from the Channel drop-down box, then change the second Input Levels numeric box to 0.95. This removes the hint of green in the yellow color to add more warmth to the light.

6 All that remains now is to create the incandescent lights. Create a new layer called "light," then use the Elliptical Marquee tool to create a selection over one of the switched-off ceiling spotlights.

MIXING DIFFERENT LIGHT SOURCES

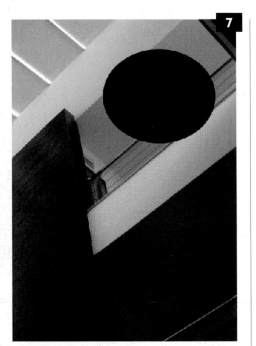

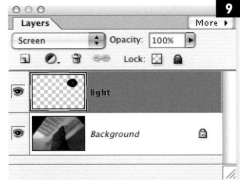

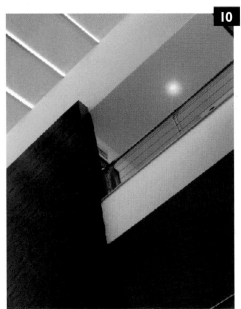

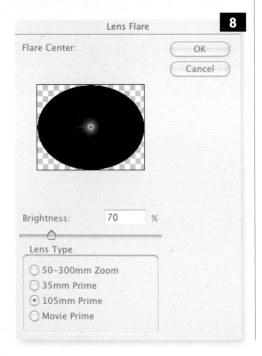

7 Make sure that the new layer is active, then fill the selection with black using *Edit* > **Fill**. Finally, deselect the selection by pressing Ctrl/Cmd+D.

8 The light source itself will be created by using the Lens Flare filter applied to the black ellipse. Go to *Filter* > *Render* > **Lens Flare**. Apply the settings as shown.

9 To hide the black fill and leave the flare visible, change the light layer's blend mode to "Screen."

10 The result of the Screen blend mode shows no trace of the original black fill. The reason it was necessary to fill the elliptical selection is that the Lens Flare filter cannot be applied to a transparent area.

11 Once the first light has been created, it is a simple matter to create additional lights by duplicating the original. To achieve this, hold the Alt/Opt key and use the Move tool to drag the light. This will duplicate the light and create its own layer at the same time.

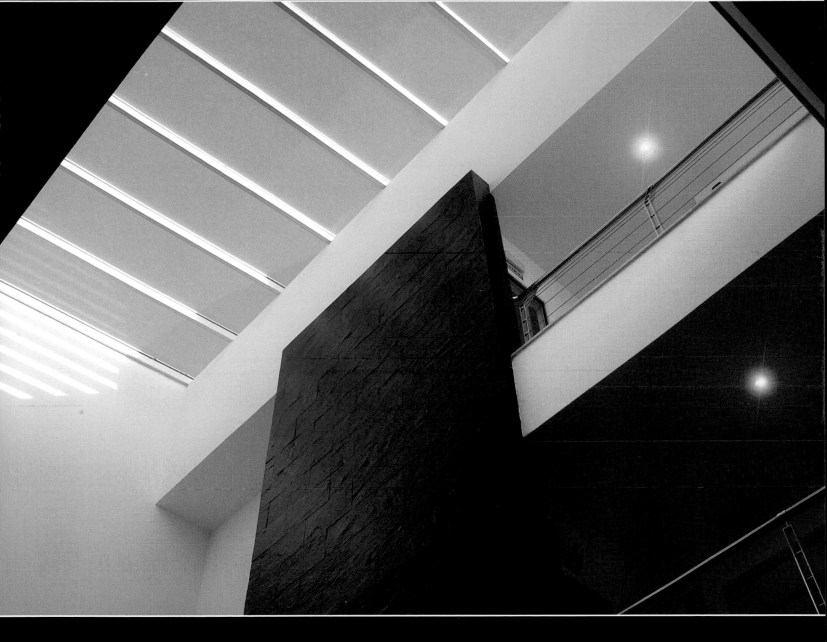

The final image is shown with the additional
light dragged into place over the second
spotlight. The effect is an interesting
contrast of light and color.

NEON LIGHT

Although the glow from neon light is delicate, neon in itself could never be described as subtle. Its association with garish advertising signs and late-night bars and clubs means that it occupies a peculiar niche where it reigns as king of all things kitsch. However, it is perennially popular with all entertainment and leisure businesses. This beautifully lit bar is the perfect setting for just such a neon sign.

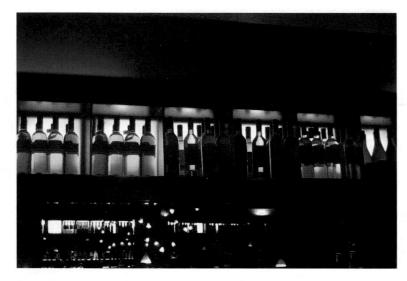

Original image

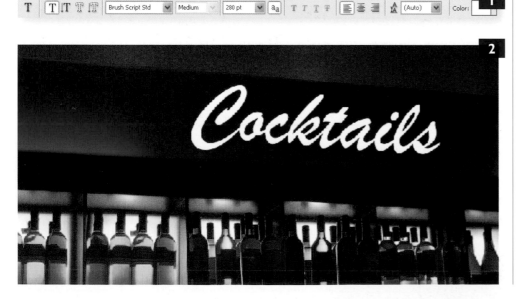

1 Select the Horizontal Type tool and choose Brush Script Std or something similar for the font. Set the Size to 280 pt and set the Color to white.

2 Type the word "Cocktails" and position it above the bottles. A text layer will automatically be created.

3 If the Styles and Effects palette is not open, go to Window > *Styles and Effects* to open it. Leave it set to Layer Styles, and choose Outer Glows from the drop-down box at the top of this palette.

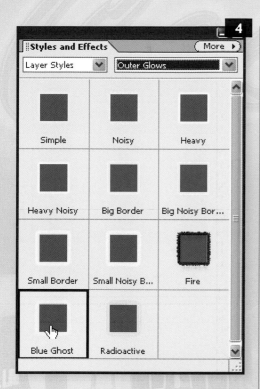

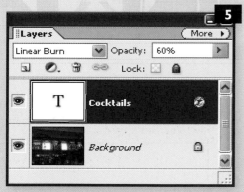

4 Click the Blue Ghost thumbnail from the menu to apply the effect to the text.

5 Change the text layer's blend mode to Linear Burn.

6 Double click the small "f" icon in the Cocktails layer to access the settings for the Outer Glow.

7 Change the Outer Glow Size value to 18.

8 Duplicate the text layer by clicking the More button and choosing Duplicate Layer.

9 The main glow from the neon will be created using a selection based on the text. Keep the Ctrl/ Cmd key pressed and click the thumbnail in either of the text layers to generate a selection from it.

NEON LIGHT

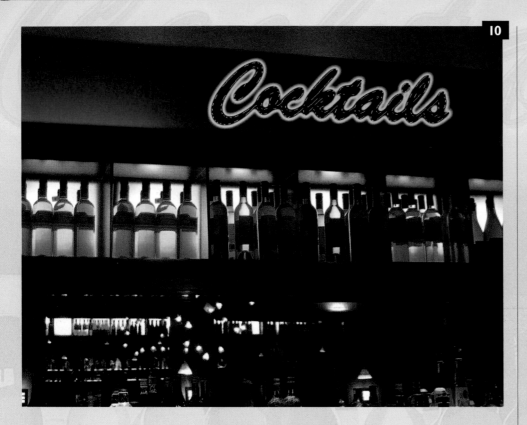

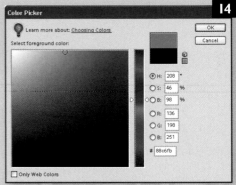

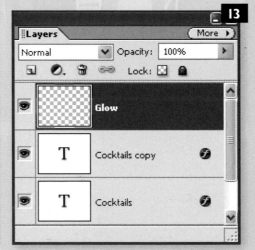

10 The contents of the text layer, not including the outer glow, should now be selected..

11 To increase the size of the selection, go to *Select > Modify > **Expand***. Enter a value of 6.

12 The glow should also be softened, so go to *Select > **Feather*** and enter a value of 6 pixels.

13 Create a new layer named "Glow."

14 Click the foreground color square in the Toolbox to access the Color Picker. Using the RGB numerical boxes enter the following color values: R: 136, G: 198, B: 251.

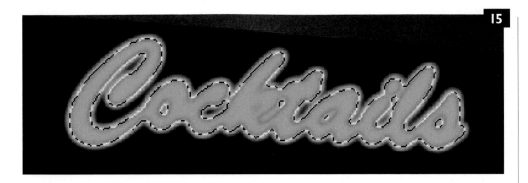

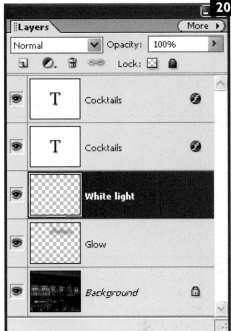

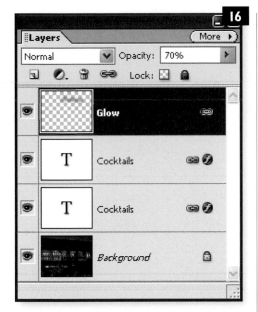

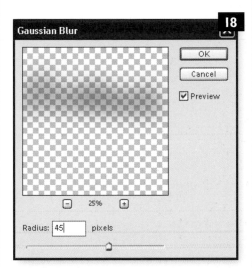

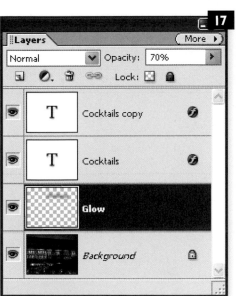

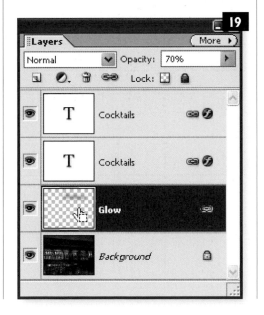

15 Fill the selection with the new color by pressing Alt/Opt+Backspace.

16 Reduce the Opacity of the Glow layer to 70 percent.

17 Drag the Glow layer below the two text layers in the Layers palette.

18 The glow is a little too distinct. To soften it, go to *Filter > Blur > Gaussian Blur*. Enter a Radius of 45 pixels in the dialog box.

19 Now, load the selection from the Glow layer to enhance the neon glow. Keep the Ctrl/Cmd key pressed and click the thumbnail of the Glow layer in the Layers palette.

20 Create a new layer above the Glow layer naming it "White light."

NEON LIGHT

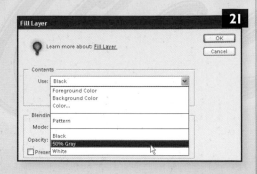

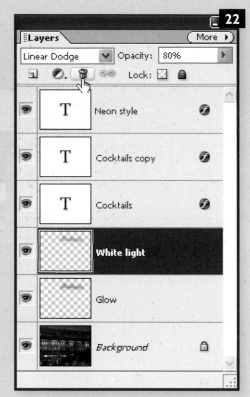

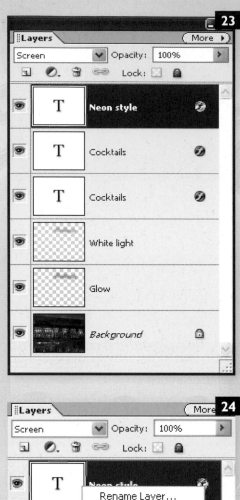

21 Go to *Edit > Fill Selection*. Choose 50% Gray from the Use drop-down box.

22 Change the White light layer's blend mode to Linear Dodge and the Opacity to 80 percent.

23 Duplicate the Cocktails copy layer so that it is positioned at the top of the Layers palette. Rename it "Neon style."

24 If you are on a PC, right click the "f" symbol on the Neon style layer and choose Clear Layer Style. For Mac users, instead of right clicking, keep the Control key pressed when clicking the "f" symbol.

25 From the Styles and Effects palette, choose Wow Neon from the drop-down box. Click the Wow-Neon Purple Off thumbnail to apply it to the latest text layer.

26 Double click the "f" symbol in the Neon style layer to access the Style Settings. Apply the settings shown to create a stronger burst of light and complete the effect.

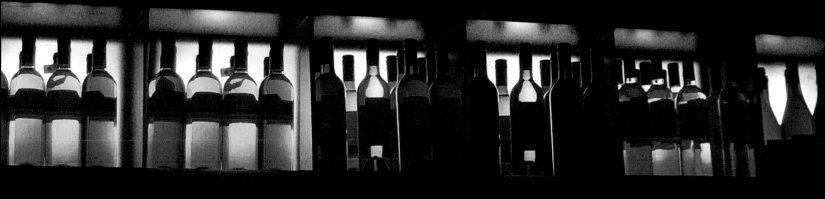
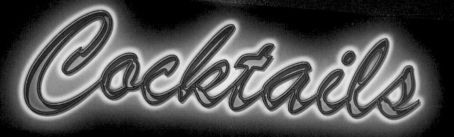

CREATING CANDLELIGHT

The warm, soft glow of candlelight—even when it is only a small element of an image—can draw the eye and become the focal point of an image. Although its light may be limited in intensity it can often "outshine" the other elements of a scene. This is particularly true when a variety of light sources are present. This stained-glass window image is fairly cold, so we will add a small, comforting glow of light by simulating some custom-made candlelight.

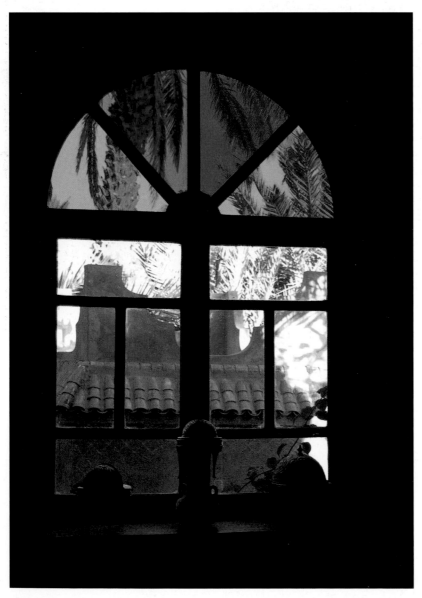

Original image

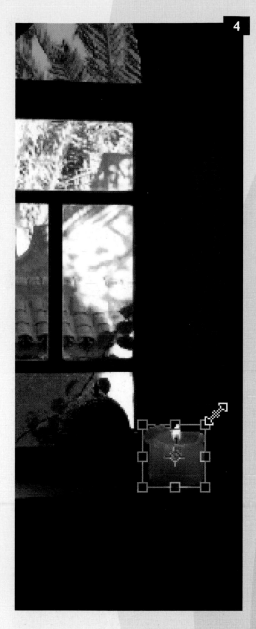

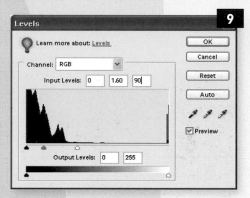

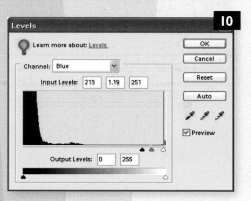

1 As well as creating the candlelight you will also need to create the candle. The simplest method is to borrow one from another image. Make a selection of your candle, being sure to include the flame.

2 With both the candle and the window image open, use the Move tool to drag the candle selection into the window image. The dragged selection will automatically be added as a new layer.

3 Name the new layer "Candle."

4 To resize the candle go to *Image > Transform > Free Transform*. When the bounding box appears drag any of the corner handles toward the center, keeping the Shift key pressed in order to maintain the proportions.

5 Click the Eye icon next to the Candle layer in the Layers palette to hide the candle image.

6 Using the Lasso tool, make a selection of an area that would be covered by the glow emitted from the candle.

7 To soften the selection go to *Select > Feather*. Enter a value of 25.

8 Go to *Layer > New > Layer via copy* to copy and paste the selection to a new layer. Name the new layer "Glow."

9 The Feathered selection can now be adjusted for light and color to depict a realistic glow of light from the candle. Go to *Enhance > Adjust Lighting > Levels*. Starting with the default RGB channel, adjust the gray Input slider to 1.60 and the white slider to 90.

10 Select the Blue channel from the Channel drop-down box and adjust the black Input slider to 213, the gray slider to 1.19 and the white slider to 251.

CREATING CANDLELIGHT

11 The result is a soft glow reminiscent of the light cast by a candle.

12 Reveal the Candle layer again, and create a new layer above it named "Highlight."

13 Make an elliptical selection over the candle flame.

14 Press Ctrl/Cmd+D to bring up the Feather dialog box and enter a value of 15.

15 Make sure the Highlight layer is active then go to *Edit* > **Fill Selection** and choose 50% Gray from the Use drop-down box. Then Deselect the selection.

16 Change the Highlight layer's blend mode to Color Dodge and reduce the Opacity to 95 percent.

17 Although there is now a very warm light in the surrounding area of the candle, the candle itself has a slightly different color quality. To match the surrounding light click the Candle layer then go to *Filter* > *Adjustments* > **Photo Filter** and choose the Warming Filter (85) at a density of 70 percent.

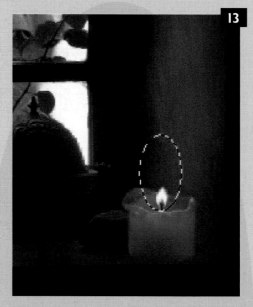

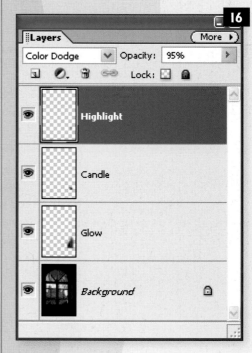

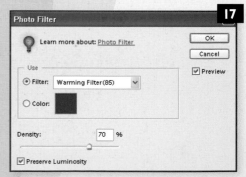

The glow of the candle creates a new focal point, and stands in contrast to the cold light filtering through the window. It immediately alters the tale behind the image in the viewer's mind.

Special effects with light

MULTIPLE COLORED LIGHTS

If you want to spice up a dull image, just add color. If you want to make it alluring as well, just add colored light. It's a simple recipe, so why is it so prone to looking cheap and overdone? It's all about whether the effect is created in such a way as to look natural. We will use Photoshop Elements' Lighting Effects filter here to simulate a very expensive real-world lighting set up. We are going to use it in a way that allows control over the degree of each light and its color settings so that we can influence the way the lights interact with each other.

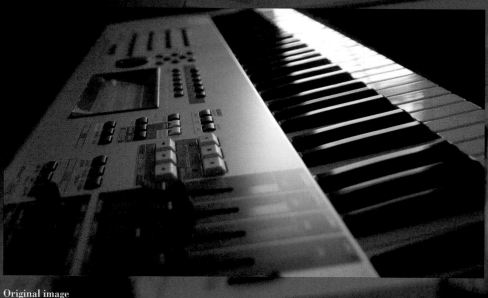

Original image

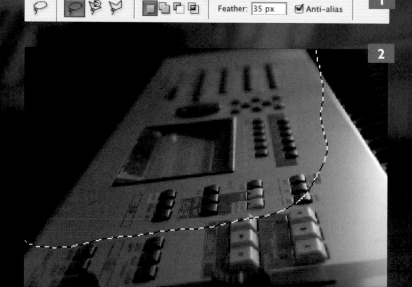

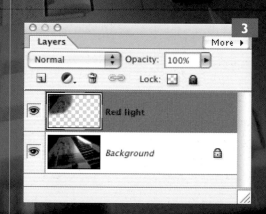

1 Select the Lasso tool and set the Feather option to a value of 35 pixels.

2 Create a selection that covers approximately one quarter of the image, starting in the top-left corner.

3 Go to *Layer > New > Layer via copy* to copy and paste the selection on to a new layer. Name the new layer "Red light."

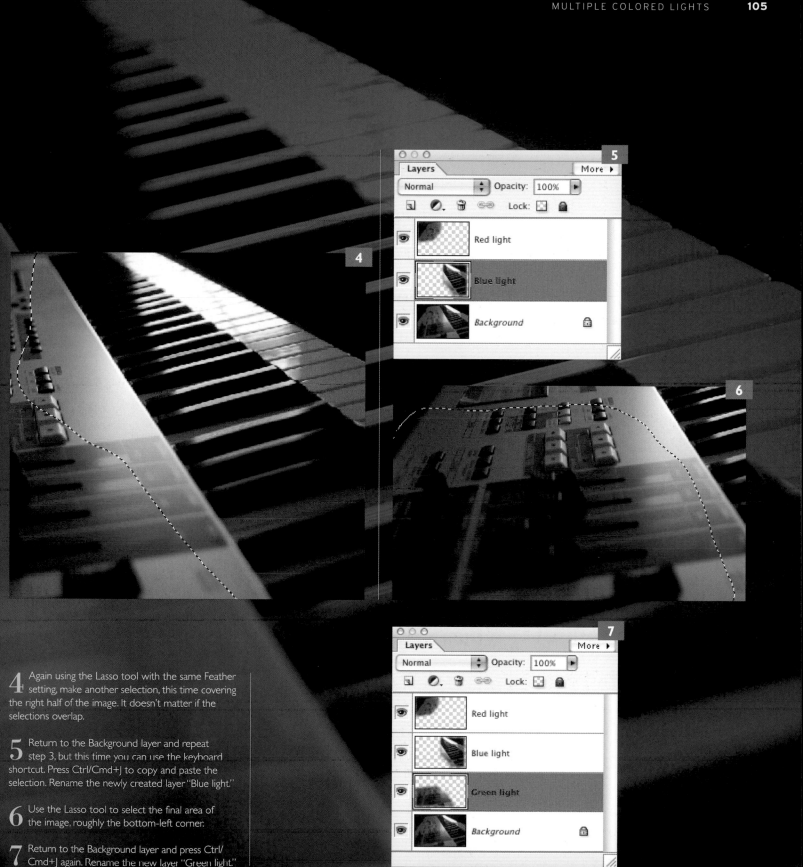

4 Again using the Lasso tool with the same Feather setting, make another selection, this time covering the right half of the image. It doesn't matter if the selections overlap.

5 Return to the Background layer and repeat step 3, but this time you can use the keyboard shortcut. Press Ctrl/Cmd+J to copy and paste the selection. Rename the newly created layer "Blue light."

6 Use the Lasso tool to select the final area of the image, roughly the bottom-left corner.

7 Return to the Background layer and press Ctrl/Cmd+J again. Rename the new layer "Green light."

MULTIPLE COLORED LIGHTS

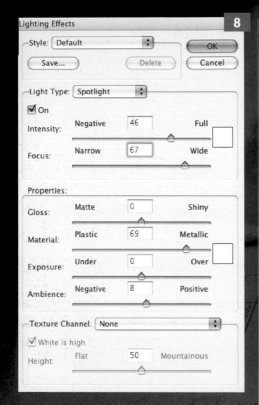

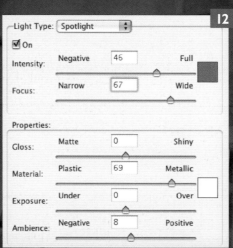

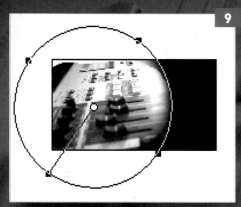

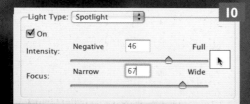

8 The image has now been split into three different layers and lights can be applied independently to each layer. With the Green light layer active go to *Filter > Render > Lighting Effects*. Select Spotlight from the Light Type drop-down box.

9 Use the handles on the edge of the light in the Preview window to create a light similar to that shown in the example.

10 In the Light Type section, click the white square open the Color Picker.

11 Choose a mid-green color then click OK to close the Color Picker and return to the Lighting Effects filter dialog box.

12 Copy the other settings as shown in the example and click OK to close the dialog box.

13 Activate the Blue light layer then repeat steps 8 to 12 to create the next light, except this time choose blue as the color.
 Finally, repeat the same procedure for the Red light layer. If any harsh edges appear between the three layers use the Eraser tool with a low Opacity setting to rub over the edges and make them fade away.

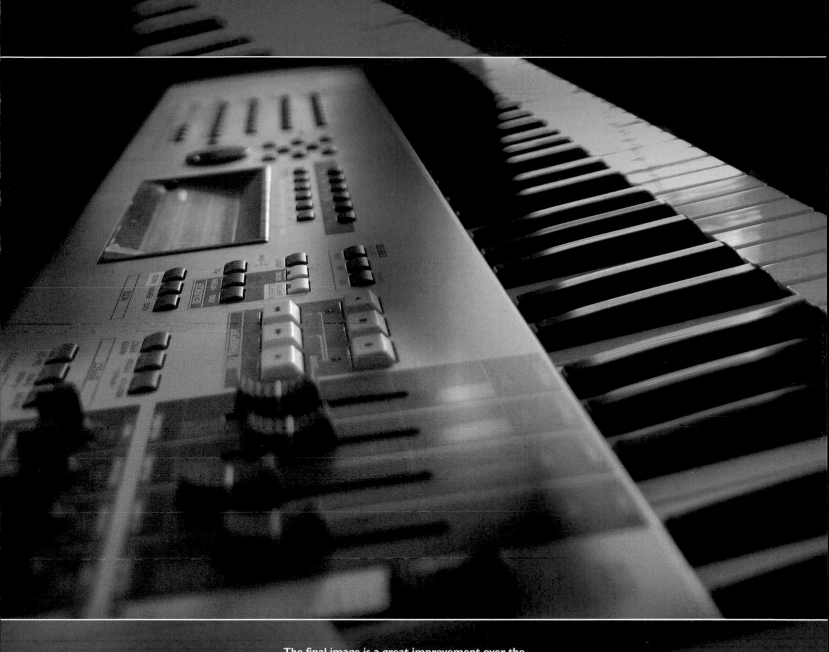

The final image is a great improvement over the original, with the new lights adding interest and appeal to an otherwise bland original.

RETRO STUDIO LIGHTING

Walk into any home today and you are as likely to find a camera as you are a television or a washing machine—it has become a part of the home's standard equipment. Perhaps because of this, professionally photographed family portraits have all but faded away. A professional studio setup at home involving lighting, backdrops, and a dedicated space may be the preserve of the keen enthusiast, but that doesn't necessarily exclude everyone else from creating professional-style images. By following the steps in this example you will be able to immortalize your portraits in the classic style of years gone by.

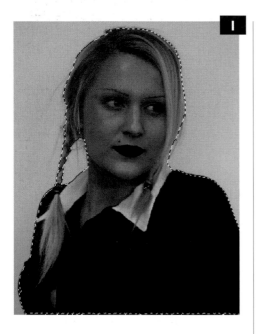

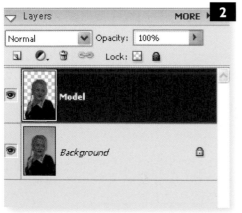

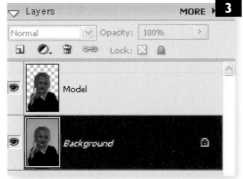

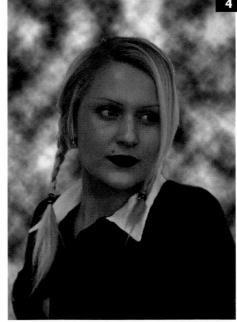

1 Make a selection of the model, capturing as much of the hair as possible.

2 Go to *Layer > New > Layer via copy* to cut and paste the selection to a new layer. Name the new layer "Model."

3 Press "D" on the keyboard to set the foreground and background colors to the default black and white, then click the Background layer to activate it. We'll replace the background using a filter.

4 Go to *Filter > Render > Clouds* to create a typical studio backdrop.

5 To make the backdrop more subtle go to *Filter > Blur > Gaussian Blur*. Use a setting of 27.0 pixels.

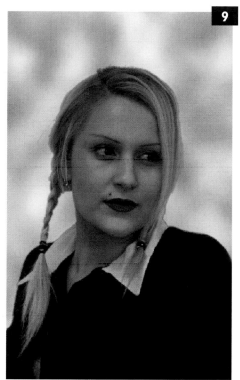

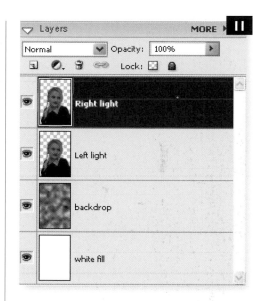

6 Double click the Background layer to convert it to an ordinary layer that can have its Opacity reduced. Name the layer "Backdrop."

7 Create a new white-filled layer at the bottom of the stack in the Layers palette. Call it "white fill."

8 Reduce the Backdrop layer's Opacity to 53 percent.

9 Activate the Model layer. The next step will give this layer the appearance of a grayscale image. Go to *Enhance > Adjust Color > **Remove Color.***

10 The Model layer needs some adjustment to improve the contrast and general impression of light. Go to *Enhance > Adjust Lighting > **Levels.*** Adjust the black, gray, and white Input sliders to the values as shown in the example.

11 Duplicate the Model layer. Rename the two layers "Left light" and "Right light."

RETRO STUDIO LIGHTING

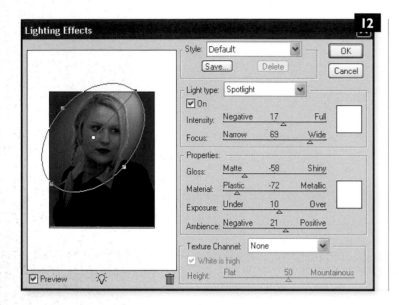

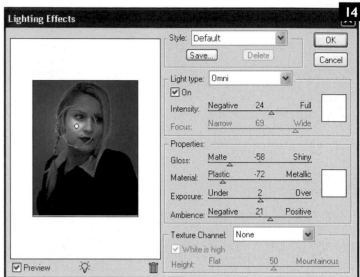

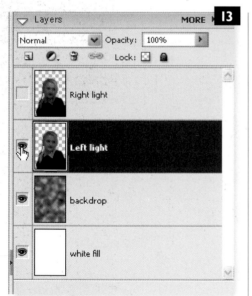

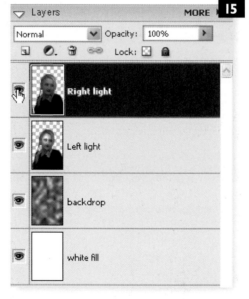

12 With the Right light layer active, go to *Filter > Render > Lighting Effects*. Position a spotlight shining from the top-right corner of the model and copy the settings in the example.

13 Hide the Right light layer and activate the Left light layer.

14 Once again go to *Filter > Render > Lighting Effects*. Change the Light Type to Omni and copy the other settings.

15 Reveal and activate the Right layer.

16 Choose the Eraser tool and apply a soft-edged brush at a size of 250 pixels and an Opacity of 50 percent.
Working on the Right light layer, erase away the left side of the model to reveal the layer below. This allows the lighting from both layers to show through.

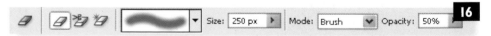

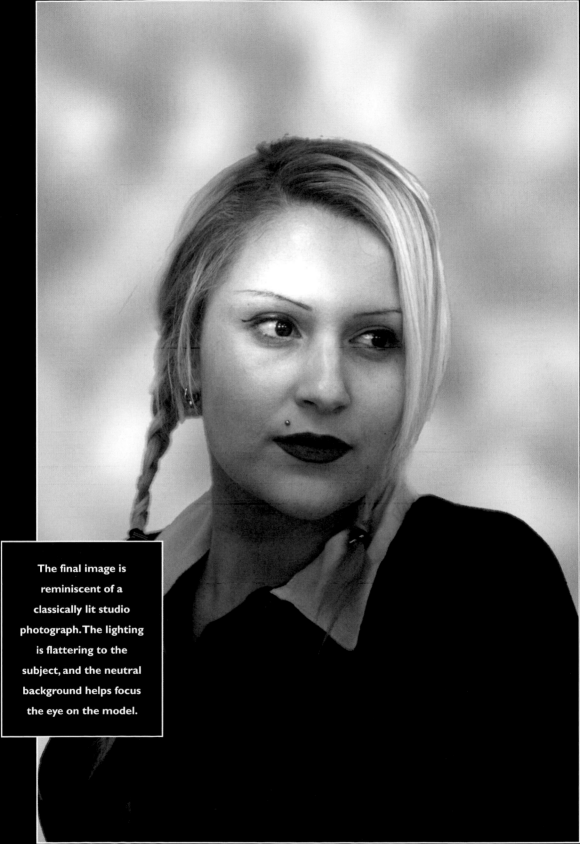

The final image is reminiscent of a classically lit studio photograph. The lighting is flattering to the subject, and the neutral background helps focus the eye on the model.

SMOKE CREATION

It is often said that children and animals are the most difficult and impatient of photographic subjects—constantly shifting, irritable, and generally unresponsive to the direction of the photographer. Although this assessment may be true, there is another candidate that could be added to the list—smoke. It is an elegant photographic subject, but it has all of the dubious attributes of a prima donna; independent, undisciplined, and rebellious as it drifts with the whims of the air currents. Imagine if there were a type of smoke that was the perfect model—one that would obey your every command so that you could control every twist and turn of its sinuous path. Well, that's exactly the kind of smoke we are about to create.

The image of the statue below contains an incense stick that will be the perfect subject to add some wisps of smoke to.

1 Make a rectangular selection with a Feather of 30 pixels over the area where the smoke will appear.

2 Create a new layer and name it "Smoke."

3 Press D on the keyboard to set the default colors, then go to *Filter > Render > **Clouds***.

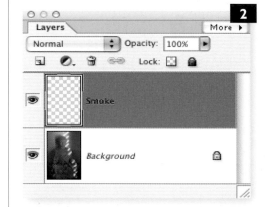

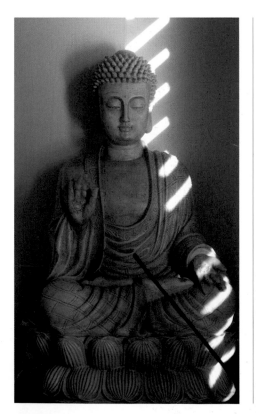

Original image

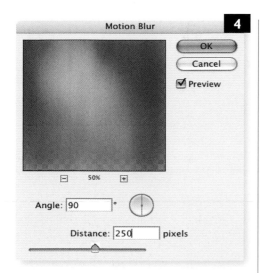

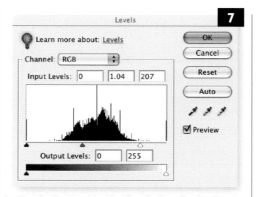

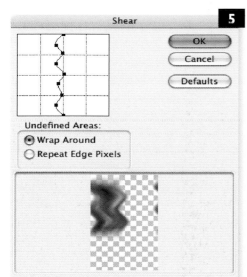

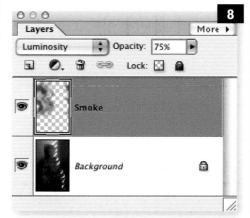

4 Deselect the selection and go to *Filter > Blur > Motion Blur*. Set the Angle to 90 degrees and the Distance to 250 pixels.

5 The first stage of the waviness of the smoke will be created by shearing the blurred clouds. Go to *Filter > Distort > Shear*. In the dialog box Preview window, click and drag the vertical line to create a zigzag pattern as shown in the example.

6 The smoke is too uniform at present and needs a more random, swirling look. Go to *Filter > Distort > Wave* and apply the settings shown in the example.

7 The black needs to be minimized and the paler areas increased slightly. Go to *Enhance > Adjust Lighting > Levels*. Adjust the gray Input slider to 1.04 and the white slider to 207.

8 Change the Smoke layer's blend mode to Luminosity and reduce the opacity to 75 percent.

9 There's no smoke without fire, so we need to make a glowing tip for the incense stick. Create a circular selection over the end of the incense stick with a Feather value of 5 pixels.

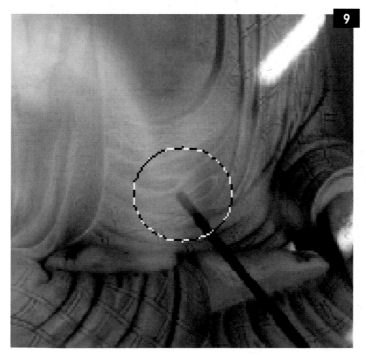

SMOKE CREATION

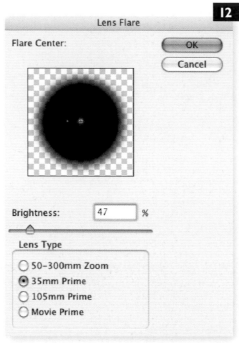

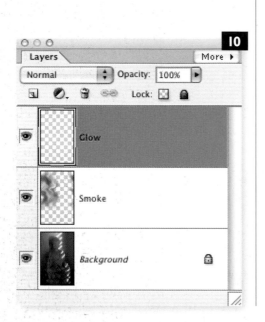

10 Create a new layer called "Glow" at the top of the Layers palette.

11 Fill the selection with black, then Deselect the selection with Ctrl/Cmd+D.

12 Go to *Filter > Render > **Lens Flare***. Use the 35mm Prime lens at 47 percent Brightness. Click the middle of the black area in the Preview window to place the flare.

13 Change the Glow layer's blend mode to Screen to remove the black area.

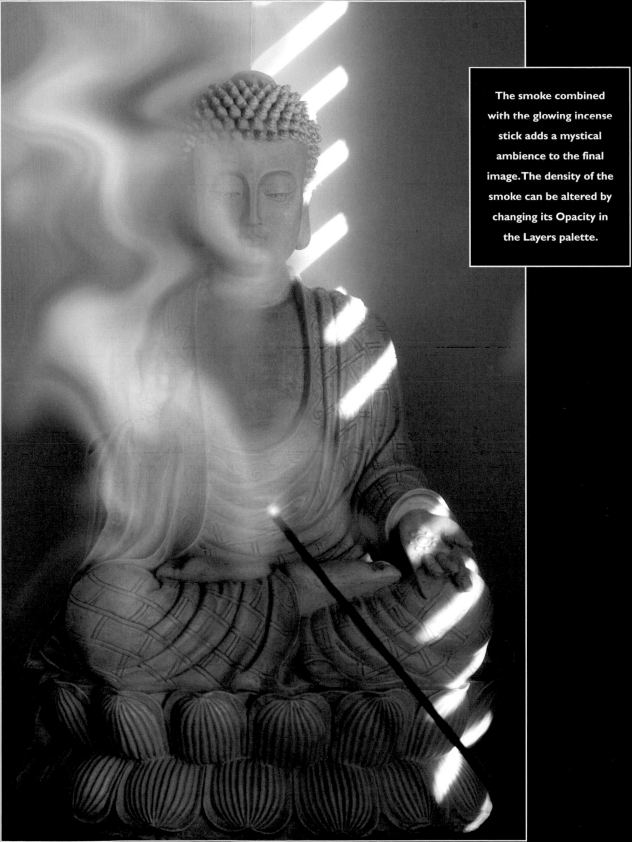

The smoke combined with the glowing incense stick adds a mystical ambience to the final image. The density of the smoke can be altered by changing its Opacity in the Layers palette.

FILM NOIR

The classic film genre that has become known as film noir is as famous for its atmospheric black-and-white images as it is for any of its story lines or movie-screen idols. What makes the genre so evocative is the clever use of shadows and the controlled rationing of minor-source lighting. What is concealed is just as important as what is revealed, and it is this interplay of shadow and light that is so enigmatic and haunting. We will adopt these tried-and-tested principles now to create a classic 1940s image.

1 Start by taking your color image and making it grayscale. The final image won't be a true grayscale because we will be applying a subtle blue cast to give it a sophisticated feel. For now, you can just desaturate the color. Go to *Enhance* > *Adjust color* > **Remove color**.

2 It is often the case when desaturating color images that the grayscale result is lackluster and disappointing, so some contrast adjustment and color tinting comes next. Go to *Enhance* > *Adjust Lighting* > **Levels**. Adjust the black and white Input sliders as shown.
 To add a blue tint to the image, select Blue from the Channel drop-down box. Adjust the gray Input slider to 0.96 and the white slider to 210.

3 Set the foreground color to white and the background color to black.

Original image

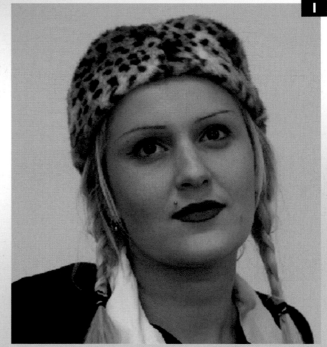

4 Select the Gradient tool, and, using the Tool Options Bar at the top of the screen, set its options to Foreground to Background and Radial.

5 On a new layer named "Round light," drag the Gradient tool to create a soft white circle just off-center of the image.

6 Change the layer's blend mode to Soft Light.

7 Change the Gradient tool option to Reflected.

8 On another new layer named "Straight light," drag the Gradient tool at a slight angle roughly over the model's eyes. Change this new layer's blend mode to Soft Light.

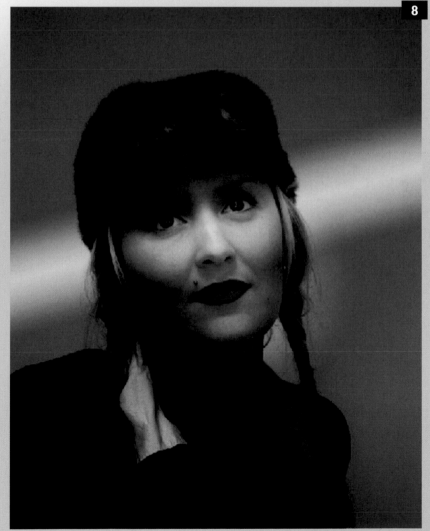

FILM NOIR

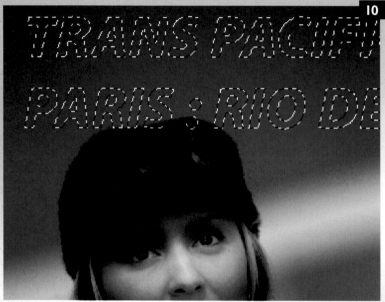

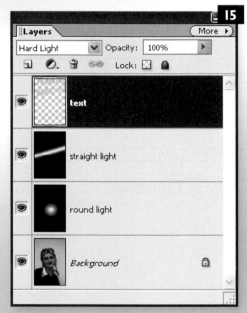

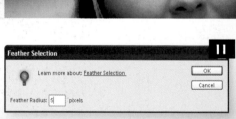

9 You can also add some text to show what the model might be looking at. Select the Horizontal Type Mask tool from the Toolbox.

10 Choose any simple, bold font at Size 160 pt. and type on a new layer in upper case: "TRANS PACIFIC" on the first line and "PARIS : RIO DE JANEIRO" on the second line. Don't worry if the text runs off the end of the image.

11 Go to *Select > **Feather.*** Apply a value of 5.

12 Use the Eyedropper tool to sample a pale blue color from the background.

13 Use the sampled color to fill the selection then deselect the selection.

14 The text should appear as if it is light cast from the lettering on a window. Go to *Image > Transform > **Distort.*** Drag the corner handles of the bounding box so that the text appears slanted and slopes away to the right. Press the Enter/Return key to confirm the transformation.

15 Change the text layer's blend mode to Hard Light. Position the text partially over the model's hat where it will appear to have its own light qualities.

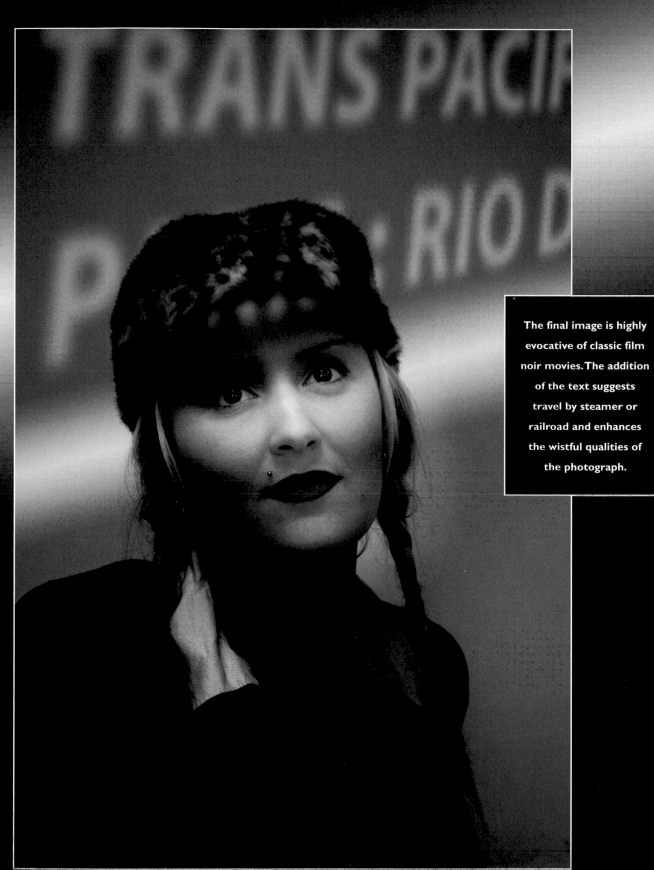

The final image is highly evocative of classic film noir movies. The addition of the text suggests travel by steamer or railroad and enhances the wistful qualities of the photograph.

LIGHT THROUGH DUST

Sharp beams of light act as wonderful spotlights that highlight the multitude of dust particles that hang in the air. These, often apparently invisible, particles burst into life when caught in a ray of sunlight and they seem to dance erratically as if performing. This can be quite a spectacle photographically, and is a favorite device for any moviemaker who wants to create the atmosphere of a hot desert landscape. For this image, we are going to create the whole package—the sunlight, the rays, and even the dust.

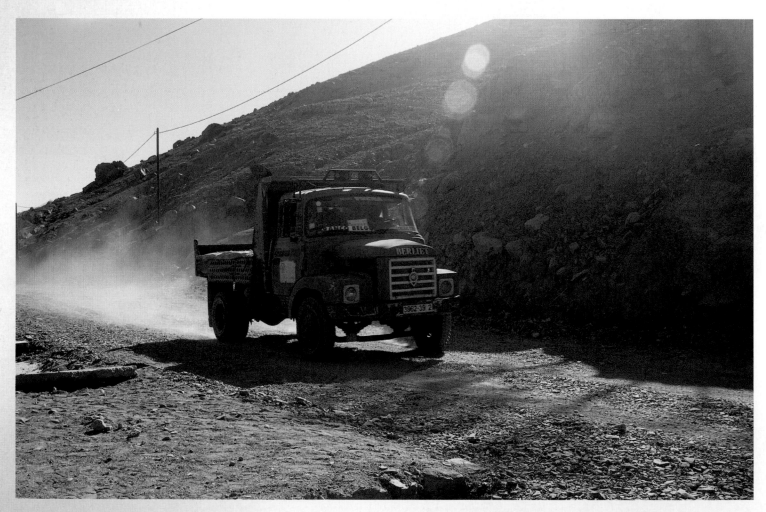

Original image

1 Make a rectangular selection in the top-right corner of the image covering one quarter of the image.

2 Using the Eyedropper tool, select a light and a dark color from the earth; one for the foreground color and one for the background color. The sampled colors will be used as the basis for the Clouds filter that will be applied next to simulate dust.

3 Create a new layer named "dust."

4 Go to *Filter > Render > **Clouds*** to fill the selection.

LIGHT THROUGH DUST

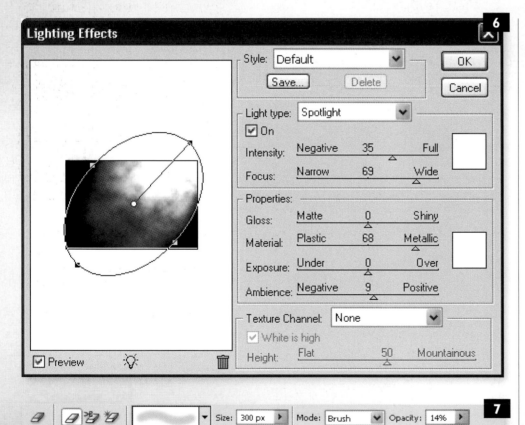

5 Deselect the selection (Ctrl/Cmd+D) then press Ctrl/Cmd+T to bring up the Transform bounding box. Drag the bottom-left handle of the bounding box toward the bottom-left of the image, increasing its size to cover the entire image. Press the Enter/Return key to confirm the transformation.

6 The source of sunlight will be generated by using the Lighting Effects filter. Go to *Filter > Render > Lighting Effects* and enter the settings shown to create a strong directional light shining from the top-right corner.

7 Choose the Eraser tool set to a soft-edged brush at a Size of 300 pixels and an Opacity of 14 percent.

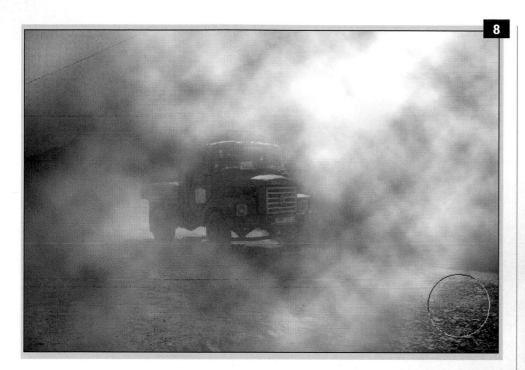

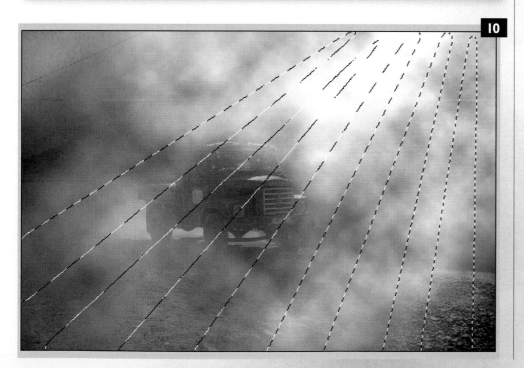

8 Erase parts of the dust layer revealing some of the truck and other random areas of the image.

9 Choose the Polygonal Lasso tool set to Add to selection Mode and with a Feather of 20 pixels.

10 Create a series of independent selections representing rays of sunlight.

11 Create a new layer at the top of the Layers palette and name it "composite." This layer will be used to hold a copy of all the other layers in one neat composite.

LIGHT THROUGH DUST

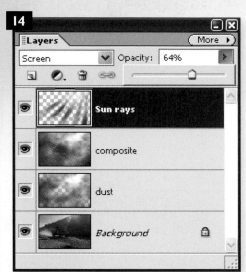

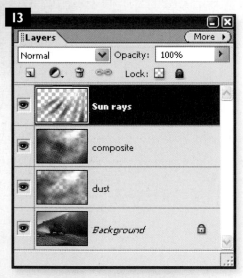

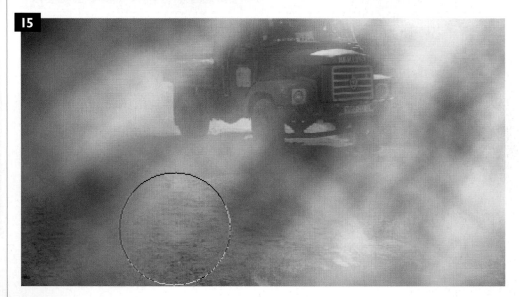

12 To make the composite layer, press Ctrl/Cmd+Alt/Opt+Shift+E.

13 The purpose of making the composite layer is so that the sun ray selections can be used to copy and paste both the background and dust layers in one move. *Go to Layer > New > **Layer via copy*** to copy and paste the selection to a new layer. Name the new layer "Sun rays."

14 Change the Sun rays layer's blend mode to Screen and reduce the Opacity to 64 percent.

15 Use the Eraser tool again to partially remove some of the sun rays at the bottom of the image.

CREATING FIRE

Fire can often look a little too solid when created digitally. The challenge here is to create completely artificial fire without a photographic head start, and yet still manage to emulate the fine fluidity of billowing flames. To complete the realism we will also use a technique that will bathe the surrounding area in the hot glow of the inferno.

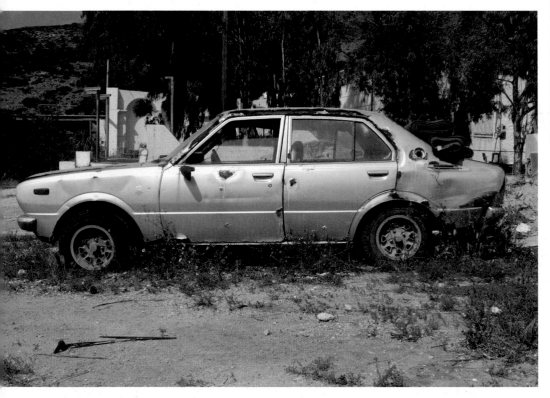

Original image

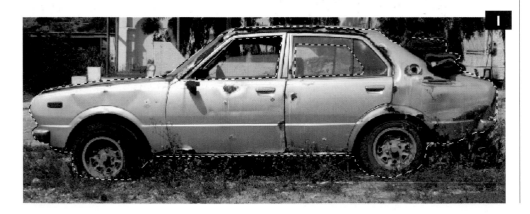

1 The car needs to be cut out and placed onto a new layer. The selection does not have to be too accurate because the edges will be quite indistinct and engulfed in flames, so a selection with the Lasso tool will be sufficient.

2 Go to *Layer > New > Layer via copy* to copy and paste the selection to a new layer. Name the layer "cutout car."

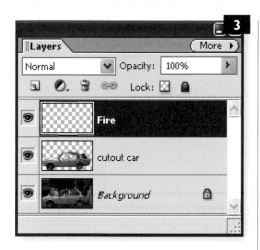

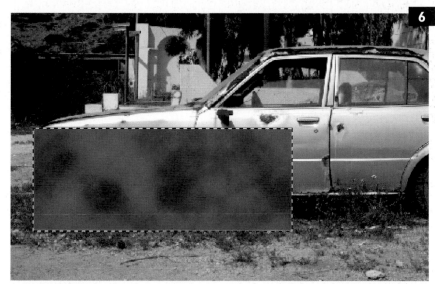

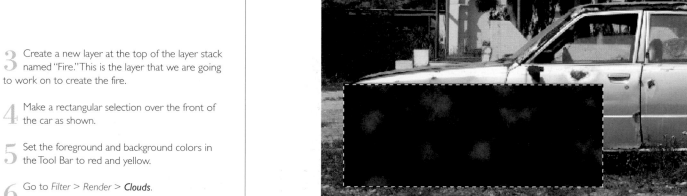

3 Create a new layer at the top of the layer stack named "Fire." This is the layer that we are going to work on to create the fire.

4 Make a rectangular selection over the front of the car as shown.

5 Set the foreground and background colors in the Tool Bar to red and yellow.

6 Go to *Filter > Render > **Clouds***.

7 Go to *Filter > Render > **Difference clouds***. This will invert the effect.

CREATING FIRE

8 Press Ctrl/Cmd+F several times. Each time the key sequence is pressed, the colors will be displayed in a different configuration. Keep pressing until you have a strong, streaky, red and yellow finish.

9 Deselect the selection (Ctrl/Cmd+D) and go to *Edit > Transform > **Free Transform***. Use the handles around the edge of the rectangular bounding box to stretch the fire until it completely covers the car. Press the Enter/Return key to confirm the transformation.

10 Using the Magic Wand tool with a Tolerance setting of 20, click any pure red area of the fire.

11 The selection needs to have soft edges, so we'll increase it slightly to pick up some of the orange-red shades. Go to *Select > **Similar**.* Then *Select > **Feather**.* Enter a value of 40.

12 Press the Delete key on your keyboard to remove the strong red areas.

13 A second fire layer is needed. Click the More button in the Layers palette and choose Duplicate Layer.

14 Drag the original Fire layer below the cutout car layer. The cutout car layer is now sandwiched between the two fire layers.

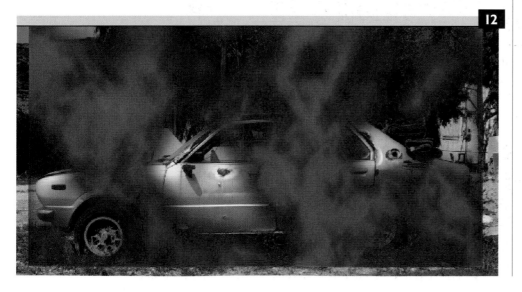

CREATING FIRE

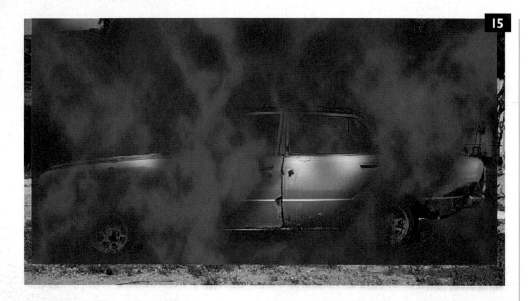

15

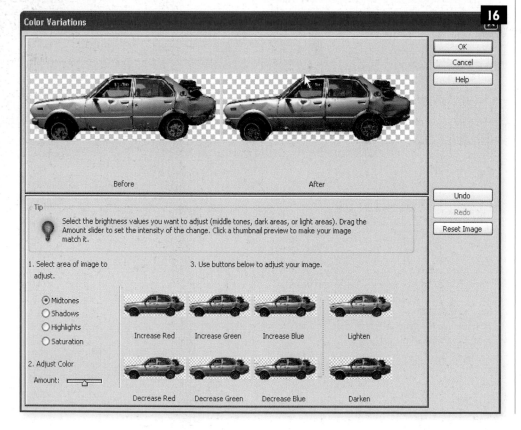

15 Return to the Fire copy layer then go to *Image > Rotate > **Flip Horizontal***. The car now appears engulfed in flames, giving it a more 3D appearance.

16 If the fire were real, the silver car would be reflecting the colors of the flames and so appear to have a red/yellow color cast. To mimic this effect, return to the cutout car layer then go to *Enhance > Adjust color > **Color Variations***. Leave the default Midtones radio button enabled, and click the Increase Red thumbnail four times. Next, click the Increase Green thumbnail once to throw a yellow cast over the car. Click OK to confirm the setting.

17 Finally, using the Crop tool, drag a rectangle around the fire effect, then press the Enter/ Return key on your keyboard to confirm the crop.

The final image gives a good impression of
an object absolutely engulfed in flames. By
layering the flames either side of the car, the

CREATING SILHOUETTES

Silhouettes can add drama and impact to an otherwise very ordinary image. The choice of subject matter is critical if a successful silhouette is to be achieved. Simple, bold images work best with strong light sources as the backdrop. Unsurprisingly, many of the most interesting silhouettes feature sunsets or moonlight as the primary light source, but any strongly backlit scene is a potentially good candidate.

1

3

2

1 The subject to be silhouetted needs to be separated onto its own layer. In this instance the uniform blue sky makes it easier to select the background of the image rather than the subject.

2 Select the Magic Wand tool then, using the Tool Options Bar at the top of the screen, set the Tolerance to 16 and uncheck Contiguous.

3 Click with the Magic Wand tool just above the bell as shown.

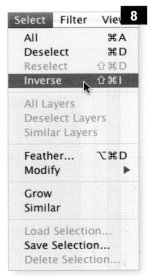

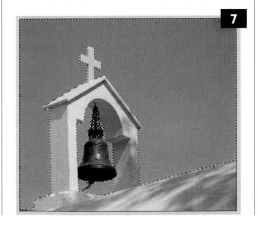

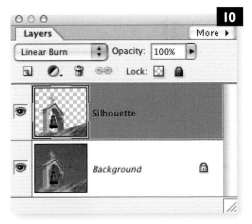

4 This achieves the objective of selecting the bulk of the blue sky. Setting the Tolerance of the Magic Wand and knowing where to click can take some trial and error, but the object is to make the best selection with the minimum of work.

5 The top-right and left corners of the image still have some unselected areas. To add these areas, select the Lasso tool and change the mode to Add to Selection using the Tool Options Bar at the top of the screen.

6 Using the Lasso tool, draw a loop around the unselected area in the top-right corner.

7 Do the same in the top-left corner so the whole blue sky area is selected.

8 Now you can reverse the selection so that the subject becomes the selected object as opposed to the sky. Go to *Select > Inverse*.

9 To copy and paste the selection to a new layer, go to *Layer > New > Layer via copy*. Rename the new layer "Silhouette."

10 The Silhouette layer can now be darkened independently. Change the layer's blend mode to Linear Burn.

CREATING SILHOUETTES

11 Further darkening can now be controlled using a Levels adjustment layer. Using an adjustment layer will allow you edit the amount of darkness at a later stage if you are not happy with it. Go to *Layer > New Adjustment Layer > **Levels**.*

12 Check the box labeled Group With Previous Layer. This ensures the adjustment is only carried out on the current layer.

13 Adjust the black and gray Input sliders to values of 176 and 0.77 respectively. This setting darkens the image without completely blacking it out.

14 Silhouetted objects are often less well defined, so a little blur will simulate this. Make sure the Silhouette layer is active, then go to *Filter > Blur > **Gaussian Blur**.* Apply a blur Radius of 2.7 pixels.

15 Create a new layer between the Background and Silhouette layers and name it "Black." This layer is going to become the new background.

16 Set the foreground and background colors to white and black.

17 Select the Gradient tool and choose the Foreground to Background option from the Gradient drop-down box.

18 Select the Radial gradient option. Make sure the Black layer is active, then drag the Gradient tool from the top of the pointed roof to the bottom-right corner of the image to create the new background. If you don't get the right look just drag the Gradient tool again. The longer the drag, the greater the white area will be.

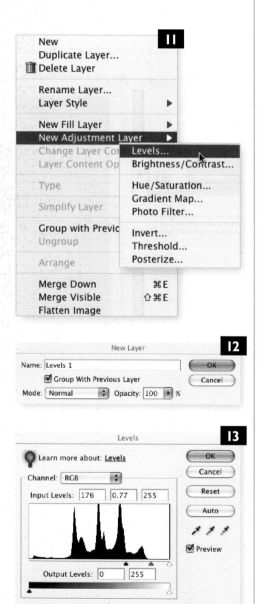

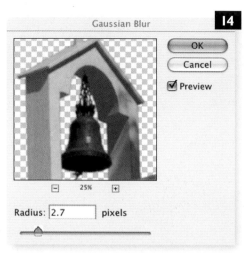

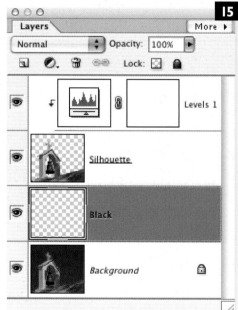

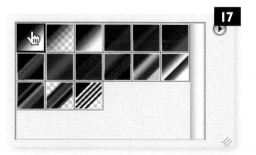

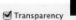

The final image is highly evocative, bringing
to mind famous films, and visions of dusk at
the Alamo. The result is made all the more
striking by its black-and-white nature.

LASER LIGHTS

Ever since that classic moment from early 1960s cinema when a certain British secret agent was strapped to a table and poised to be dismembered by the new, ultra-modern laser beam, we have been fascinated by this still largely mysterious type of light. None more so than the film industry, where the omission of some form of laser device from a science-fiction film would be tantamount to treason. Today lasers are often used at concerts and son et lumières to add sparkle to the event. We'll create just that effect here, with multicolored lasers cutting through the night sky.

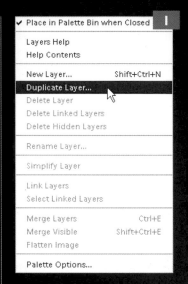

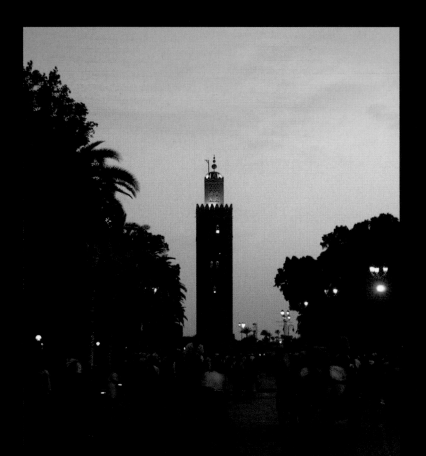

1 For the lasers to look effective, the overall scene needs to be much darker. Duplicate the Background layer by going to the More button in the Layers palette and choosing Duplicate Layer from the flyout menu.

2 Change the duplicate layer's blend mode to Multiply to darken the images.

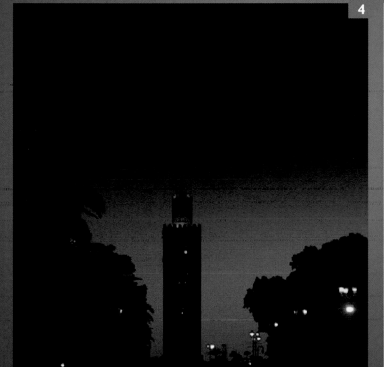

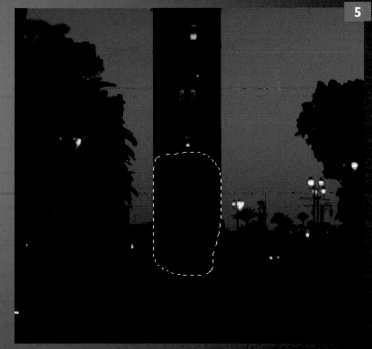

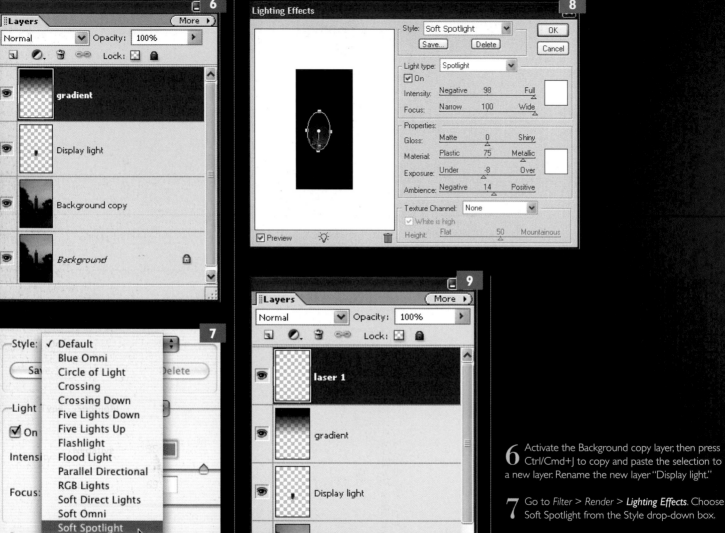

6 Activate the Background copy layer, then press Ctrl/Cmd+J to copy and paste the selection to a new layer. Rename the new layer "Display light."

7 Go to *Filter > Render > **Lighting Effects***. Choose Soft Spotlight from the Style drop-down box.

8 Copy the settings, position, and shape of the light as shown in the example.

9 Now for the lasers. Create a new layer at the top of the Layers palette naming it "laser 1."

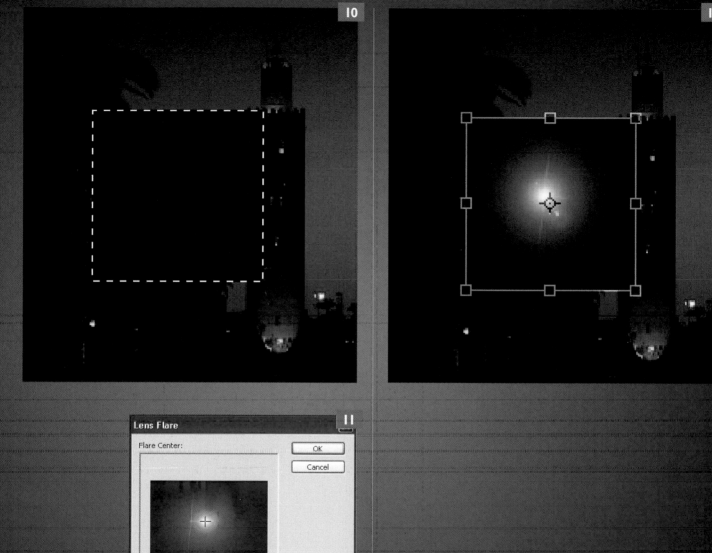

Lens Flare

Flare Center:

OK

Cancel

Brightness: 107 %

Lens Type

○ 50-300mm Zoom
○ 35mm Prime
● 105mm Prime
○ Movie Prime

10 Create a rectangular selection of about 350 pixels square, and fill it with black.

11 Go to *Filter > Render > **Lens Flare***. Use the 105mm lens at a value of 107 percent.

12 Deselect the selection then go to *Image > Transform > **Free Transform*** to bring up the Transform bounding box.

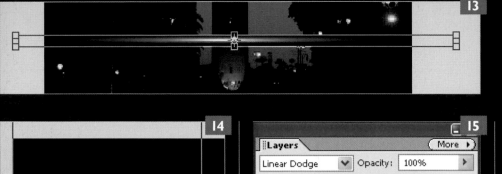

13 Use the side handles to convert the square to a long thin rectangle.

14 Position and rotate the lens flare at an angle on the left of the image. Press Enter/Return to confirm the transformation.

15 Change the layer's blend mode to Linear Dodge to intensify the laser effect.

16 Repeat steps 9 to 15 to create another laser. To change the color of the new laser, go to *Enhance > Adjust color > **Adjust Hue/Saturation**.* Enable the Colorize check box and set the Hue slider to 9 and the Saturation slider to 25.

Create as many new laser lights as required and adjust the colors using the Hue/Saturation command.

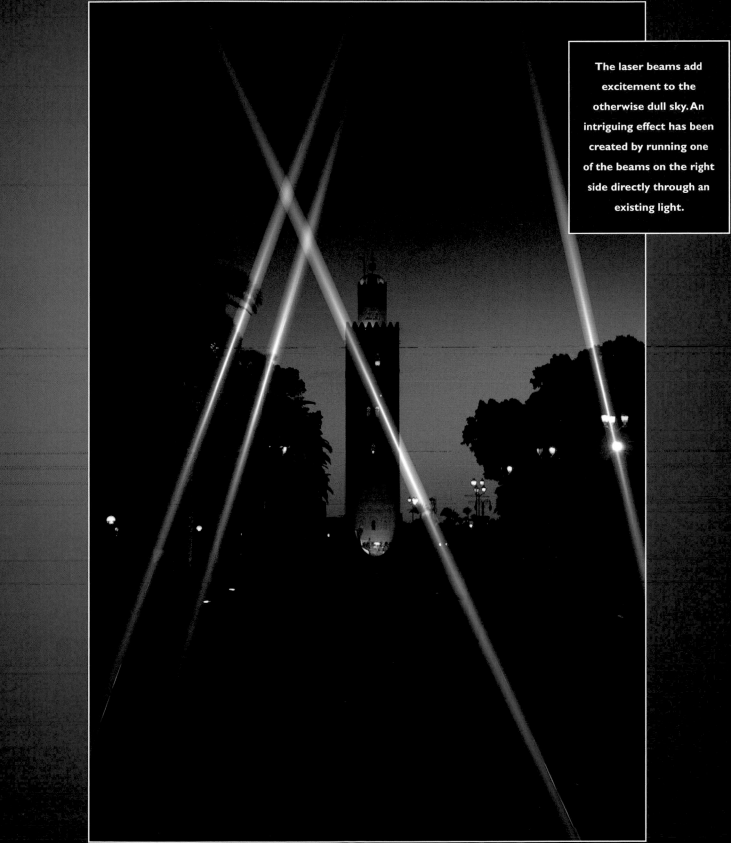

The laser beams add excitement to the otherwise dull sky. An intriguing effect has been created by running one of the beams on the right side directly through an existing light.

GLASS AND REFRACTION

Glass has a curious effect on light as its rays pass through its surface. This is particularly noticeable when the glass is thick or unusually shaped. A typical case in point is the humble spherical paperweight. Hold one up to the light to view a scene through it and the world takes on the perspective of a dreamlike, Alice-in-Wonderland vision where reality is twisted and distorted into a cacophony of wild shapes and colors. In this section we are going to create an image distortion effect as if we were looking through a glass paperweight.

1 The raindrops in this example image will enhance the glass sphere effect that we are creating. Make a circular selection as shown.

2 The selection is going to take on the properties of a glass paperweight. Go to *Filter > Distort > Spherize*. Apply the maximum setting of 100% with the Mode set to normal.

3 To really emphasize the effect, press Ctrl/Cmd+F to repeat the filter at the same settings.

Original image

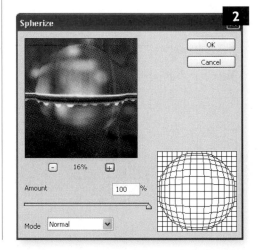

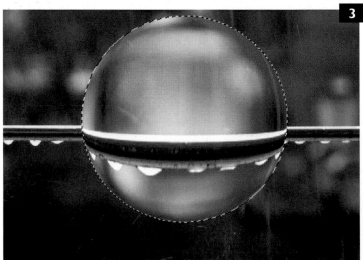

4 The selection it is still required, so keep it active. It will also be called upon later, so the next step is to save it. Go to *Select* > **Save Selection**. Name it "Circle" when the dialog box opens.

5 Create a new layer named "Dark edge."

6 Go to *Select* > **Inverse.** This turns the selection inside out so that the area outside the circle is now selected.

7 Press Ctrl/Cmd+D to bring up the Feather dialog box. Enter a value of 15.

8 Press D on the keyboard to set the default black and white foreground and background colors, then press Alt/Opt+Backspace to fill the selection with black.

9 Deselect the selection (Ctrl/Cmd+D) then load the selection that was saved previously. Go to *Select* > **Load Selection**. Choose the Circle selection and check the Invert checkbox.

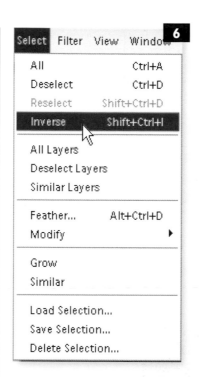

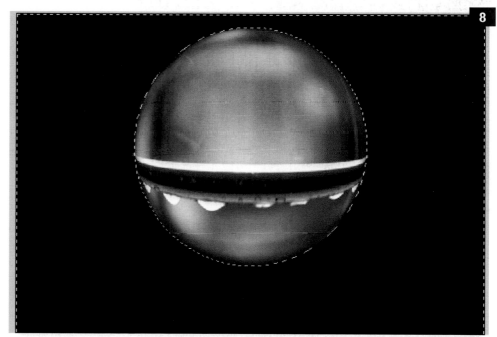

GLASS AND REFRACTION

10 Press the Delete key on the keyboard to remove the black fill on the outside of the circle. The result is a subtly faded dark ring on the inside of the circle. This is typical of the effect seen around the edge of any glass spherical object.

11 For added realism, change the layer's blend mode to Soft Light.

12 To help with the illusion of the reflective qualities of glass, we'll make a semi-transparent gradient. Create a new layer called "Highlights" then make a selection as shown with a 1 pixel Feather.

13 Set up the Gradient tool to use the Foreground to Transparent option and Radial. Make sure white is the foreground color.

14 Drag with the Gradient tool from the bottom-left to the top-right of the selection. Repeat steps 12 to 14 to create a further reflection toward the bottom right of the sphere.

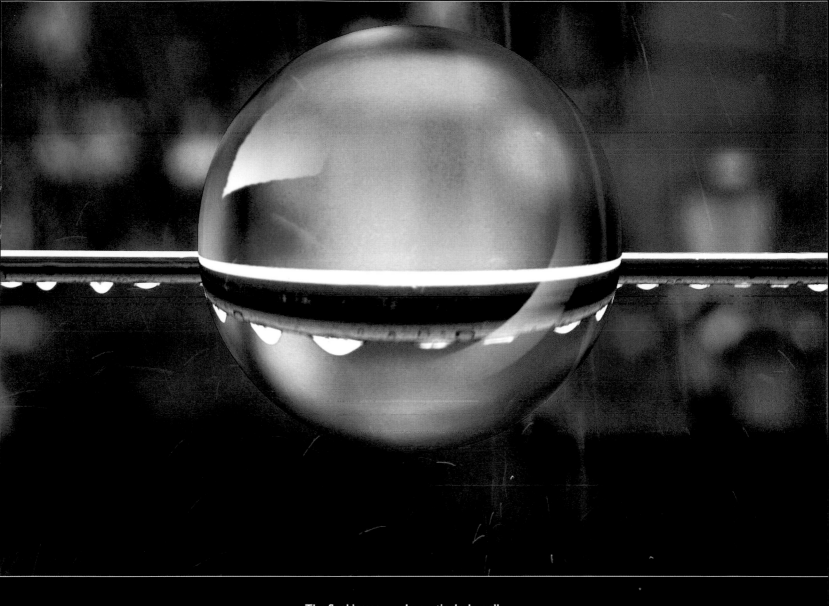

The final image works particularly well
because of the subject matter. The addition
of the new glass sphere effect mirrors the
magnifying effect of the water droplets in
the original photograph.

UNDERWATER LIGHT

Light and color both diminish with depth underwater. As you descend deeper into water, the red, green, and blue wavelengths are absorbed or reflected back in that order, so that the deeper you go, the bluer the scene becomes until you reach a depth at which the light cannot penetrate, leaving you in total darkness. For obvious reasons, we are not going to create a scene at this depth, but we will create one at a depth of about 150 feet. Here, even in warm tropical waters, the scuba diver enters an eerie, deep-blue world that, depending on conditions, can have dramatically reduced visibility.

Original image

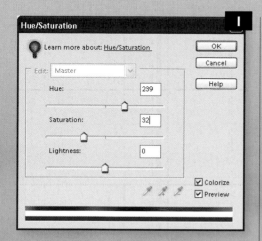

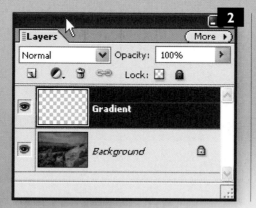

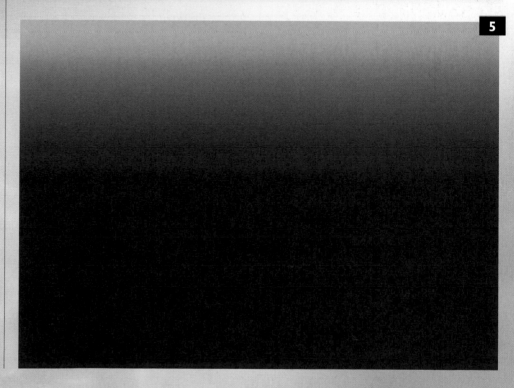

1 Color diminishes as the depth of water increases, so in one step we are going to drain the color from the image and introduce a strong blue cast, characteristic of deep water. Go to *Enhance > Adjust color > **Adjust Hue/Saturation***. Click the Colorize checkbox, then set the Hue slider to 239, and the Saturation slider to 32.

2 Create a new layer and name it "Gradient."

3 Set the foreground color to R: 67, G: 227, B: 229. This is a turquoise color. Set the background color to R: 15, G: 54, B: 112, a deep blue.

4 Choose the Gradient tool, setting its options to Foreground to Background and Linear using the Tool Options Bar at the top of the screen.

5 Drag the Gradient tool from the top of the image to about one third of the way down.

UNDERWATER LIGHT

6 Change the Gradient layer's blend mode to Hard Light.

7 Visibility also suffers when scenes are viewed underwater, so a little blurring is appropriate. Return to the Background layer and go to *Filter > Blur > **Gaussian Blur**.* Apply a setting of 4.0.

8 The classic liquid distortions witnessed underwater can be created by applying a filter that could have been designed specifically for this project. Go to *Filter > Distort > **Wave**.* Copy the settings shown.

9 There is still a little too much clarity in the scene. Double-click the Background layer and rename it "backdrop." Change the layer's Opacity to 46 percent.

10 Underwater, objects a greater distance from the viewer appear less distinct. The original horizon looks too sharp to be realistic, so that needs some selective blurring. Make a selection with a Feather of 20 pixels over the horizon.

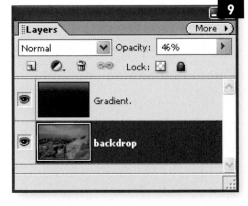

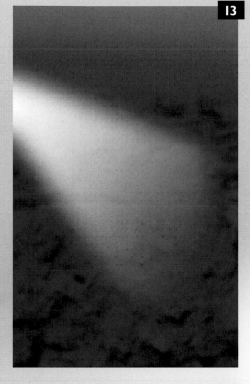

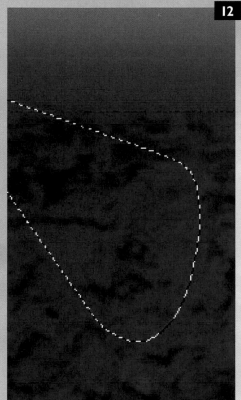

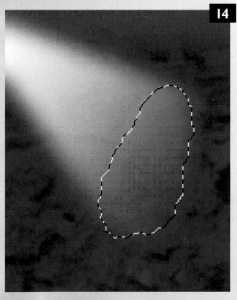

11 Go to *Filter* > *Blur* > **Gaussian Blur**. Apply a Radius setting of 30 pixels.

12 The true colors of objects at depth underwater can only be revealed by illumination with an artificial light. To add some foreground interest you can create an artificial light that is apparently shining onto a deep water organism covering one of the rocks. Create a selection with a Feather of 20 pixels representing the beam of torchlight.

13 On a new layer, drag a White to Transparent linear gradient through the selection, then Deselect the selection.

14 Create another Feathered selection covering part of the rock below the beam of light. This will be the plant organism.

UNDERWATER LIGHT

15 Return to the backdrop layer and press Ctrl/ Cmd+J to copy and paste the selection to a new layer. Rename the new layer "Plant" and position it at the top of the Layers palette.

16 Go to *Enhance > Adjust Color > Adjust Hue/Saturation.* Enable the Colorize check box and change the Hue slider to 353 and the Saturation slider to 29.

17 To create some texture go to *Filter > Artistic > Plastic Wrap.* Copy the settings as shown.

18 Reduce the layer's Opacity to 45 percent.

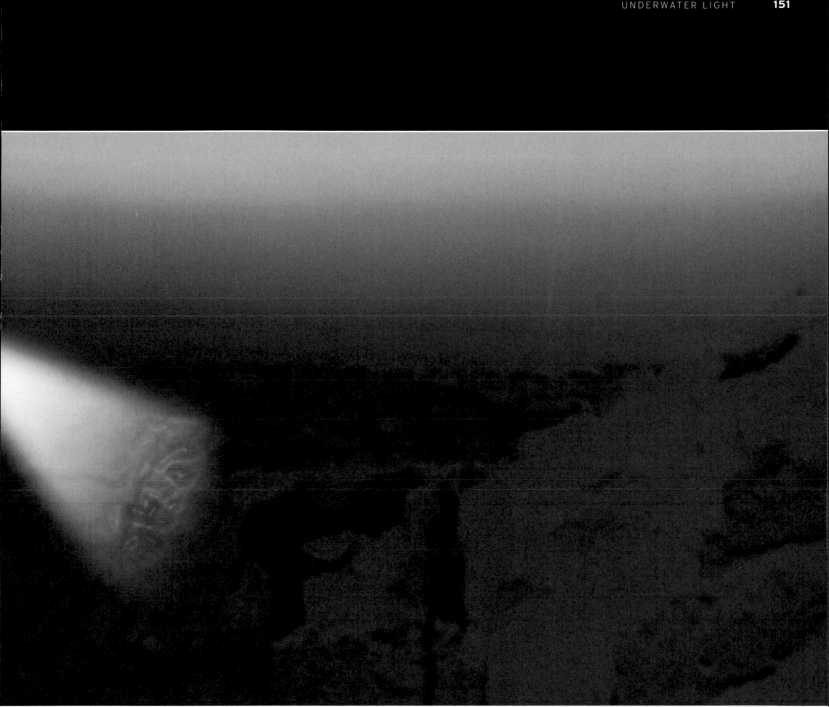

LIGHT TRAILS

Light trails are tell-tale paths of light that record the movement of lit objects as they move through the night. The light source of any car, ship, or plane, when photographed in low light with a slow exposure, will record a continuous light trail through its path of movement until the exposure ends. The darker vehicle will require a greater degree of brightness or a longer exposure time in order to be visible at every stage of its movement throughout the exposure.

1 To simulate an image taken with a camera set to a slow shutter speed, the scene will need to be darkened to depict twilight. Duplicate the Background layer by clicking the More button in the Layers palette and choosing Duplicate Layer.

2 Change the Background copy layer's blend mode to Multiply.

Original image

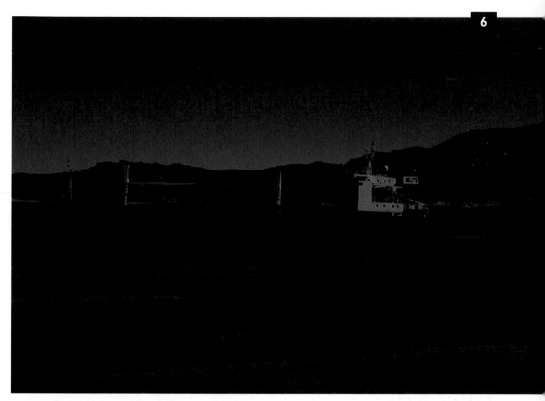

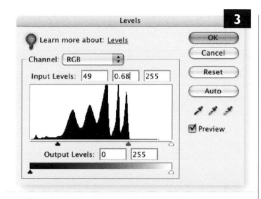

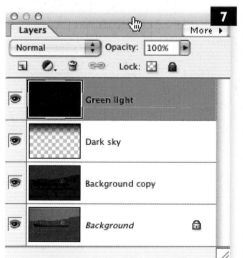

3 Go to *Enhance > Adjust Lighting > **Levels***. Set the black Input slider to 49 and the gray slider to 0.68 to further darken the Background copy layer.

4 Using the Eyedropper tool, sample a dark blue color from the sea.

5 Choose the Gradient tool and set its options to Foreground to Transparent, and Linear.

6 On a new layer named "Dark sky," drag the Gradient tool from the top of the image to about one quarter of the way down.

7 With the twilight scene ready, it's time to create a green starboard light to shine from the boat. Create a new layer named "Green light" and fill the layer with black.

LIGHT TRAILS

8 Go to *Filter > Render > **Lens Flare***. Use the 105mm Prime lens at 20 percent Brightness.

9 To make the light green, go to *Enhance > Adjust Color > **Adjust Hue/Saturation***. Copy the Hue and Saturation settings and enable the Colorize checkbox.

10 Change the Green light layer's blend mode to Screen and reduce its Opacity to 79 percent.

11 Choose the Brush tool, then, using the Tool Options Bar at the top of the screen, select any basic brush. Set the Size to 30 pixels and the Mode to Vivid Light.

12 On the extreme right of the Tool Options Bar, click the More Options button to reveal a flyout with more Brush settings. Set the Spacing to 47 percent and the Fade to 60. This will give the brush stroke a staggered effect reminiscent of a flashing light. The Fade setting will diminish the stroke toward its end, giving the illusion of the light fading away.

13 On a new layer named "light streak" place the Brush over the green light and drag to the left, keeping the Shift key pressed to constrain the stroke to a straight line.

14 Reduce the light streak layer's Opacity to 50 percent. Repeat steps 7 to 14 to create a red port light and a white navigation light to finish the image.

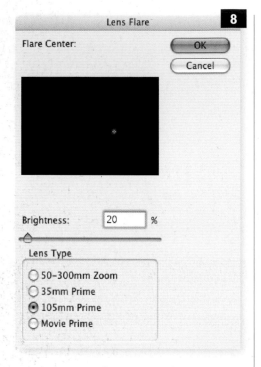

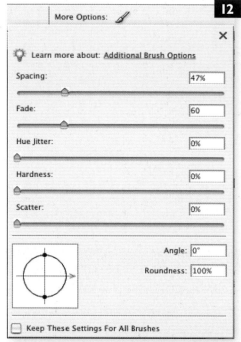

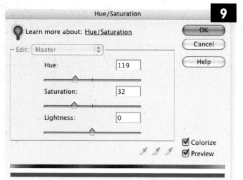

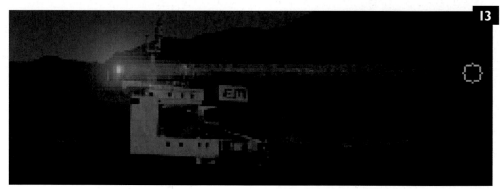

**The final image gives a good impression
of movement over time. Compared to the
static original, there is now a greater sense
of atmosphere in the photograph.**

SOLAR ECLIPSE

The rare spectacle that is a full solar eclipse is a sought-after photographic prize and enthusiasts travel across the globe to witness these awe-inspiring events. If the next one is just too far into the future, or if you are a bit of an armchair solar-eclipse admirer, then you can recreate the effect in Elements.

The example image used here was slightly over-exposed at the time of shooting because this will help to create the eerie, unique light quality that accompanies a full solar eclipse.

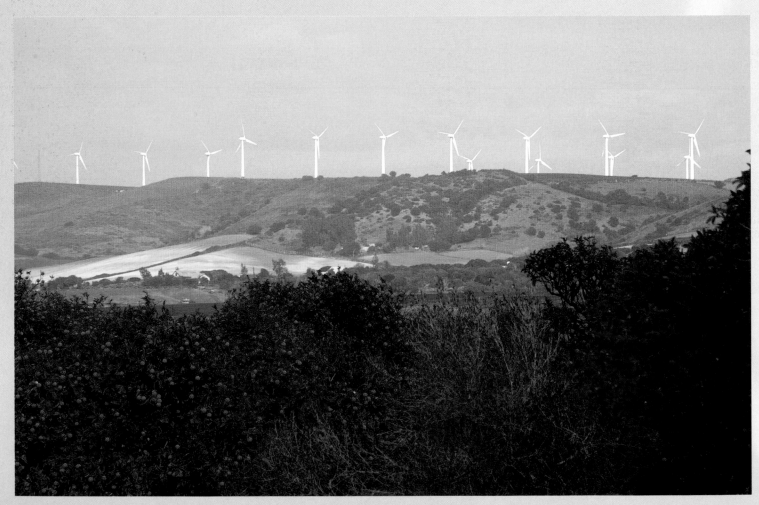

Original image

Solid Color...
Gradient...
Pattern...

Levels...
Brightness/Contrast...

Hue/Saturation...
Gradient Map...
Photo Filter...

Invert
Threshold...
Posterize...

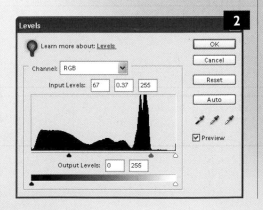

Levels

Learn more about: Levels

Channel: RGB

Input Levels: 67 0.37 255

Output Levels: 0 255

OK
Cancel
Reset
Auto

☑ Preview

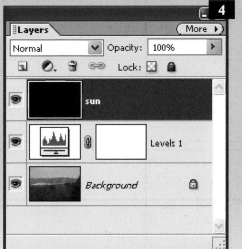

Layers More ▶

Normal Opacity: 100%

Lock:

sun

Levels 1

Background

1 Create a Levels adjustment layer by clicking the Create adjustment layer icon at the top of the Layers palette.

2 Copy the settings for the black and gray Input sliders. shown here

3 This setting gives a good rendition of the unusual lighting characteristics of a solar eclipse at the moment when the sun reappears after total darkness.

4 Create a new layer named "Sun," and fill the layer with black.

SOLAR ECLIPSE

5 To create the sun, go to *Filter > Render > Lens Flare*.

6 Apply the 105mm Prime setting at 100 percent.

7 To hide the black area, change the Sun layer's blend mode to Screen.

8 The radiance of the sun needs to be reduced. Add a Levels adjustment layer to the Sun layer, but this time use the menu command *Layer > New Adjustment Layer > Levels*.

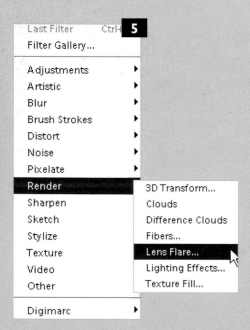

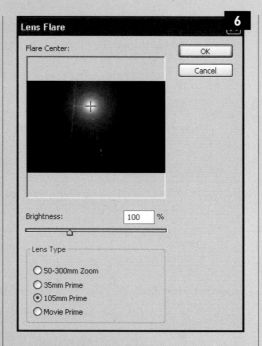

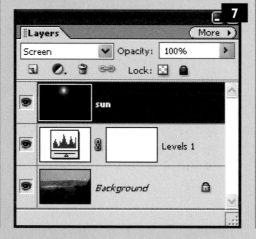

9 Enable the checkbox labeled Group with Previous Layer in the New Layer dialog box that appears. This makes sure that the adjustment will only affect the Sun layer, and not the Background layer.

10 Set the black Input slider to 56 and the gray slider to 0.63 in the Levels dialog box.

11 The Lens Flare filter may have created some extra traces of light designed to reproduce the effect of pointing a camera lens at the sun. This is undesirable for this image. To remove the extra lights, make sure the Sun layer is active and use the Brush tool to paint them out with black.

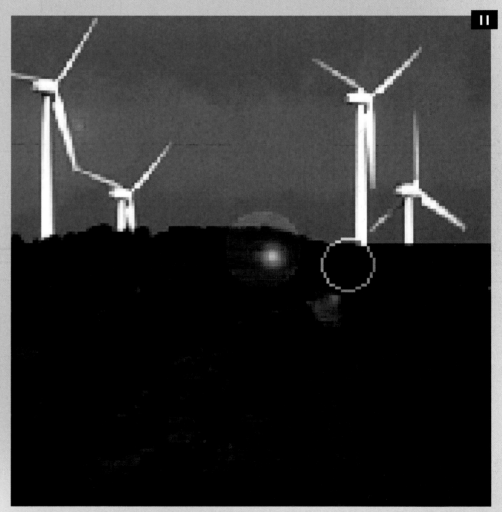

SOLAR ECLIPSE

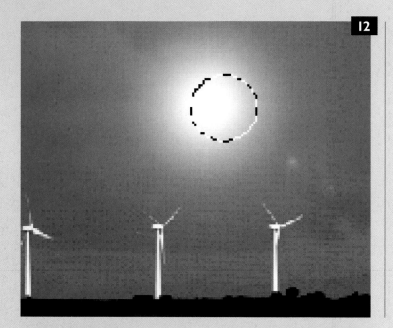

12 For the eclipse itself, create a circular selection with a Feather of 12 pixels over the sun. Make the selection a little smaller than the sun and place it slightly to one side.

13 Create a new layer called "Eclipse" at the top of the Layers palette.

14 Fill the selection with black.

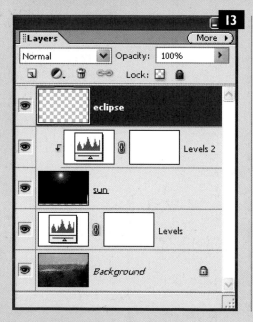

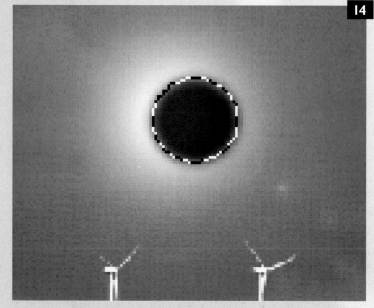

15 Deselect the selection, then reduce the Eclipse layer's Opacity to 77 percent.

16 At this stage of an eclipse, a crescent of light sometimes appears as the sun reemerges. This is the final element that needs to be created. Make a square selection of about 500 pixels.

17 Create a new layer called "crescent" and fill the selection with black. Deselect the selection.

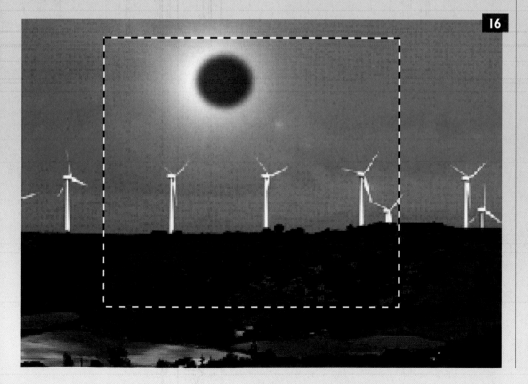

SOLAR ECLIPSE

18 Go to *Filter > Render > Lens Flare*. Use the 105mm Prime lens at 100 percent. Click in the middle of the Preview window to place the flare.

19 Go to *Image > Transform > Free Transform*. Drag the bounding box handles to reshape the square to a long, thin rectangle. Press the Enter/Return key to confirm the transformation.

20 To bend the shape, go to *Filter > Distort > Polar Coordinates*. Click the Rectangular to Polar radio button.

21 Press Ctrl/Cmd+T to bring up the Free Transform dialog box. Drag the bounding box handles to shape, rotate, and position the crescent as shown in the example.

22 Change the crescent layer's blend mode to Linear Dodge to give it an illuminated effect and complete the image.

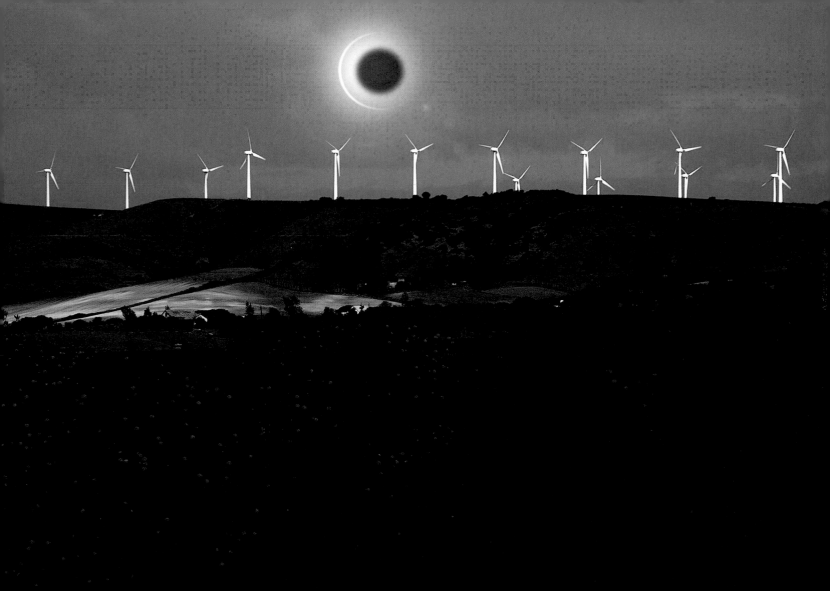

RADIOACTIVE GLOW

It's a safe bet that anyone planning to incorporate a radioactive glow into their image will definitely not be using the real thing, so a Photoshop Elements imitation is the only option. Here, we'll take a light-hearted approach to the subject, creating a "potent" aftershave.

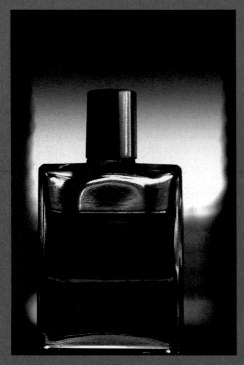

Original image

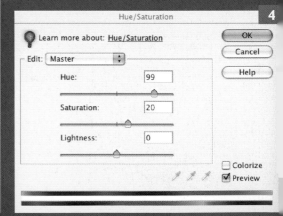

1 Make a selection of the blue central area of the bottle with a Feather of 20 pixels.

2 Go to *Layer > New > **Layer via copy*** to copy and paste the selection to a new layer. Rename the new layer "Inner glow."

3 Go to *Filter > Adjustments > **Invert**.* This creates a negative version of the layer.

4 The glow looks good but a better color would make the radioactivity more obvious. Go to *Enhance > Adjust Color > **Adjust Hue/Saturation**,* then set the sliders as shown in the example.

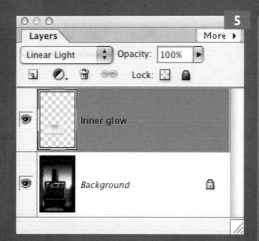

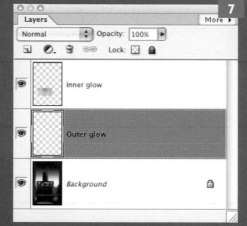

5 Change the Inner glow layer's blend mode to Linear Light.

6 Create a rectangular selection as shown with a Feather of 40 pixels.

7 Create a new layer that is positioned between the Background and Inner glow layers. Name this new layer "Outer glow."

8 Using the Eyedropper tool, sample a color from the brightest blue/green in the image.

9 Now click the foreground color square in the Toolbox to open the Color Picker and pick a paler shade than the one that was sampled. This makes sure the outer glow matches the base color.

RADIOACTIVE GLOW

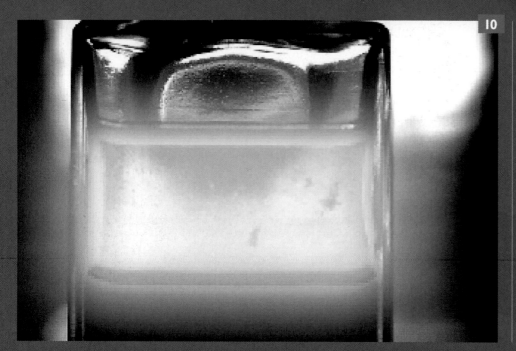

10 Fill the selection with the new color.

11 Change the layer's blend mode to Pin Light and use the layer's Opacity to define the strength of the glow. Try a fairly lethal dosage of 76 percent.

12 As it would be dangerous to leave such hazardous material unlabeled, open an appropriate skull image and drag it into the working image. Position the layer at the top of the Layers palette.

Finally, type the word "RADIATION" below the skull. The font used here is called "Stencil."

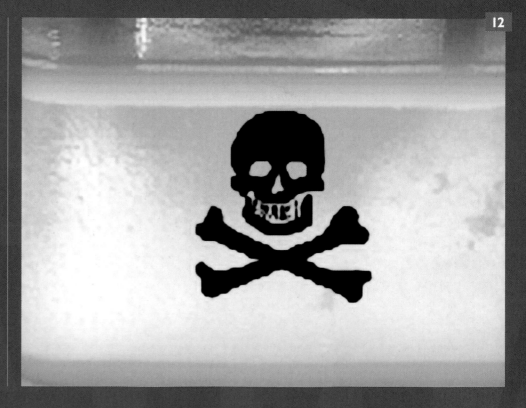

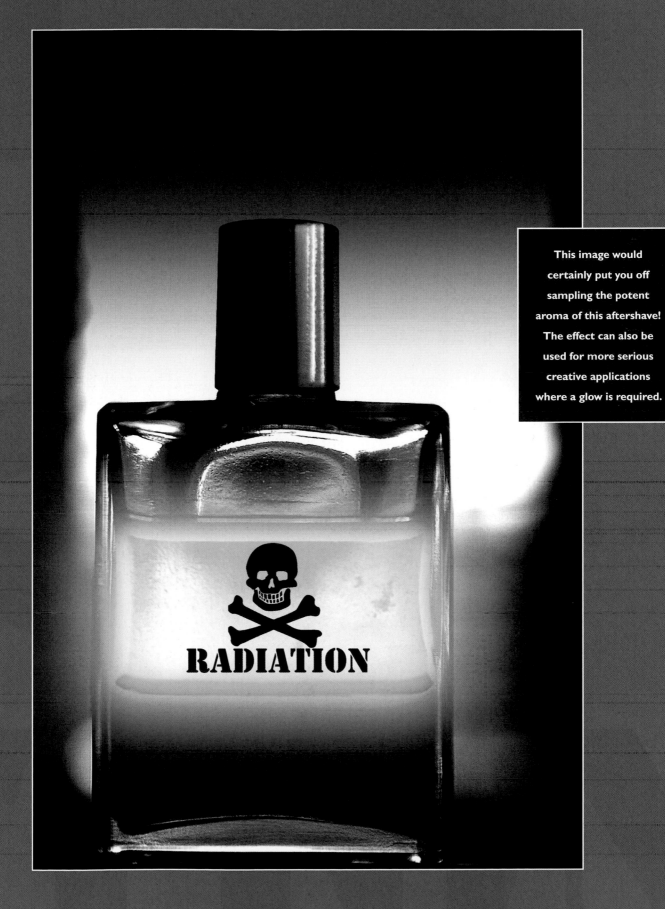

This image would certainly put you off sampling the potent aroma of this aftershave! The effect can also be used for more serious creative applications where a glow is required.

STARRY SKY

It is a sad fact that cities and star-filled skies do not sit comfortably together. The amount of light pollution generated over most cities makes starry vistas a rare sight in built-up areas. If you venture out to more desolate landscapes the stars may appear, but you could find it difficult to locate suitable landmarks for scale and composition. Photoshop Elements offers a variety of techniques for generating your own star-studded skies. In this section we'll work through a technique that lets you not only create your own stars, but also allows you to effortlessly customize their density to suit your photographic needs.

1 Using the Magic Wand tool, select the dark lower area of the image. Go to *Select* > **Invert** to reverse the selection.

2 Create a new layer named "Stars."

3 Fill the layer with black, then go to *Filter* > *Noise* > **Add Noise**. Apply an Amount of 35 percent using Gaussian Distribution and checking Monochromatic.

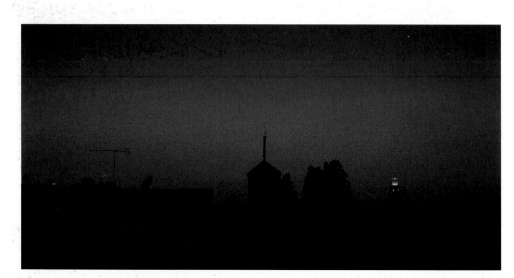

Original image

4 Blurring the effect will soften the edges. Go to *Filter > Blur > **Gaussian Blur***. Use a setting of 0.3 pixels.

5 To control the amount of stars, go to *Filter > Adjustments > **Threshold***. Apply a value of 129.

6 Change the Stars layer's blend mode to Screen so that the black area becomes hidden.

7 A real star field would diminish nearer to the horizon. To simulate this, make a rectangular selection over the lower part of the image with a Feather of 100 pixels.

8 Make sure the Stars layer is active, then press the Delete key on your keyboard. Press Ctrl/Cmd+D to deselect.

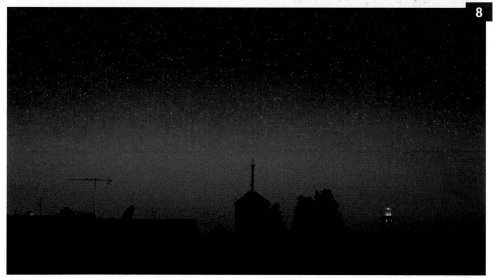

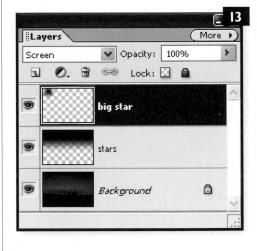

STARRY SKY

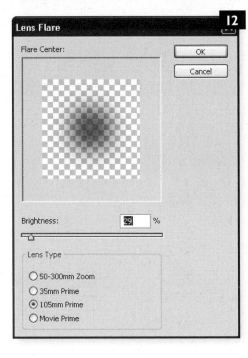

9 There are always a few larger dominant stars in the night sky. We'll use a different effect for these bigger stars. Make a new layer called "big star."

10 Make a rectangular selection with a Feather of 50 pixels somewhere in the sky.

11 Fill the selection with black.

12 Go to *Filter* > *Render* > **Lens Flare**. Use the 105mm Prime lens at 29 percent. Click in the middle of the black area in the Preview window.

13 Change the big star layer's blend mode to Screen. Repeat steps 9 to 13 to create as many big stars as you require. Consider using different sizes to create some variety in the sky.

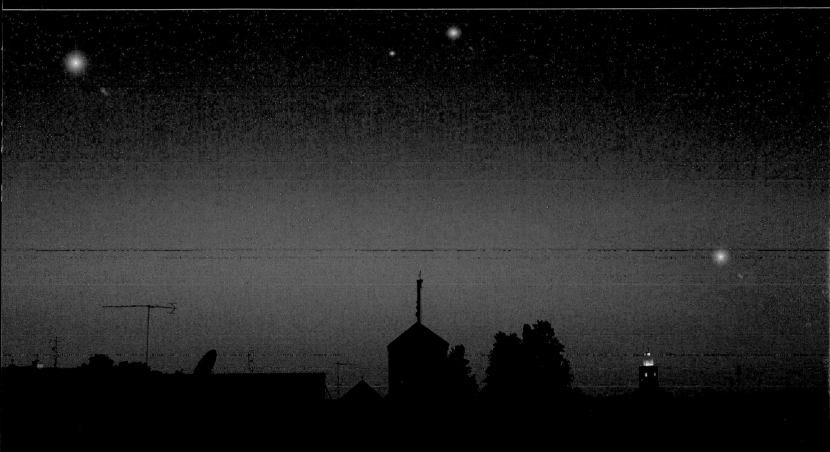

PRECIOUS METALS

If you have ever wondered if it is possible to create a photographic-quality image without any actual photographic elements, here is the answer. Using only some Photoshop Elements tools that are more commonly used for enhancing actual photographs, we will create a 3D object with a shiny gold finish.

1 Create a new blank document by going to *File > New > Blank File.* Enter the document dimensions as shown in the example.

2 Choose the Horizontal Type tool and type the word "GOLD" in uppercase characters. Use any large, bold font at a size that nearly fills the image window. The font used here is Eras bold ITC.

3 If the Styles and Effects palette is not open, go to *Window > Styles and Effects* to reveal it. Choose Layer Styles and Wow Chrome from the drop-down boxes at the top of the palette.
 Click the thumbnail in the top-left corner of the palette named Wow-Chrome Beveled Edge.

4 This action applies the style to the text layer. The default settings can be farther customized in order to emphasize the effect. Double-click the "f" icon of the text layer in the Layers palette.

5 Enter a value of 35 using the Bevel Size slider.

6 In order to apply additional effects to the text, we have to simplify it so it is no longer text but a simple collection of pixels. In the text layer, right-click the "f" icon if you are using a PC or press the Control key and click the "f" if you are on a Mac, then choose Simplify Layer.

7 To give the gold more brilliance, you need to lighten the image a little. Go to *Enhance > Adjust lighting > **Levels**.* Adjust the gray Input slider to 1.06 and the white slider to 133.

8 Now for the color. Go to *Enhance > Adjust Color > **Adjust Hue/Saturation**.* Enable the Colorize check box, then set the Hue slider to 54 and the Saturation slider to 49.

PRECIOUS METALS

SILVER[9]

Silver—Hue: 189, Saturation: 15

COPPER

Copper—Hue: 25, Saturation: 50

BRASS

Brass—Hue: 42, Saturation: 60

9 Experiment with the Hue and Saturation settings to make different kinds of metals. Alternatively, push the Saturation higher to make highly polished and rounded gemstones. You could just leave the image uncolored to produce silver, but we've added a touch of blue here.

10 For the background, use the Eyedropper tool to sample a middle tone color from the gold text.

11 The sampled color will appear in the Toolbox as the foreground color. Next, set the background color to white.

12 Pick the Gradient tool, and set it to the Foreground to Background option, and the gradient type to Reflected. Drag the gradient through the Background layer at an angle.

The final result is a photorealistic
representation of a metallic material.
The effect doesn't have to be used on
text, it can be applied to other objects
to create different materials.

Lighting
and weather

CREATING SUNSETS FROM DAYLIGHT

Sunsets are perhaps the most attractive time of day from the point of view of the photographer. The richness and warmth of the colors as the sun sinks to the horizon can transform an otherwise ordinary scene into one that gives a classic photographic opportunity. Unfortunately, sunsets are also one of the most fleeting times of day, so we'll look at recreating one in Elements here.

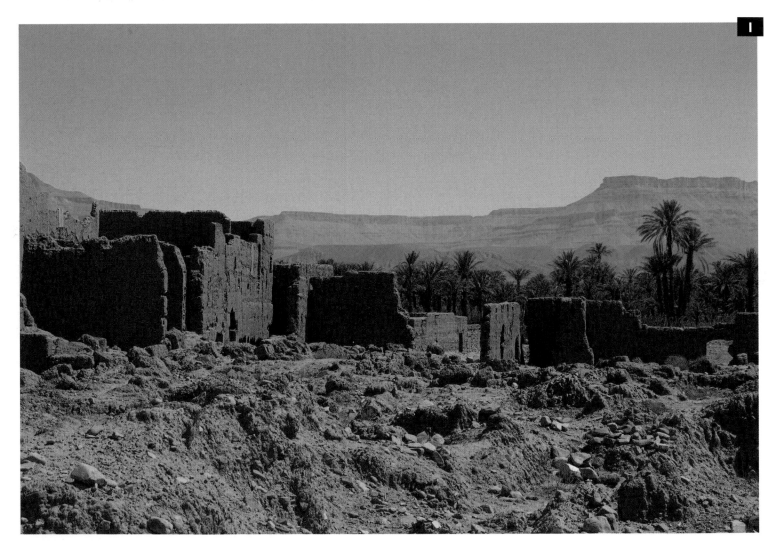

1 This photograph was taken at midday and the quality of light clearly reflects this. In order to make the fake sunset convincing, the overall colors of the image need to be warmed to depict the red and orange tones that would be in evidence later in the day.

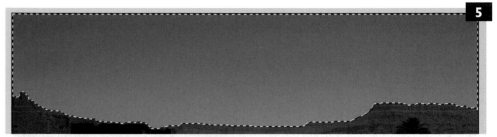

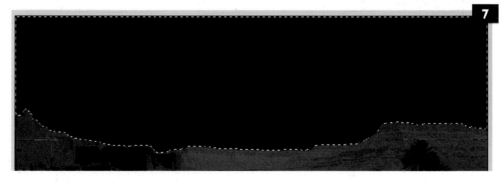

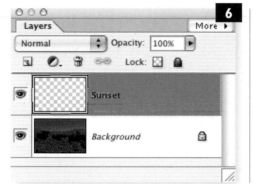

2 Go to *Enhance* > *Adjust Lighting* > **Levels**. First, adjust the black and gray Input sliders as shown. This has the effect of darkening the image.

3 From the Levels Channel drop down box, choose the Red channel and adjust the white slider to a value of 244. This introduces a warm red to the scene.

4 Finally, choose the Blue channel and adjust all the sliders to the values displayed in the example. These settings darken the image further while generating a warm yellow light.

5 Using the Magic Wand tool, make a selection of the sky.

6 Create a new layer and name it "Sunset."

7 Fill the selection with black, then deselect the selection by pressing Ctrl/Cmd+D.

CREATING SUNSETS FROM DAYLIGHT

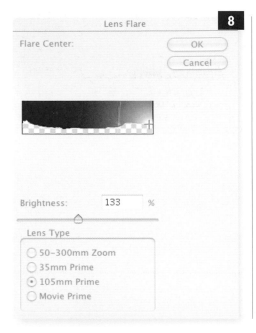

8 The black selection will be used as the base for the sunset effect. The method we are going to use utilizes the Lens Flare filter. This filter can only be applied to a pixel-based area and not transparent areas, hence the need for the black fill. Go to *Filter > Render > Lens Flare*. Choose the settings as shown, clicking to place the flare in the bottom-right corner of the black-filled area.

9 Of course we can no longer see the original sky because the black hides it, but this can be easily fixed by using a layer blend mode. Choose Screen from the Sunset layer's blend mode drop-down box at the top of the Layers palette. This serves to hide the black areas of the layer revealing only the bright areas of flare.

10 We've now made a convincing sun, but it still looks too early in the day.

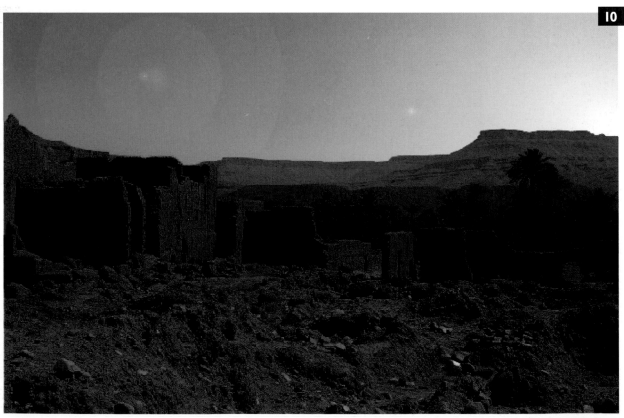

11 Again, use Levels to generate a deeper colored, late-in-the-day sun. Make sure the Sunset layer is active and press Ctrl/Cmd+L to bring up the Levels dialog box. First adjust the black slider to a value of 72.

12 Now use the Channel drop-down menu to access the Red channel and adjust the white Input slider to 200. This adds a red glow to the light.

13 Lastly, choose the Blue channel and adjust the gray Input slider to 0.10 to increase the yellow content of the image.

14 At this stage the sunset is sufficiently realistic, but the mountains that the sun is apparently sinking behind show too much detail. The proximity of a real sun would create a strong silhouette effect.

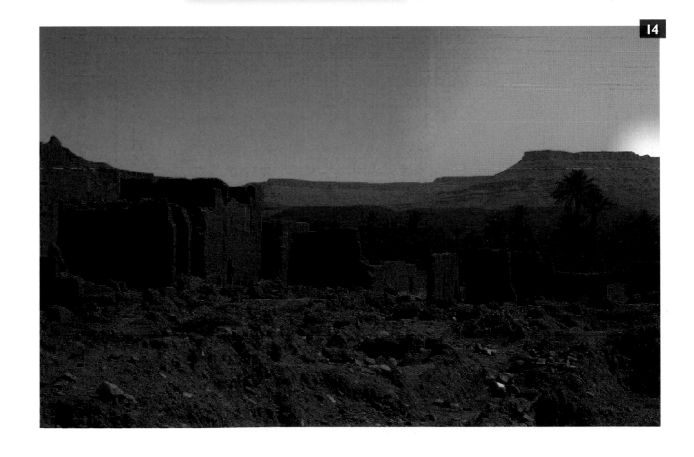

CREATING SUNSETS FROM DAYLIGHT

15 Burning some shadow into the mountain area will solve the problem, but first a selection of the area in which to work is required. Hold down the Ctrl/Cmd key and click the Sunset layer in the Layers palette to load its selection.

16 The loaded selection can now be inverted to provide access to the lower area of the image. To invert the selection, press Ctrl/Cmd+Shift+I.

17 Select the Dodge tool from the Toolbox.

18 Apply the settings shown in the Tool Options Bar at the top of the screen. This creates a subtle effect that will be more convincing.

19 Make sure the Background layer is selected and use the Dodge tool to brush over the mountains. You don't need to worry about inadvertently darkening the sky because the inverted selection we have loaded will protect the sky area. For realism it is better to make several subtle passes with the Dodge tool rather than one heavy sweep.

MAKING SUNNY DAYS FROM GRAY DAYS

The vagaries of the weather can wreak havoc with your photographic schedule. Fate sometimes decrees that the day you choose to go on a landscape photography shoot with the intention of capturing blue skies and bright sun is the day the weather decides to deliver you a dull, nondescript washout. Don't be deterred! With a few crafty Photoshop Elements techniques you can create high summer any time you like.

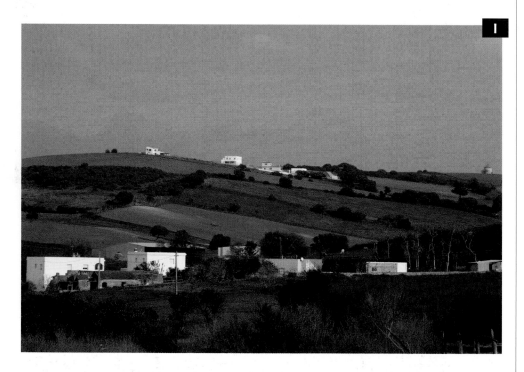

1 The first thing to do is flatten the sky in order to remove the clouds, leaving a blank canvas over which the sunny sky can be created.

2 Using the Magic Wand tool at its default setting, click in the sky to select it. Shift+ click any outstanding areas to add them to the selection if required.

3 Open the Levels dialog box and adjust the gray Input slider to 2.26 and the white slider to 174.

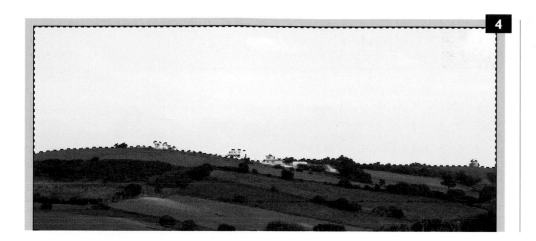

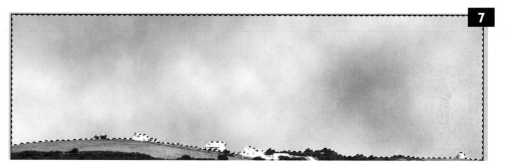

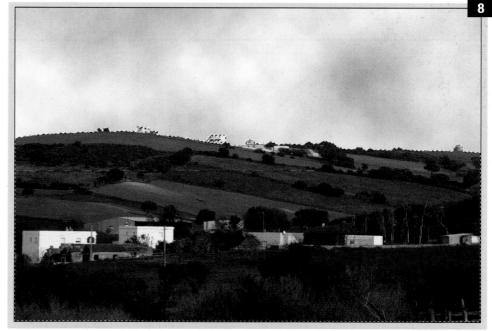

4 These settings remove most of the detail that was present in the sky.

5 Create a new layer called "Sky."

6 Choose a blue color that is reminiscent of a sunny day as the foreground color, and white as the background color.

7 Go to *Filter* > *Render* > **Clouds**.

8 It isn't necessary to change the color of the sky any more, but the land will be changed radically so you can simply reuse the selection that is still live. Go to *Select* > **Inverse** to reverse it.

MAKING SUNNY DAYS FROM GRAY DAYS

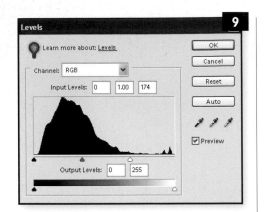

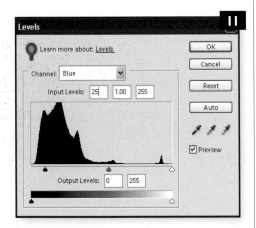

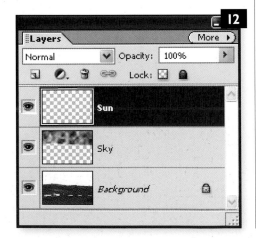

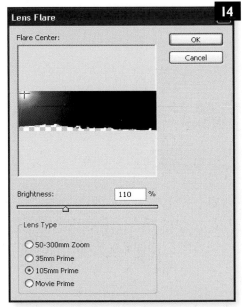

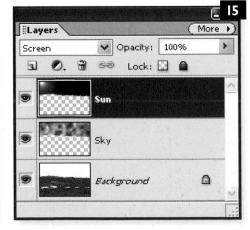

9 Return to the Background layer and go to *Enhance > Adjust Lighting > **Levels***. Adjust the white Input slider to 174. This lightens the selected part of the image.

10 Staying in Levels, click the Channel drop-down box and choose the Blue channel.

11 Adjusting the black slider will add more yellow to the image. Drag the black slider to about 25. You can also adjust the value by eye until you generate just the right amount of warm yellow.

12 Invert the selection again (Ctrl/Cmd+I), and make a new layer at the top of the layer stack named "Sun."

13 Fill the selection on the Sun layer with black.

14 To add the sun, go to *Filter > Render > **Lens Flare***. Choose the 105mm Prime lens at 110 percent. Click in the top-left corner of the Preview window to position the sun.

15 To hide the black area of the layer, change the Sun layer's blend mode to Screen. The selection can now be deselected. Reduce the Sky layer's Opacity to about 35 percent for more subtlety.

DRAMATIC SKIES

The sky is potentially the photographer's most versatile tool. It acts as a highly effective backdrop, and it is the greatest light source you could ever hope for, offering everything from softly diffused lighting to harsh direct light with unlimited intensity. But perhaps its most intriguing incarnation is when it is used as the main subject of a photograph. Here it performs all these roles in one, providing the backdrop, the lighting, and the desirably photogenic subject. In this section we are going to take a sky image with lots of potential and boost it into an even more dramatic offering.

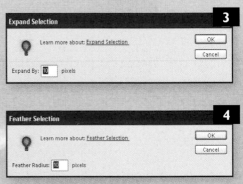

1 A lot of the information needed to create a dramatic sky is already present in this image, but it needs to be selected in order to enhance it.

2 Using the Magic Wand tool with a Tolerance of 10, click the darkest area of the cloud.

3 The selection needs to be expanded to pick up a few more slightly lighter shades of the cloud. Go to *Select > Modify > **Expand**.* Enter a value of 10.

4 Next, the selection should be feathered to avoid hard and obvious edges appearing in the final piece. Go to *Select > **Feather**,* and enter a value of 10.

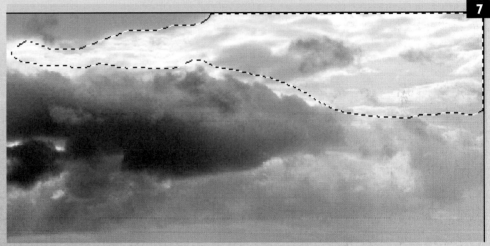

5 Press Ctrl/Cmd+J to copy and paste the selection to a new layer. Name the new layer "dark clouds."

6 Change the dark clouds layer's blend mode to Linear Light.

7 Make another selection in the top right corner. Use the Lasso tool to do this with a Feather of 25.

8 Once complete, this selection should be copied and pasted to a new layer; return to the Background layer and press Ctrl/Cmd+J. Name the layer "top corner."

DRAMATIC SKIES

9 Change the top corner layer's blend mode to Multiply. Deselect the selection.

10 The final selection needs to be made below the main cloud base. There is a natural area of light here that can be enhanced. Using the Lasso tool again, make a selection and Feather it with a value of 30 pixels.

11 Return to the Background layer and press Ctrl/Cmd+J. Name the layer "natural light" and change the layer's blend mode to Vivid Light,

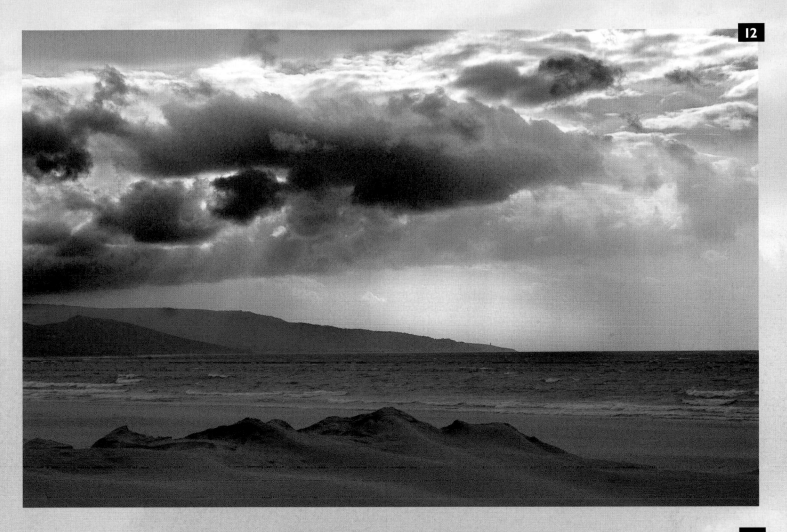

12

12 At this stage the image should already look much more dramatic, but we're not finished yet!

13 To heighten the drama we will create some sunbursts that appear to emerge from behind the dark cloud. Use the Polygonal Lasso tool with a Feather of 15 and create a selection as shown.

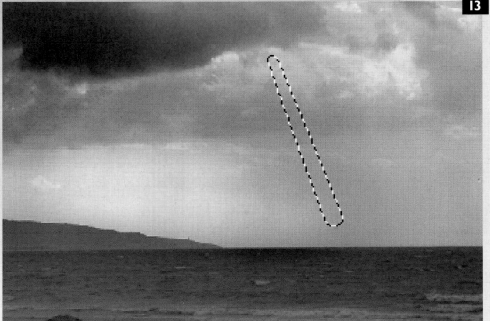

13

DRAMATIC SKIES

14

15

17

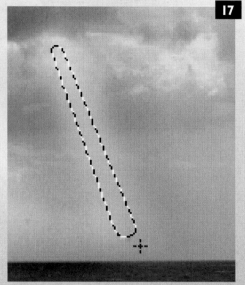

18

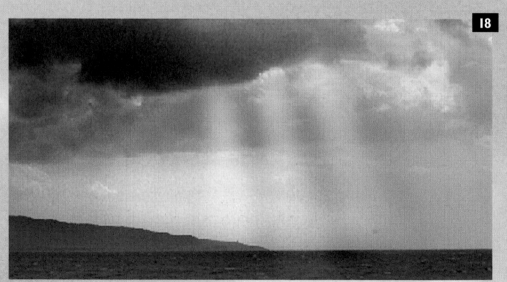

16

19

14 Create a new layer named "sunray" above the Background layer.

15 Using the Eyedropper tool, sample a pale yellow color from the top right of the image.

16 Select the Gradient tool and choose the Linear and Foreground to Transparent settings from the Tool Options Bar.

17 Drag the gradient through the selection you made in step 13.

18 Create two more sunbeams in the same way.

19 Finally, a slight darkening to the overall image will add some more impact. Activate the Background layer then press Ctrl/Cmd+L to bring up the Levels dialog box. Adjust the gray Input slider to 0.97.

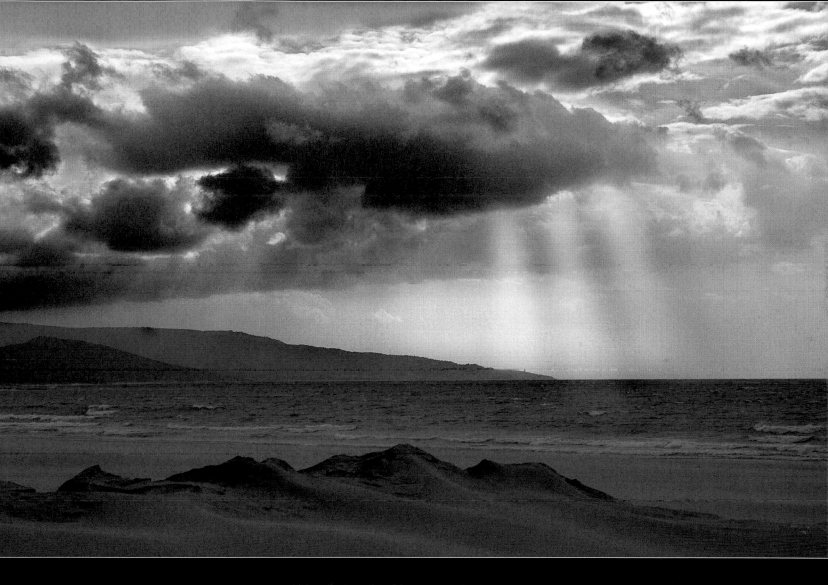

Although the original image contained some
drama, the final result is bursting with the
tension created by the enhanced light and
dark tones in the photograph.

LIGHTNING

Photographing lightning is almost always a hit-and-miss affair. Mother nature—not known for her patience as a photographic subject—is notorious for putting on the show of a lifetime just as you are still struggling with the lens cover. Luckily, creating your own lightning in Photoshop Elements is relatively easy. All you need is a good photograph to start with.

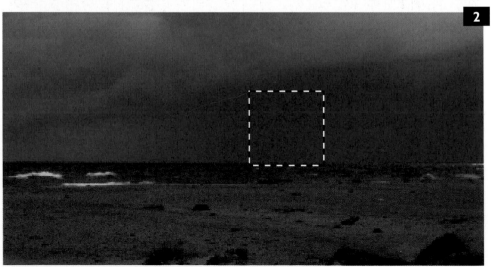

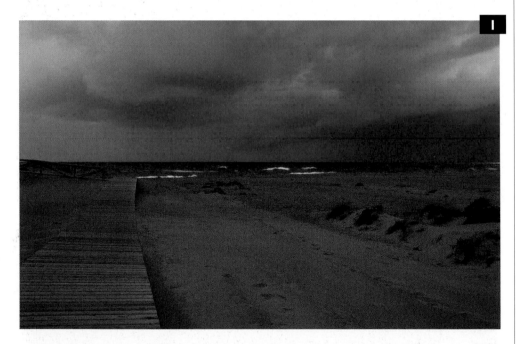

1 As with so many simulated effects, the choice of image is critical to the success of the project. This coastal scene has all the ingredients for a lightning storm: a heavy, dark sky; angry threatening clouds; and a broad area of empty horizon to act as a stage.

2 Using the Rectangular Marquee tool, make a rectangle selection roughly over the area where the lightning is going to appear.

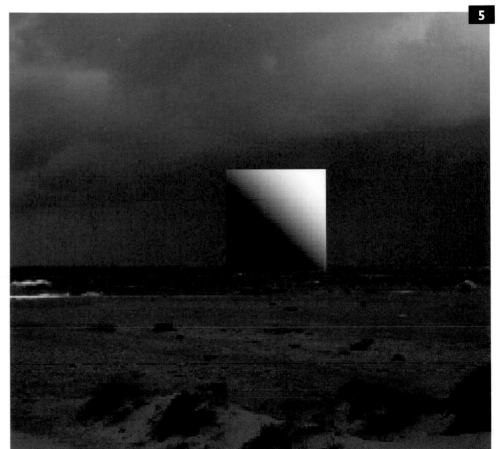

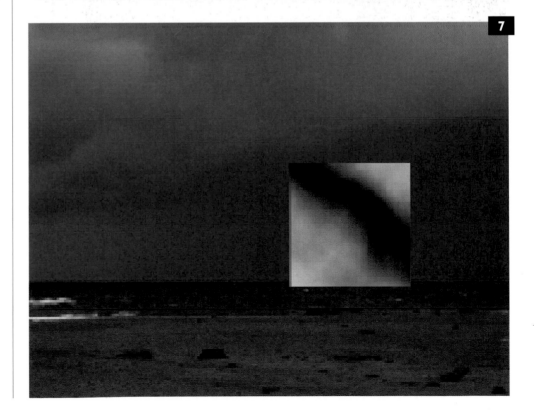

3 Select the Gradient tool and choose a Black to White Linear gradient from the Gradient drop-down box in the top-left corner of the screen.

4 Create a new layer and name it "Lightning."

5 With the Lightning layer active, drag the gradient through the rectangular selection at roughly a 45 degree angle, then deselect the selection by pressing Ctrl/Cmd+D.

6 Make sure the Toolbox colors are set to their default of black and white.

7 To begin the process of converting the rectangular gradient into a streak of lightning, go to *Filter* > *Render* > **Difference clouds**. The aim is to produce a thin streak in the cloud.

LIGHTNING

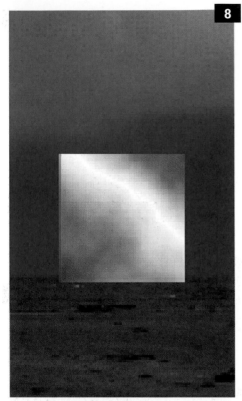

8 The lightning needs to be pale, so the first thing to do is invert the gradient colors. Go to *Filter > Adjustments > **Invert.***

9 Go to *Enhance > Adjust Lighting > **Levels.*** The bolt of lightning will be developed by creating extreme contrast between black and white. Adjust the black and gray Input sliders to values of 140 and 0.22 respectively.

10 The result is a fine streak, but there is still a black rectangle that needs to be removed.

11 Change the Lightning layer's blend mode to Color Dodge. This removes the black area.

12 Lightning can appear as a variety of colors, from white and yellow through to blue and purple. We are going to create something in the blue to purple area that will produce a strong electric glow when combined with the Color Dodge blend mode that was applied in the previous step. Go to *Enhance > Adjust color > **Adjust Hue/Saturation.*** Click the Colorize checkbox in the bottom-right corner of the dialog box, then set the Hue and Saturation sliders to 290 and 34 respectively.

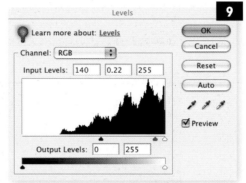

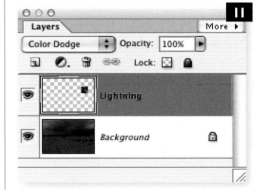

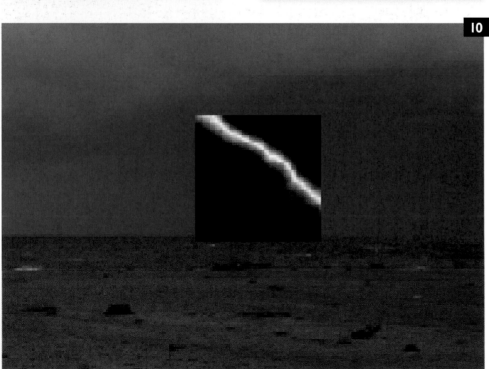

13 Press Ctrl/Cmd+T to bring up the Transform bounding box. Place the cursor near one of the corner handles and rotate the lightning so that it is almost vertical to the ground. Press the Enter/Return key to confirm the transformation.

14 Use the Eraser tool with a low Opacity setting to remove the area that overlaps the horizon and also to taper the top end of the lightning.

15 Reproduce steps 2 to 14 to create additional bolts. Alternatively the lightning can be duplicated by keeping the Alt key pressed and then clicking and dragging the lightning to a different part of the screen using the Move tool. This will duplicate the lightning onto a new layer. The size and angle of each lightning streak can be adjusted by going to *Image > Transform > **Free Transform***, or pressing Ctrl/Cmd+T as in step 13.

16 Once you have created all of the desired lightning bolts, they needed to be blended into the scene. To put the lightning in context, some additional reflective lighting is required. The first step is to create a subtle burst of light at the cloud base that connects with the lightning. Select the Lasso tool and set the Feather to 50 to make a soft edge.

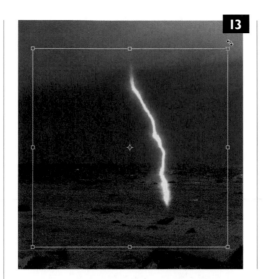

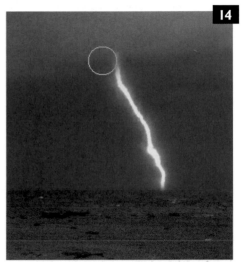

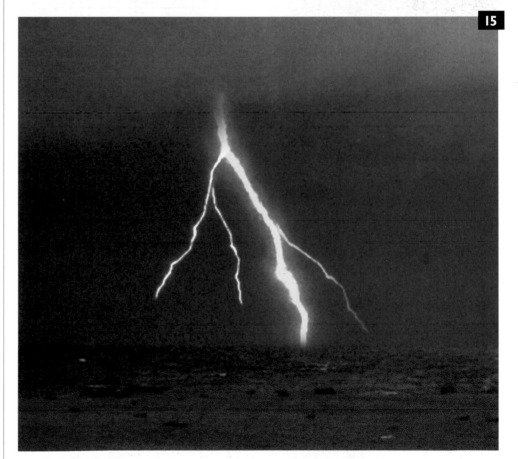

LIGHTNING

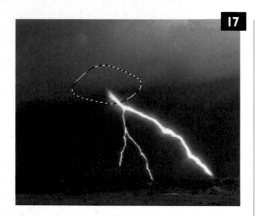

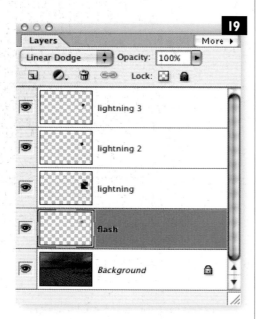

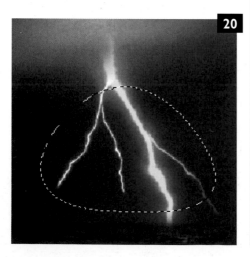

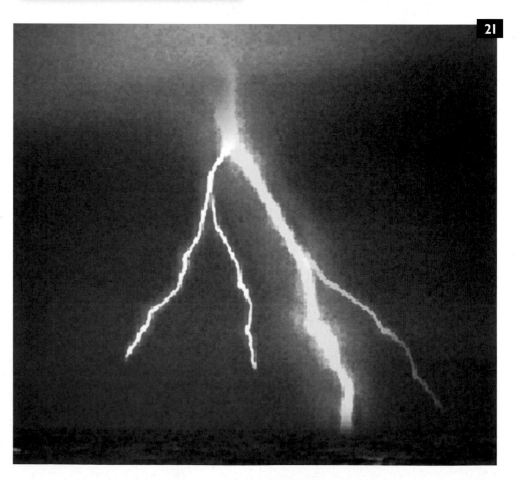

17 Make a rough selection with the Lasso tool at the cloud end of the lightning.

18 Click the Background layer to activate it because this is the layer that we are going to copy from. Press Ctrl/Cmd+J to copy and paste the selection onto a new layer. Rename this new layer "flash." The new layer will automatically be above the Background layer.

19 Change the flash layer's blend mode to Linear Dodge.

20 Create a Lasso selection with a Feather of 40 pixels roughly around the area of the lightning.

21 Repeat step 18 naming the new layer "flash2." As before, change the new layer's blend mode to Linear Dodge.

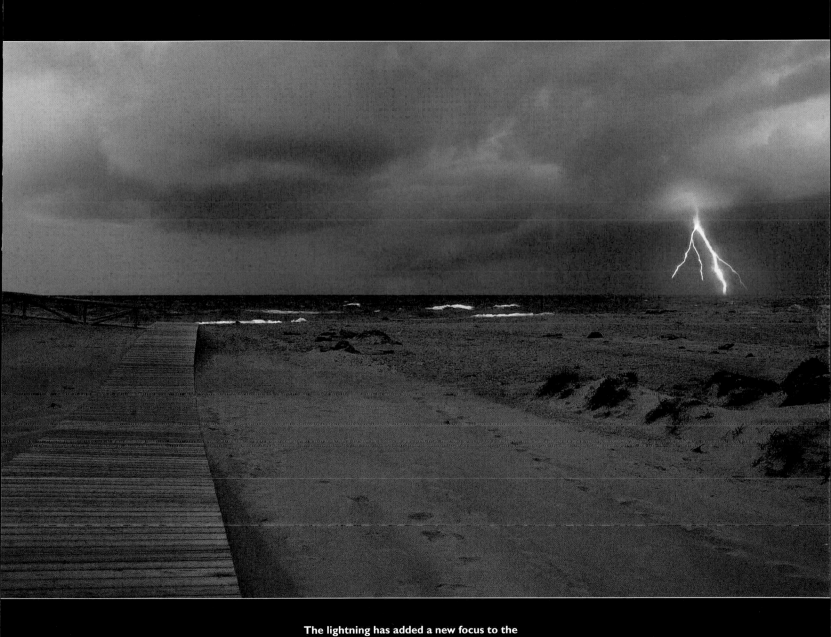

The lightning has added a new focus to the
scene. Before, there was a brooding sky with
the threat of storms to come; now, with the
fresh menace of the lightning, the storm is
already upon us.

RAINBOWS

One of nature's most fascinating atmospheric phenomena is also one of the trickiest to photograph successfully. Many rainbows only appear for fleeting moments, rarely giving the photographer time to find a good vantage point for composition. Add to this the fact that the camera is pointing at the sky, making exposure tricky if the colors are to be captured accurately without plunging the landscape into shadow. Perhaps this is why there is a ready-made rainbow gradient in Photoshop Elements. Here, however, we'll take things one step farther and add some customization for added realism, and to avoid that overdone computer filter look.

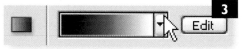

1 This ominous, wet, inky blue sky mixed with bright sunlight is exactly the kind of place you'd expect to find a rainbow. In fact, a rainbow did appear shortly after this photograph was taken, but we'll see if we can beat the real thing.

2 Create a new layer named "rainbow."

3 Select the Gradient tool from the Toolbox, then click the Gradient drop-down box in the top-left corner of the screen.

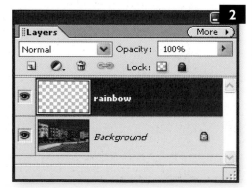

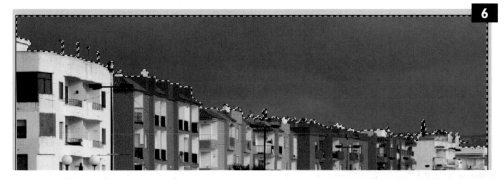

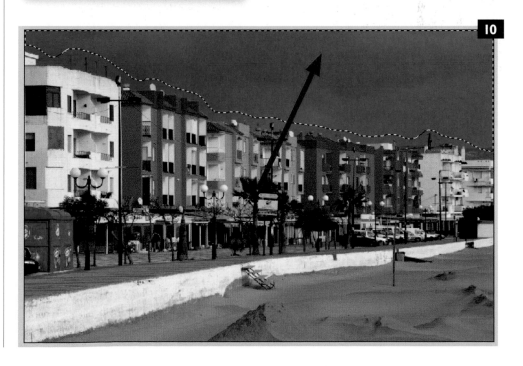

4 Click the pop-up menu button in the top corner of the Gradient palette and choose "Special Effects" from the flyout menu.

5 The Special Effects palette contains a gradient called Russell's Rainbow. Click the thumbnail to select it.

6 Before drawing a rainbow with the gradient, a selection needs to be made to define the area in which the rainbow will appear. Rainbows often fade away at one or both ends, and we can make this happen automatically. Activate the Background layer, then select the Magic Wand tool and click the sky area.

7 By contracting the selection, the rainbow can be made to fade out at the edges. Go to *Select > Modify > **Contract***. Enter 25 in the dialog box.

8 Feathering the selection will help the illusion by softening the edges. Go to *Select > **Feather***. Enter a value of 25.

9 Return to the rainbow layer. Select the Gradient tool, making sure the Radial option is chosen.

10 Drag across the image with the Gradient tool as shown.

RAINBOWS

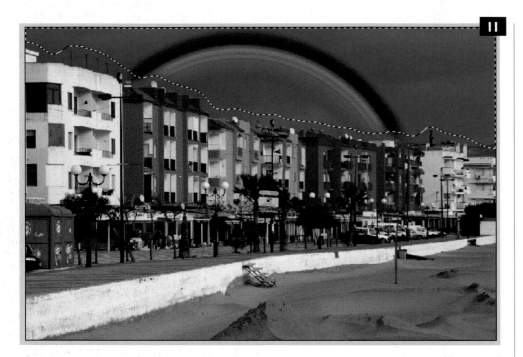

11 This is how the rainbow should look. If yours is very different, just press Ctrl/Cmd+Z to undo it and drag again. Once you are happy with the look, deselect the selection by pressing Ctrl/Cmd+D.

12 As it stands, this rainbow wouldn't fool anyone and it needs tweaking to make it look more realistic. Change the rainbow layer's blend mode to Screen and reduce the layer's Opacity to 40 percent.

13 To dampen down the colors a little, go to *Enhance > Adjust color > **Adjust Hue/Saturation**.* Enter a value of -55 in the Saturation box.

14 The final step is to add some blur to really blend the rainbow into the sky. Go to *Filter > Blur > **Gaussian Blur**.* Enter a Radius of 21 pixels.

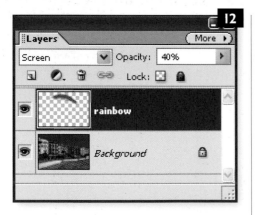

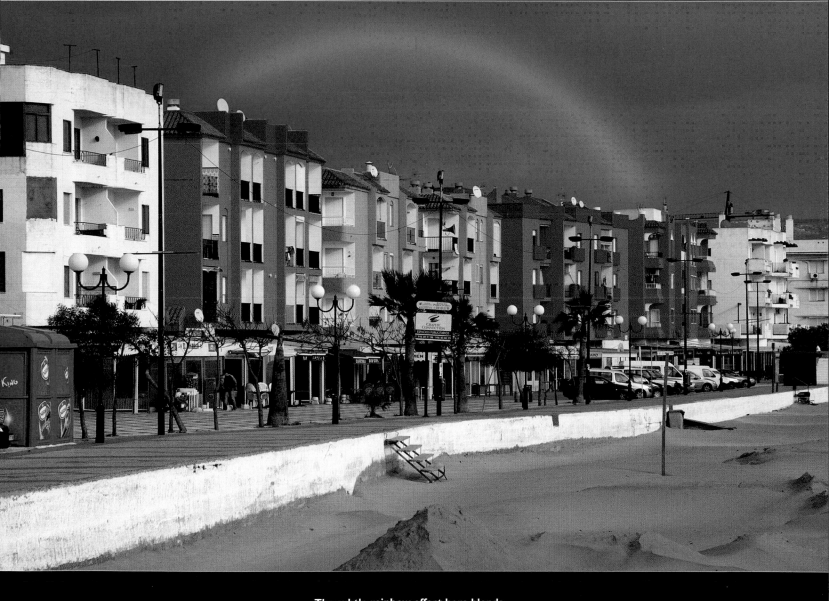

The subtle rainbow effect here blends
perfectly into the sky, and is much more
effective than a stronger rainbow would be.

HEAT HAZE

The classic heat haze, distinguished by wavy, glass-like distortions, can appear anywhere where hotter air and cooler air come together. Typical places for this phenomenon to manifest itself are just above a road on a hot summer's day, or near the spout of a boiling kettle. The air is less dense where it is cooler, and this gives it a lower refractive index than hotter air. Essentially, as light passes through air of different refractive indices we see it bend, accounting for the signature shimmering effect.

Original image

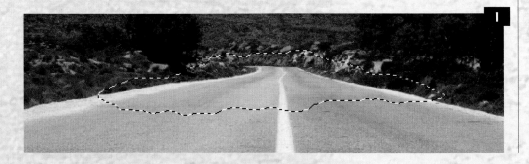

1 This empty road is the perfect place to apply the heat haze effect. Using the Lasso tool, create a selection over the surface of the road.

2 To avoid any harsh edges the selection needs to be Feathered. This will have the effect of softening the edge. Go to *Select > Feather*.

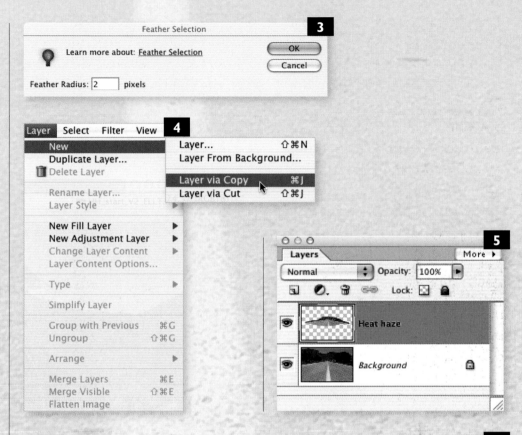

3 Enter a value of 2 in the numeric box. The amount of Feather applied will create a different result depending on the resolution of the image. The value used will have a greater effect on low-resolution images than it will have on high-resolution images.

4 The selected area can now be copied and pasted to a new layer. Go to *Layer > New > Layer via Copy*, or press Ctrl/Cmd+J.

5 Rename the copied layer "Heat haze."

6 Now the Heat haze layer can be distorted using one of Photoshop Elements' built-in filters: go to *Filter > Distort > Ocean Ripple*. You can be quite creative here and make the adjustments by eye using your own judgement based on the kind of effect you are trying to achieve. The Preview window shows you just the selected area, removing any guesswork.

HEAT HAZE

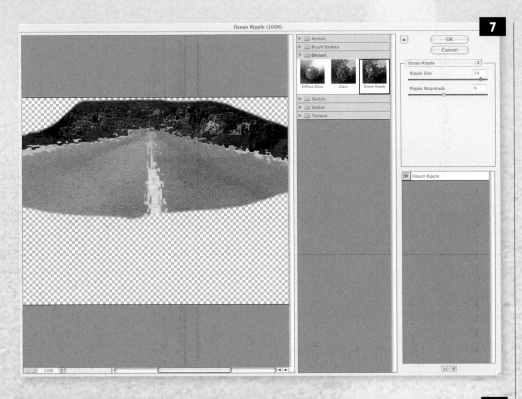

7 In this scene, we'll attempt to create a watery look without breaking up the image too much. The danger of using filters is that they can look false and too computerized. A setting of 14 for the Ripple Size and 9 for the Ripple Magnitude achieves just the right blend.

8 The Ripple filter has managed to achieve the glassy, watery effect so characteristic of heat hazes, but it is a little too distinct to be convincing.

9 The finishing touch is to blur the selection. Go to *Filter > Blur > **Gaussian Blur***. Enter a Radius setting of 1.0 pixels.

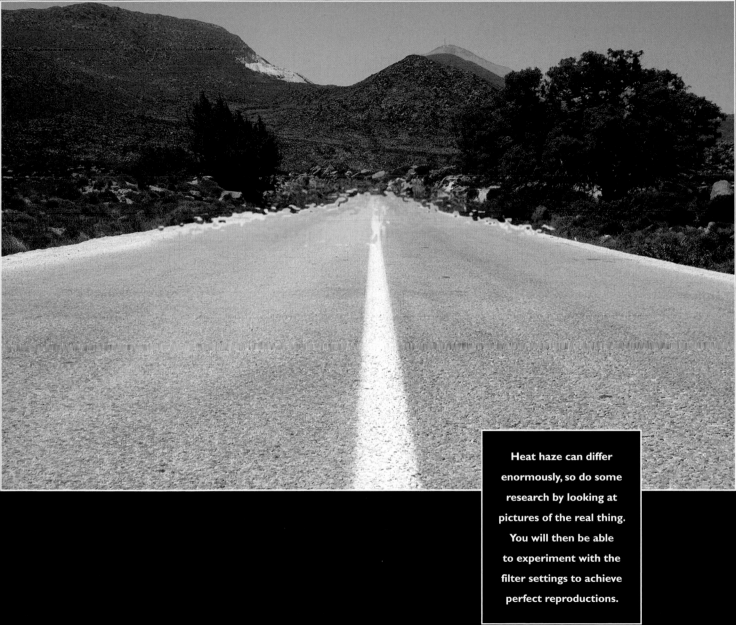

Heat haze can differ
enormously, so do some
research by looking at
pictures of the real thing.
You will then be able
to experiment with the
filter settings to achieve
perfect reproductions.

FOG

Foggy days might at first glance seem to be good days to put the camera away and do something else. Why struggle to compose an image when visibility ends somewhere just ahead of your nose? In fact, there is a great reason to brave the cold and fog with your camera at the ready: atmosphere. Nothing is more enigmatic, tantalizing, or hypnotic than the swirling mist that drapes itself over every element of a scene. Whether your photograph depicts the dark, winding streets of Victorian London or the great lakes of a vast continent at dawn, it will be dramatically transformed by a carefully rendered cloak of digital fog.

Original image

1 Fog has the effect of draining the color from a scene, so the first task is to reduce the intensity of the color. Go to *Enhance* > *Adjust Color* > **Adjust Hue/Saturation**. Reduce the Saturation slider to -56.

2 There is still a certain warmth to the image, but most foggy days are cooler, and a colder light would be evident. To replicate this go to *Filter* > *Adjustments* > **Photo Filter**. Click the color square to access the Color Picker to choose a customized color.

3 Choose a pale blue color, then click OK to close the Color Picker.

4 Apply the color at 50 percent Density.

5 Contrast is the next casualty of fog. The realism will be enhanced by having less definition in the image. Go to *Enhance > Adjust Lighting > **Levels***. Drag the black Output slider to 92 and the white one to 165. Adjusting the Output sliders in Levels has the effect of reducing contrast, as opposed to the more commonly used Input sliders that increase contrast.

6 The versatile Clouds filter can be used to create the familiar patchiness associated with fog. First set up the foreground and background colors to be white and mid blue.

7 Create a new layer and name it "fog."

8 Go to *Filter > Render > **Clouds***.

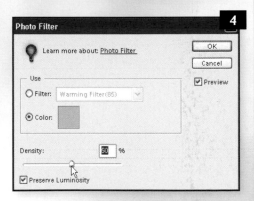

FOG

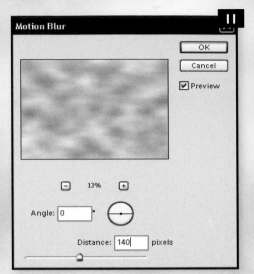

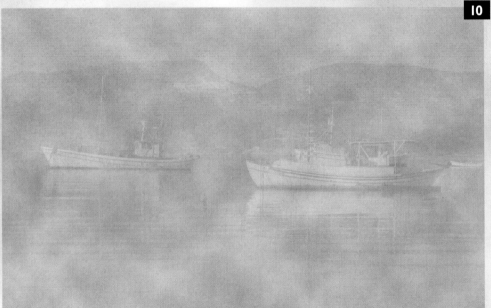

9 Obviously the result is a bit too heavy and the scene has been completely lost. Change the fog layer's blend mode to Screen and reduce the layer's Opacity to 60 percent.

10 Fog has a variety of manifestations. This technique has created a particularly patchy variety.

11 This works fine, but if you are looking for a finer, less well-defined fog, then one more trick is required. Go to *Filter > Blur > **Motion Blur**.* Set the Angle to 0 degrees and the Distance to 140 pixels.

12 The thing that makes the current state of the scene less than realistic is the clarity of the distant hills. For this density of fog, distant objects would be far less distinct than they currently are. Create a new layer and call it "distant mist."

13 Select a very pale blue for the foreground color.

14 Pick the Gradient tool, then choose the Foreground to Transparent and Linear options in the Tool Options Bar at the top of the screen.
 Using the Gradient tool, drag from the top of the image to about one quarter of the way down to cover the mountain area.

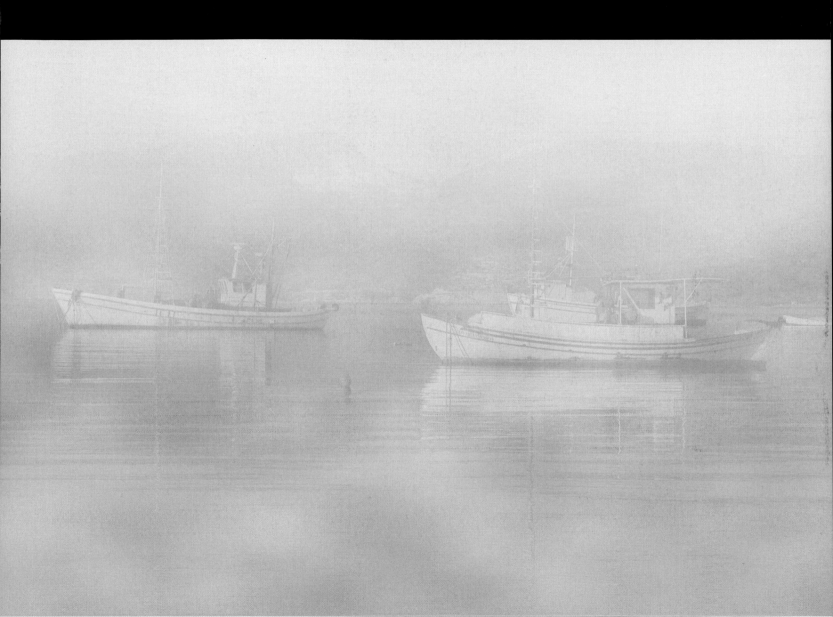

Reference

GLOSSARY

additive colors The color model describing the primary colors of transmitted light: red, green, and blue (RGB). Additive colors can be mixed to form all other colors in photographic reproduction and computer display monitors.

adjustment layer Adjustment layers give you the ability to make non-destructive tonal or color adjustments to underlying image layers. The majority of the usual command-based adjustments are available as adjustment layers, such as Levels, Curves, and Hue/Saturation. The advantages of adjustment layers are twofold. First, you can make adjustments to an image without permanently affecting the layers below, and further adjustments can be made at any point during image-editing by simply double-clicking the adjustment layer in the Layers palette.

alpha channel A place where information regarding the transparency of a pixel is kept. In image files this is a separate channel—in addition to the three RGB channels—where selection "masks" are stored.

anti-aliasing A technique of optically eliminating the jagged effect of bitmapped images or text reproduced on monitors. This is achieved by blending the color at the edges of the object with its background by averaging the colors of the range of pixels involved.

artifact Any flaw in a digital image, such as noise. Most artifacts are undesirable, although adding noise can create a grainy texture, if desired.

background The area of an image upon which the principal subject, or foreground, sits.

bit A commonly used acronym for binary digit, the smallest piece of information a computer can use.

bit depth The number of bits assigned to each pixel on a monitor, scanner, or image file. One-bit, for example, will only produce black and white (the bit is either on or off), whereas 8-bit will generate 256 grays or colors (256 is the maximum number of permutations of a string of eight 1s and 0s), and 24-bit will produce 16.7 million colors (256 x 256 x 256). Most systems can now handle 24 bit, or up to 16.7 million, colors. In contrast, the GIF file format can only support eight-bit color, or 256 different hues. Also called color depth.

bitmap A bitmap is a "map" describing the location and binary state of "bits" which define a complete collection of pixels or dots that comprise an image. In Photoshop Elements this term is also used to refer to pictures that only have black and white pixels.

Blend modes Blend modes allow you to blend individual layers with the layers below. Blend modes are selected in the Layers palette. By default, a new layer is always set to Normal mode, where the pixels on the layer have no interaction with those on the layer below. The actual science of blending modes is complicated, and by far the best method of using blend modes is by trial and error. By experimenting with different blend modes you can often create some very successful and unexpected effects.

brightness The amount of light reflected by a color.

brightness range The range of tones in a photographic subject, from the darkest to the lightest.

bump map A bitmap image file, normally grayscale, used for modifying surfaces or applying textures. The gray values in the image are assigned height values, with black representing the troughs and white the peaks. In Photoshop Elements, bump maps are found as displacement maps and texture maps.

byte A single group made up of eight bits (0s and 1s) that is processed as one unit. It is possible to configure eight 0s and 1s in only 256 different permutations; thus a byte can represent any value between 0 and 255.

calibration The process of adjusting a machine or item of hardware to conform to a known scale or standard so that it performs more accurately. In graphic reproduction it is important that the various devices and materials used in the production chain, such as scanners, monitors, and printers, conform to a consistent set of measures in order to achieve true color fidelity.

Canvas Size The Canvas Size command adds your chosen amount of extra space around the outside of an image. By default, the size of the available canvas is limited to the actual outer boundaries of the original image. You can choose how much extra canvas to add, and where around the image to add it in the Canvas Size dialog.

Channel Images are commonly described in terms of channels, which can be viewed as a sheet of color similar to a layer. Commonly, a color image will have a channel allocated to each primary color (red, green, and blue in a standard RGB image) and sometimes an extra alpha channel for transparency.

clone/cloning In Photoshop Elements, the clone tools allow you to sample pixels from one part of an image, such as a digital photograph, and use them to paint over another area of the image. This process is often used for the removal of unwanted parts of an image or correcting problems, such as facial blemishes.

color The visual interpretation of the various wavelengths of reflected or refracted light.

Color cast A bias in a color image that can be either intentional or undesirable. The cast could be due to any of a number of causes occurring when the image was photographed, printed, or manipulated on the computer.

Color Picker A palette of colors used to describe and define the colors used in Elements. The Color Picker can be opened by clicking on one of the color chits in the Tool Bar.

color temperature A measure, or composition, of light. This is defined as the temperature—measured in degrees Kelvin (a scale based on absolute darkness rising to incandescence)—to which a black object would need to be heated to produce a particular color of light. A tungsten lamp, for example, measures 2,900°K, whereas the temperature of direct sunlight is around 5,000°K and is considered the ideal viewing standard in the graphic arts.

complementary colors Two colors directly opposite each other on the color wheel that, when combined, form white or black, depending on the color model.

Contiguous Contiguous is an option available with the Magic Wand tool. This indicates that any similarly colored pixels must be touching each other or interconnected before they are selected together with the tool. Unchecking this option indicates that similarly colored pixels should be selected together regardless of whether they are interconnected or not.

contrast The degree of difference between adjacent tones in an image (or computer monitor), from the lightest to the darkest. High contrast describes an image with light highlights and dark shadows but with few shades in between, whereas a low-contrast image is one with even tones and few dark areas or highlights.

cool colors A subjective term used to describe colors that have a blue or green bias.

desaturate To reduce the strength or purity of color in an image, thus making it grayer.

dots per inch (dpi) A unit of measurement used to represent the resolution of devices such as printers; and also (erroneously) of monitors and images, whose resolution should more properly be expressed in pixels per inch (ppi). The closer the dots or pixels (i.e., the more there are to an inch), the better the quality. Typical resolutions are 72ppi for a monitor, and 300dpi for a printer.

Eyedropper tool The Eyedropper tool is used for sampling the color underneath the cursor. Some dialog boxes contain their own versions of the tool for picking specific tones, such as white and black points in the Levels dialog box.

feathering A similar process to antialiasing, this blurs the edge pixels of a selection to give a soft border.

fill In Photoshop Elements, selections can be filled with colors, tones, or patterns, using the Paint Bucket tool.

filter Photoshop Elements contains many filters for applying graphical effects to your images. These range from simple blurring or sharpening to complex lighting techniques. Filters can be applied from the Filter Gallery or from the Filter menu.

gradient The smooth transition from one color/tone to another. Gradients are applied using the Gradient tool, and range from simple, linear transitions to radial or diamond-shaped gradients.

gray Any neutral tone in the range between black and white, with no added color.

grayscale The rendering of an image in a range of grays from white to black. In a digital image and on a monitor this usually means that an image is rendered with eight bits assigned to each pixel, giving a maximum of 256 levels of gray.

green One of the three additive colors (red, green, and blue). See additive colors.

histogram A "map" of the distribution of tones in an image, arranged as a graph. The horizontal axis is arranged in 256 steps from black to white (or dark to light), and the vertical axis is the number of pixels. In a dark image you will find taller bars in the darker shades. The histogram is most commonly seen in the Levels palette, but it can also be viewed separately by going to Window > Histogram.

hue Pure spectral color, which distinguishes a color from others. Red is a different hue from blue; and although light red and dark red may contain varying amounts of white or black, they may be the same hue.

interpolation A computer calculation used to estimate unknown values that fall between known ones. One use of this process is to redefine pixels in bitmapped images after they have been modified in some way—for instance, when an image is resized (called "resampling") or rotated, or if color corrections have been made. In such cases the program makes estimates from the known values of other pixels lying in the same or similar ranges. Interpolation is also used by some scanning and image-manipulation software to enhance the resolution of images that have been scanned at low resolution. Photoshop Elements allows you to choose an interpolation method—for example, Nearest Neighbor (for fast but imprecise results, which may produce jagged effects), Bilinear (for medium-quality results), and Bicubic (for smooth and precise results, but with slower performance).

Inverse An option available via Select > Inverse, where the current selection is literally reversed, and unselected areas become selected and vice versa.

Invert Available via Filter > Adjustments > Invert, this command inverts all of the colors and tones within an image, resulting in what we perceive as a negative image in regard to film photography.

JPEG/JPG (Joint Photographic Experts Group) An ISO (International Standards Organization) group that defines compression standards for bitmapped color images. The abbreviated form (pronounced "jay-peg") gives its name to a lossy compressed file format in which the degree of compression from high compression/low quality to low compression/high quality can be defined by the user. This makes the format doubly suitable for images that are to be used either for print reproduction or for transmitting across networks such as the Internet—for viewing in Web browsers. See lossy compression.

Lasso A lasso designates a selected area within an image, enabling changes to be made to this selected area only. The lasso itself is shown by a dotted line, otherwise known as "marching ants." Typically, you would use the Lasso tool to generate this type of selection.

Layers Layers are at the heart of image manipulation in Elements, and can be thought of as separate sheets of acetate or duplicate images stacked on top of the original Background layer. By using layers, you can manipulate or paint onto an image without actually affecting a single pixel on the underlying layers. When you copy and paste parts of an image, the pasted image data is contained on a new, separate floating layer. Individual layers can be moved within the

layer stack in the Layers palette, where the topmost layer will always appear to be in front of any underlying layers. When a new layer is added, it is completely blank until image data is added to it. Any parts of a layer that contain no image data remain completely transparent.

Lens flare The Lens Flare filter, accessible via Filter > Render > Lens Flare, mimics the effect of a light shining directly into a camera lens. Within the Lens Flare dialog, you can control the position and intensity of the flare itself, and even reproduce the effect of a flare though lenses of various focal lengths.

lightness The tonal measure of a color relative to a scale running from black to white. Also called "brightness" or "value."

lossless compression Methods of file compression in which no data is lost (as opposed to lossy compression). Both LZW and GIF are lossless compression formats.

lossy compression Methods of file compression in which some data may be irretrievably lost during compression (as opposed to lossless compression). JPEG is a lossy format.

mask A grayscale template that hides part of an image. One of the most important tools in editing an image, it is used to make changes to a limited area. In Photoshop Elements, a mask can only be applied to an adjustment layer, but in Photoshop masks can be applied to all layers.

midtones/middletones The range of tonal values in an image anywhere between the darkest and lightest—usually referring to those approximately halfway.

monitor Your computer screen, or the unit that houses it. Variously referred to as screens, displays, VDUs, and VDTs. Monitors display

images in color, grayscale, or monochrome, and are available in a variety of sizes (which are measured diagonally), ranging from 9in (229mm) to 21in (534mm) or more. Although most monitors use cathode-ray tubes, some contain liquid-crystal displays (LCDs), particularly portables and laptops and, more recently, gas plasma (large matrices of tiny, gas-filled glass cells).

noise function A random-pattern generator for creating random artifacts, thus preventing colors from looking too flat, perfect, and computer generated.

Opacity Opacity refers to the extent to which an upper layer obscures the content of the layer below it. The opacity of the pixels on a layer can be increased or reduced in the Layers palette. By default, a layer's pixel content has 100 percent opacity, so that any pixels on the layer completely hide the pixels on the layer beneath it, not withstanding the effects of any applied layer blend modes. The opacity of some of Elements' tools can also be modified, such as the Brush tool.

pixel Acronym for picture element. The smallest component of a digitally generated image, such as a single dot of light on a computer monitor. In its simplest form, one pixel corresponds to a single bit: 0 = off (black) and 1 = on (white). In color and grayscale images or monitors, a single pixel may correspond to several bits: an 8-bit pixel, for example, can be displayed in any of 256 colors (the total number of different configurations that can be achieved by eight 0s and 1s).

pixel depth The number of shades that a single pixel can display, determined by the number of bits used to display the pixel. One bit equals a single color (black); four bits (any permutation of four 1s and 0s

such as 0011 or 1001) produces 16 shades; and so on, up to 32 bits (although actually only 24—the other eight being reserved for functions such as masking), which produces 16.7 million colors.

plug-in A third-party filter or subprogram that supplements a host application.

PNG (portable network graphics) A file format for images used on the Web that provides 10–30 percent lossless compression, and supports variable transparency through alpha channels, cross-platform control of image brightness, and interlacing.

red One of the three additive primary colors (red, green, and blue).

resampling Changing the resolution of an image either by removing pixels (and lowering the image resolution) or adding them (and increasing the resolution).

resolution The number of pixels across an image or monitor by the number of pixels down. Common resolutions are 640 x 480, 800 x 600—the size most Web designers use—and 1,024 x 768.

RGB (red, green, blue) The primary colors of the "additive" color model— used in video technology (including computer monitors) and also for graphics (for the Web and multimedia, for example) that will not ultimately be printed by the four-color (CMYK) process method.

saturation The variation in color of the same tonal brightness from none (gray), through pastel shades (low saturation), to pure color with no gray (high saturation, or "fully saturated"). Also called "purity" or "chroma."

sepia A brown color, and also a monochrome print in which the normal shades of gray appear as shades of brown.

shadow areas The areas of an image that are darkest or densest.

sharpening Enhancing the apparent sharpness of an image by increasing the contrast between adjacent pixels.

smoothing The refinement of bitmapped images and text by a technique called "anti-aliasing" (adding pixels of an "in-between" tone). Smoothing is also used in Photoshop Elements with all tools that contain an Anti-aliasing option in the Tool Bar, such as the Magic Wand tool.

swatch A color sample.

TIFF, TIF (tagged image file format) A standard and popular graphics file format— originally developed by Aldus (now merged with Adobe) and Microsoft—that is used for scanned high-resolution bitmapped images, and for color separations. The TIFF format can be used for black-and-white, grayscale, and color images that have been generated on different computer platforms.

tint The resulting shade when white is

supports 256 levels of transparency, ranging from a fully opaque color or layer through to completely transparent. Transparency is indicated in Photoshop Elements by a checkerboard pattern that can be seen around the layer's content in the Layers palette, or when the Background layer contains no image data.

Unsharp mask (USM) One of the Sharpen filters within Elements and one of the most flexible and frequently used. The filter itself works by creating halos around the perceived edges in an image, giving the impression of increased sharpness. Although the filter is very effective, it must be used subtly to avoid these halos becoming too exaggerated and obvious.

warm colors Any color with a hue veering toward red or yellow—as opposed to cool colors, which veer toward blue or green.

white light The color of light resulting from red, blue, and green being combined in equal proportions.

ELEMENTS KEYBOARD SHORTCUTS

MENU COMMAND	ELEMENTS MAC	ELEMENTS WINDOWS
Adjust Smart Fix	Cmd+Shift+M	Ctrl+Shift+M
Auto Color Correction	Cmd+Shift+B	Ctrl+Shift+B
Auto Contrast	Cmd+Option+Shift+L	Ctrl+Alt+Shift+L
Auto Levels	Cmd+Shift+L	Ctrl+Shift+L
Auto Red Eye Fix	Cmd+R	Ctrl+R
Auto Smart Fix	Cmd+Option+M	Ctrl+Alt+M
Bring Forward/Send Backward	Cmd+[or]	Ctrl+[or]
Bring to Front/Send to Back	Cmd+Shift+[or]	Ctrl+Shift+[or]
Canvas Size dialog box	Cmd+Option+C	-
Clear Selection	Backspace	Backspace
Close	Cmd+W	Ctrl+W
Close All	Cmd+Option+W	Ctrl+Alt+W
Color Settings	Cmd+Shift+K	Ctrl+Shift+K
Copy	Cmd+C	Ctrl+C
Copy Merged	Cmd+Shift+C	Ctrl+Shift+C
Cut	Cmd+X	Ctrl+X
Deselect	Cmd+D	Ctrl+D
Exit	Cmd+Q	Ctrl+Q
Extras, show or hide	Cmd+H	Ctrl+H
Feather Selection	Cmd+Option+D	Ctrl+Alt+D
File Info	Cmd+Option+Shift+I	-
Filter, repeat last	Cmd+F	Ctrl+F
Filter, repeat with new settings	Cmd+Option+F	Ctrl+Alt+F
Fit on Screen	Cmd+0 (zero)	Ctrl+0 (zero)
Free Transform	Cmd+T	Ctrl+T
Help contents	Help	F1
Hue/Saturation	Cmd+U	Ctrl+U
Hue/Saturation, use previous settings	Cmd+Option+U	Ctrl+Alt+U
Image Size dialog box	Cmd+Option+I	Ctrl+Alt+I
Inverse Selection	Cmd+Shift+I	Ctrl+Shift+I
Invert	Cmd+I	Ctrl+I
Layer Via Copy	Cmd+J	Ctrl+J
Layer Via Cut	Cmd+Shift+J	Ctrl+Shift+J
Levels	Cmd+L	Ctrl+L
Levels, use previous settings	Cmd+Option+L	Ctrl+Alt+L
Merge Layers	Cmd+E	Ctrl+E
Merge Visible	Cmd+Shift+E	Ctrl+Shift+E
Minimize	Cmd+M	-
New	Cmd+N	Ctrl+N
New Creation	-	Ctrl+Alt+C
New Layer	Cmd+Shift+N	Ctrl+Shift+N

MENU COMMAND	ELEMENTS MAC	ELEMENTS WINDOWS
Open	Cmd+O	Ctrl+O
Open As	-	Ctrl+Alt+O
Page Setup	Cmd+Shift+P	Ctrl+Shift+P
Paste	Cmd+V	Ctrl+V
Paste Into	Cmd+Shift+V	Ctrl+Shift+V
Preferences	Cmd+K	Ctrl+K
Preferences, last panel	Cmd+Option+K	Ctrl+Alt+K
Print	Cmd+P	Ctrl+P
Print Contact Sheet	Cmd+Option+P	-
Print Multiple Photos	-	Ctrl+Alt+P
Print One Copy	Cmd+Option+Shift+P	-
Redo	Cmd+Y	Ctrl+Y
Remove Color	Cmd+Shift+U	Ctrl+Shift+U
Reselect	Cmd+Shift+D	Ctrl+Shift+D
Rulers, show or hide	Cmd+Shift+R	Ctrl+Shift+R
Save	Cmd+S	Ctrl+S
Save for web	Cmd+Shift+Option+S	Ctrl+Shift+Alt+S
Save As	Cmd+Shift+S	Ctrl+Shift+S
Select All	Cmd+A	Ctrl+A
Undo/Redo, toggle	Cmd+Z	Ctrl+Z
View Actual Pixels	Cmd+Option+0 (zero)	Ctrl+Alt+0 (zero)
Zoom In	Cmd++ (plus) or Cmd+= (equals)	Ctrl++ (plus) or Ctrl+=(equals)
Zoom Out	Cmd+- (minus)	Ctrl+- (minus)

APPLYING COLORS	ELEMENTS MAC	ELEMENTS WINDOWS
Delete swatch from palette	Option+click swatch	Alt+click swatch
Fill layer with background color but preserve transparency	Shift+Cmd+Backspace	Shift+Ctrl+Backspace
Fill layer with foreground color but preserve transparency	Shift+Option+Backspace	Shift+Alt+Backspace
Fill selection on any layer with background color	Cmd+Backspace	Ctrl+Backspace
Fill selection or layer with foreground color	Option+Backspace	Alt+Backspace
Lift background color from Swatches palette	Cmd+click swatch	Ctrl+click swatch
Lift foreground color from Swatches palette	Click swatch	Click swatch

PAINTING	ELEMENTS MAC	ELEMENTS WINDOWS
Brush size, decrease/increase	[or]	[or]
Brush softness/hardness, decrease/increase	Shift+[or]	Shift+[or]
Cycle through Healing Brush tools	Option+click Healing Brush tool icon or Shift+J	Alt+click Healing Brush tool icon or Shift+J
Cycle through Paintbrush tools	Option+click Paintbrush tool icon or Shift+B	Alt+click Paintbrush tool icon or Shift+B
Cycle through Eraser functions	Option+click Eraser tool icon or Shift+E	Alt+click Eraser tool icon or Shift+E
Cycle through Focus tools	Option+click Focus tool icon or Shift+R	Alt+click Focus tool icon or Shift+R
Cycle through Clone Stamp options	Option+click Clone Stamp tool icon or Shift+S	Alt+click Clone Stamp tool icon or Shift+S
Cycle through Toning tools	Option+click Toning tool icon or Shift+O	Alt+click Toning tool icon or Shift+O
Delete shape from Brushes palette	Option+click brush shape	Alt+click brush shape
Display crosshair cursor	Caps Lock	Caps Lock
Display Fill Layer dialog box	Shift+Backspace	Shift+Backspace
Paint or edit in a straight line	Click and then Shift+click	Click and then Shift+click
Reset to normal brush mode	Shift+Option+N	Shift+Alt+N
Select background color tool	Option+Eyedropper tool+click	Alt+Eyedropper tool+click
Set opacity, pressure or exposure	Any painting or editing tool+ number keys (e.g. 0=100%, 1=10%, 4 then 5 in quick succession=45%)	Any painting or editing tool +number keys (e.g. 0=100%, 1=10%, 4 then 5 in quick succession=45%)
Add new swatch to palette	Click in empty area of palette	Click in empty area of palette

MAKING SELECTIONS	ELEMENTS MAC	ELEMENTS WINDOWS
Add point to Magnetic selection	Click with Magnetic Lasso tool	Click with Magnetic Lasso tool
Add or subtract from selection	Any Selection tool+Shift or Option+drag	Any Selection tool+Shift or Alt+drag
Cancel Polygon or Magnetic selection	Escape	Escape
Change Lasso tool to Polygonal Lasso tool	Option+click with Lasso tool	Alt+click with Lasso tool
Clone selection	Option+drag selection with Move tool or Cmd+Option +drag with other tool	Alt+drag selection with Move tool or Ctrl+Alt+drag with other tool
Clone selection in 1-pixel increments	Cmd+Option+arrow key	Ctrl+Alt+arrow key
Clone selection in 10-pixel increments	Cmd+Shift+Option+arrow key	Ctrl+Shift+Alt+arrow key

MAKING SELECTIONS	ELEMENTS MAC	ELEMENTS WINDOWS
Close magnetic selection with straight segment	Option+double-click or Option+ Return	Alt+double-click or Alt+Enter
Close polygon or magnetic selection	Double-click with respective Lasso tool or press Return	Double-click with respective Lasso tool or press Enter
Constrain marquee to square or circle	Press Shift while drawing shape	Press Shift while drawing shape
Constrain movement vertically, horizontally, or diagonally	Press Shift while dragging selection	Press Shift while dragging selection
Cycle through Lasso tools	Option+click Lasso tool icon or Shift+L	Alt+click Lasso tool icon or Shift+L
Cycle through Marquee tools	Option+click Marquee tool icon or Shift+M	Alt+click Marquee tool icon or Shift+M
Delete last point added with Magnetic Lasso tool	Backspace	Backspace
Deselect all	Cmd+D	Ctrl+D
Draw out from centre with Marquee tool	Option+drag	Alt+drag
Increase or reduce magnetic lasso detection width	[or] (square brackets)	[or] (square brackets)
Move selection in 1-pixel increments	Move tool+arrow key	Move tool+arrow key
Move selection in 10-pixel increments	Move tool+Shift+arrow key	Move tool+Shift+arrow key
Move selection area in 1-pixel increments	Any selection+arrow key	Any selection+arrow key
Move selection area in 10-pixel increments	Any selection+Shift+arrow key	Any selection+Shift+arrow key
Reposition selection while creating	Spacebar+drag	Spacebar+drag
Reselect after deselecting	Cmd+Shift+D	Ctrl+Shift+D
Reverse selection	Cmd+Shift+I	Ctrl+Shift+I
Select all	Cmd+A	Ctrl+A
Select Move tool	V	V
Subtract from selection	Option+drag	Alt+drag

HIDE AND UNDO	ELEMENTS MAC	ELEMENTS WINDOWS
Display or hide all palettes, toolbox, status bar	Tab	-
Display or hide all floating palettes	Shift+Tab	Tab
Hide all except floating palettes	Tab, Shift+Tab	-
Move a panel out of a palette	Drag panel tab	Drag panel tab
Undo previous operation	Cmd+Z	Ctrl+Z

ELEMENTS KEYBOARD SHORTCUTS

TYPE	ELEMENTS MAC	ELEMENTS WINDOWS
Align left, centre or right	Horizontal type tool +Cmd+Shift+L, C or R	Horizontal type tool +Ctrl+Shift+L, C or R
Align top, centre or bottom	Vertical type tool +Cmd+Shift+L, C or R	Horizontal type tool +Ctrl+Shift+L, C or R
Edit text layer	Double-click on 'T' in Layers palette	Double-click on 'T' in Layers palette
Move type in image	Cmd+drag type when Type is selected	Cmd+drag type when Type is selected
Select all text	Cmd+A	Ctrl+A
Select word, line, paragraph or story	Double-click, triple-click, quadruple-click or quintuple-click	Double-click, triple-click, quadruple-click or quintuple-click
Select word to left or right	Cmd+Shift+left or right arrow	Ctrl+Shift+left or right arrow
Toggle Underlining on/off	Cmd+Shift+U	Ctrl+Shift+U
Toggle Strikethrough on/off	Cmd+Shift+/	Ctrl+Shift+/
Type size, increase/decrease by 2 pixels	Cmd+Shift+< or >	Ctrl+Shift+< or >
Type size, increase/decrease by 10 pixels	Cmd+Shift+Option+< or >	Ctrl+Shift+Alt+< or >

FILTERS	ELEMENTS MAC	ELEMENTS WINDOWS
Adjust angle of light without affecting size of footprint	Cmd+drag handle	Ctrl+drag handle
Clone light in Lighting Effects dialog box	Option+drag light	Alt+drag light
Repeat filter with different settings	Cmd+Option+F	Ctrl+Alt+F
Repeat filter with previous settings	Cmd+F	Ctrl+F
Reset options inside Corrective Filter dialog boxes	Option+click Cancel button	Alt+click Cancel button

F KEYS	ELEMENTS MAC	ELEMENTS WINDOWS
Help	Help key	F1
Display or hide How To palette	F6	F6
Display or hide Styles and Effects palette	F7	F7
Display or hide Info palette	F8	F8
Display or hide Histogram palette	F9	F9
Display or hide Undo History palette	F10	F10
Display or hide Layers palette	F11	F11
Display or hide Navigator palette	F12	F12

LAYERS	ELEMENTS MAC	ELEMENTS WINDOWS
Add to current layer selection	Shift+Cmd+click layer or thumbnail in Layers palette	Shift+Ctrl+click layer or thumbnail in Layers palette
Copy merged version of selection to Clipboard	Cmd+Shift+C	Ctrl+Shift+C
Create new layer, show dialog box	Option+click page icon at bottom of Layers palette or Cmd+Shift+N	Alt+click page icon layer options at bottom of Layers palette or Ctrl+Shift+N
Create new layer below target layer	Cmd+click page icon at bottom of Layers Palette	Ctrl+click page icon at bottom of Layers Palette
Create new layer below target layer, show layer options dialog box	Cmd+Option+click page icon at bottom of Layers palette	Ctrl+Alt+click page icon at bottom of Layers palette
Display or hide Layers palette	F11	F11
Duplicate layer effect/style	Option+drag effect/style to target layer	Alt+drag effect/style to target layer
Edit layer style	Double click layer style icon	Double click layer style icon
Select current layer and layer below	Shift+Option+[Shift+Alt+[
Select current layer and layer above	Shift+Option+]	Shift+Alt+]
Group neighbouring layers	Cmd+G	Ctrl+G
Group with previous layer	Option+click horizontal line in Layers palette	Option+click horizontal line in Layers palette
Intersect with current layer selection	Shift+Option+Cmd+click layer or thumbnail in Layers palette	Shift+Alt+Ctrl+click layer or thumbnail in Layers palette
Load layer as selection	Cmd+click layer or thumbnail in Layers palette	Ctrl+click layer or thumbnail in Layers palette
Merge all visible layers	Cmd+Shift+E	Ctrl+Shift+E
Merge layer with next layer down	Cmd+E	Ctrl+E
Move contents of a layer	Drag with Move tool or Cmd +drag with other tool	Drag with Move tool or Ctrl +drag with other tool
Move contents of a layer in 1-pixel increments	Cmd+arrow key	Ctrl+arrow key
Move contents of a layer in 10-pixel increments	Cmd+Shift+arrow key	Ctrl+Shift+arrow key
Move layer effect/style	Shift+drag effect/style to target layer	Shift+drag effect/style to target layer
Move to top layer	Option+]	Alt+]
Move to bottom layer	Option+[Alt+[
Moves target layer down/up	Cmd+[or]	Ctrl+[or]
Moves target layer back/front	Cmd+Shift+[or]	Ctrl+Shift+[or]
New layer via copy	Cmd+J	Ctrl+J
New layer via cut	Cmd+Shift+J	Ctrl+Shift+J
Lock transparent pixels	/	/
Subtract from current layer selection	Option+Cmd+click layer or thumbnail in Layers palette	Alt+Ctrl+click layer or thumbnail in Layers palette
Ungroup neighboring layers	Cmd+Shift+G	Ctrl+Shift+G

CROPS AND TRANSFORMATIONS	ELEMENTS MAC	ELEMENTS WINDOWS
Accept transformation	Double-click inside boundary or press Return	Double-click inside boundary or press Enter
Cancel crop	Escape	Escape
Cancel transformation	Escape	Escape
Constrained distort for perspective effect	Cmd+Shift+drag corner handle	Ctrl+Shift+drag corner handle
Constrained distort for symmetrical perspective effect	Cmd+Shift+Option+ drag corner handle	Ctrl+Shift+Alt+drag corner handle
Freely transform with duplicate data	Cmd+Option+T	Ctrl+Alt+T
Freely transform selection or layer	Cmd+T	Ctrl+T
Rotate image (always with respect to origin	Drag outside boundary	Drag outside boundary
Select Crop tool	C	C
Skew image	Cmd+drag side handle	Ctrl+drag side handle
Skew image along constrained axis	Cmd+Shift+drag side handle	Ctrl+Shift+drag side handle
Skew image with respect to origin	Cmd+Option+drag side handle	Ctrl+Alt+drag side handle
Skew image along constrained axis with respect to origin	Cmd+Shift+Option+drag side handle	Ctrl+Shift+Alt+drag side handle
Distort corner	Cmd+drag corner handle	Ctrl+drag corner handle
Symmetrically distort opposite corners	Cmd+Option+drag corner handle	Ctrl+Alt+drag corner handle

VIEWING	ELEMENTS MAC	ELEMENTS WINDOWS
100% magnification	Double-click Zoom tool or Cmd+Option+0 (zero)	Double-click Zoom tool or Ctrl+Alt+0 (zero)
Applies zoom percentage and and keeps zoom percentage box active	Shift+Return in Navigator palette	Shift+Enter in Navigator palette
Fits image in window	Double-click Hand tool or Cmd+0 (zero)	Double-click Hand tool or Ctrl+0 (zero)
Moves view to upper left corner or lower right corner	Home or End	Home or End
Scrolls image with hand tool	Spacebar+drag or drag view area box in Navigator palette	Spacebar+drag or drag view area box in Navigator palette
Scrolls up or down 1 screen	Page Up or Page Down	Page Up or Page Down
Scrolls up or down 10 units	Shift+Page Up or Page Down	Shift+Page Up or Page Down
Zooms in or out	Cmd++ (plus) or - (minus)	Ctrl++ (plus) or - (minus)
Zooms in on specified area of an image	Cmd+drag over preview in Navigator palette	Ctrl+drag over preview in Navigator palette

ORGANIZER	ELEMENTS WINDOWS
Add caption to image	Ctrl+Shift+T
Adjust date and time	Ctrl+J
Auto Red Eye Fix	Ctrl+R
Auto Smart Fix	Ctrl+Alt+M
Burn CD	Ctrl+B
Catalog	Ctrl+Shift+C
Clear date range	Ctrl+Shift+F
Color settings	Ctrl+Alt+G
Copy	Ctrl+C
Delete from catalog	Delete
Deselect	Ctrl+Shift+A
Duplicate image	Ctrl+Shift+D
E-mail image	Ctrl+Shift+E
Edit with Photoshop	Ctrl+H
Exit	Ctrl+Q
Export to computer	Ctrl+E
Find all photos	Alt+1
Find all video	Alt+2
Find all version sets	Ctrl+Alt+V
Find by caption or note	Ctrl+Shift+J
Find by filename	Ctrl+Shift+K
Get photos from camera or card reader	Ctrl+G
Get photos from scanner	Ctrl+U
Get photos from files and folders	Ctrl+Shift+G
Get photos from mobile phone	Ctrl+Shift+M
Move image file	Ctrl+Shift+V
Page setup	Ctrl+Shift+P
Preferences	Ctrl+K
Print	Ctrl+P
Redo	Ctrl+Y
Rename image	Ctrl+Shift+N
Reveal photos in stack	Ctrl+Alt+R
Rotate 90 degrees left	Ctrl+Left Arrow
Rotate 90 degrees right	Ctrl+Right Arrow
Select all	Ctrl+A
Set as desktop wallpaper	Ctrl+Shift+W
Set date range	Ctrl+Alt+F
Stack selected photos	Ctrl+Alt+S
Switch to Standard Edit mode	Ctrl+I
Undo	Ctrl+Z
Update thumbnail	Ctrl+Shift+U

INDEX

ONLINE RESOURCES

Note that website addresses can change, and sites can appear and disappear almost daily. Use a search engine to help you find new arrivals or check old addresses that have moved.

Absolute Cross Tutorials (including plug-ins)
www.absolutecross.com/tutorials/photoshop.htm

creativepro.com: resources for creative professionals
www.creativepro.com

The Digital Camera Resource Page: consumer-oriented resource site
www.dcresource.com

Digital Photography: news, reviews, etc.
www.digital-photography.org

Digital Photography Review: products, reviews
www.dpreview.com

ePHOTOzine
www.ephotozine.com

The Imaging Resource: news, reviews, etc.
www.imaging-resource.com

Laurie McCanna's Photoshop Tips
www.mccannas.com/pshop/photosh0.htm

panoguide.com: panoramic photography
www.panoguide.com

photo.net: photography resource site - community, advice, gallery, tutorials, etc.
www.photo.net

Photofects: Photoshop tutorials
www.fotofects.com

Photofoolery: Photoshop tutorials, tips, and techniques
www.photofoolery.com

Photolink International: education in photography and other related fields
www.photoeducation.net

Photoshop Support: tutorials and plugins
www.photoshopsupport.com

Photoshop Today
www.photoshoptoday.com

Planet Photoshop (portal for all things Photoshop)
www.planetphotoshop.com

Royal Photographic Society (information, links)
www.rps.org